COLOR WITH STYLE

Art Director and Designer: *Wayne Kosaka*

Illustrator: *Justine Limpus Parish*

Photographer: *Kevin Sanchez*

Editor: *Calvin J. Abe*

Hair Stylist: *Lucille Mildram*

Makeup Artist: *Ann Rathie*

Stylist: *Kathy McBride*

Assistant Hair Stylist: *Rishelle Klahn Mildram*

Production Coordinator: *Denise Hom*

Japanese Translation: *Nami Hayama*

**All fashions were provided by I. Magnin,
San Francisco, with the assistance of the I. Magnin
Personal Shopping staff, except as noted below:**

> *JLC Designs, p. 26, top; p. 32, top; p. 34, top; Cashmere of Scotland,
> p. 29, top; p. 33, bottom; p. 66-67, light blue; p. 68-69, olive green;
> Rodier of Paris, p. 34, bottom; Mondi, page 58-59, yellow;
> Casual Corner, p. 58-59, teal green.*

Models:

*Grimme Agency: Lora Abe, Pam Kay Davis, Rhonda Ivery, Kim Lincoln,
Maria Gonsalves, Shao-Yen Wang, Shanda Williams. Avalon Models:
Amanda Braun. Best Models: Florence Cruz, Simone Mith, Noelle,
Taya Waltke. Brebner-Carreon Talent Group: Annette Rodriguez.
L'uomo/Elle Agency: Andrea Perez. Metro Models: Janine Shiota.
Stars the Agency: Dian Thompson. Talent Plus Agency: Melissa Ortega,
Maria Vasquez. Independent: Dr. Joyce Takahashi Doi, Lea Kosehanadel,
Hannah Lau, Elma Nehira Ure, Kimberly Nichols, Marie Shiromoto,
Lena Turner.*

Photographs Copyright © 1991 by Kevin Sanchez, except as noted.
Photographs of the author and on page 21, Copyright © 1991 by Ted Jew

Color With Style™ is a registered trademark of Donna Fujii and Donna Fujii, Inc.
Color With Style™ by Donna Fujii with Judith Walthers von Alten
Copyright © 1992 by Donna Fujii and Donna Fujii, Inc.

Copyright © 1991 by Graphic-Sha Publishing Company, Ltd., 1-9-12 Kudan-Kita, Chiyoda-ku, Tokyo, 102 Japan
Telephone: (03) 3263-4318 Fax: (03) 3263-5297

Printed in Japan

First printing, June 1991

COLOR WITH STYLE

by Donna Fujii
with Judith Walthers von Alten

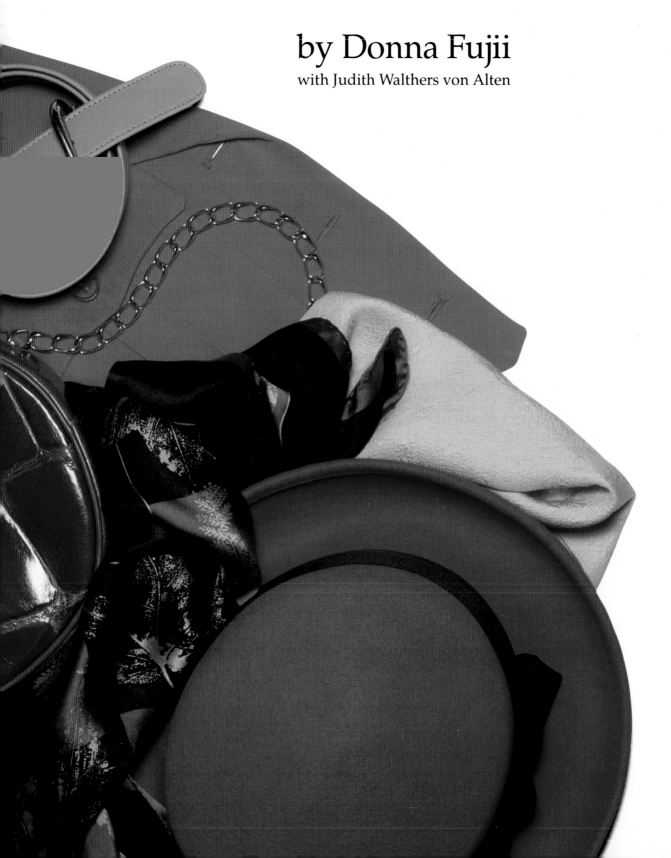

ACKNOWLEGEMENTS

This book is dedicated to Cal. The completion of this book marks the culmination of a remarkable two-year saga involving the combined talents, hard work, encouragement, and sustenance of scores of individuals. I will always be grateful to each of them for their unwavering faith in me, and their dedication to the success of this project. I would especially like to acknowledge the following individuals for their extraordinary contributions.

Wayne Kosaka, art director and designer, for taking on this project, spending countless hours designing and re-designing it, and doing a smashing job in the process. Justine Limpus Parish, for creating all of the wonderful illustrations in the book, and for being a joy to work with. Lucille Mildram, Point of View, Benicia, and top hair stylist, for her excellent hair design and styling for all of the models. Ann Rathie, Image Consultant Services, San Rafael, for doing a great job on the makeup of all of the models. Kevin Sanchez, photographer, and Kathy McBride, stylist, for jobs well done.

Toshiro Kuze, my publisher, for making this book a reality. Debra Ellingson Teton of Hues to You, Santa Barbara, for always being available to brainstorm on this project, and for her undying friendship. Marcy Tilton of The Sewing Workshop in San Francisco, for sharing her fashion and style sense, and her special communications skills. Pat Hayes, teacher at Mendocino College, for sharing her considerable expertise on color and figure analysis, as well as her kindness and humanity. Janet Lee Chen of JLC Designs in San Francisco, for her friendship, impeccable taste, and devotion. Akira Togasaki, Japan business expert extraordinaire, affiliated with the top San Francisco law firm of Minami, Lew, Tamaki, and Lee, for his deep insight, and faith in my writing ability. Ryan Abe, author and composer, for assisting with the editing, and sharing his knowledge of the writing and publishing businesses. Rose Marie Bravo, Chief Executive Officer of I. Magnin Stores, for believing in this book. Francine and Edward Joseph for their long-term support for my work.

Janice Okubo, Dr. Dale Yamashita, Andrew Teton, and Timothy G. Laddish, for their valuable assistance in editing this book. Hiroshi Hidaka, Takehiro Komatsu, Nobuya Ohta, Atsunori Andoh, and Kenichi Takehara, and my many friends at Takashimaya Department Stores, which truly understands what it takes to have a great image. Elois Jenssen, Fumi Ukai, Namiye Oshima, Elizabeth Andoh, Mike Nagai, Ed Chen, Nick Wadhwani, Joanne Fujita, Elisa Feng, Shelley Green, Rico Komanoya, and Edith Fung, for their important contributions which led to the production of this book. The Association of Image Consultants International and its members for their support and inspiration. AICI members Jeane G. Johnson, author of *Clothing Image and Impact,* Diane Parente, author of *Universal Style,* and Karen Mountain of I. Magnin Personal Shoppers. My family for their love and understanding.

CONTENTS

INTRODUCTION

Color With Style describes an easy-to-use color system that applies to any woman, whether she is Caucasian, Asian, Black, or Hispanic. Based on color and image consultant Donna Fujii's 13 years of experience working with thousands of women, the *Color With Style* approach builds on the classic "four seasons" model of two warm (yellow-based) and two cool (blue-based) palettes. The *Color With Style* system also looks at the amount of contrast between an individual's skintone and hair coloring as an important component in determining one's best colors.

Donna Fujii's passion for color and style began when, as a young child, she first experimented with different color combinations by designing clothes for her paper dolls using pencils and color crayons. After earning a college degree in fashion arts and a secondary teaching credential, she taught at the high school level for several years. In 1978, she began doing personal color analysis in the San Francisco area, refining her methodology by analyzing the colors of many individuals of virtually every ethnic background, and skin and hair coloration.

Today, Donna Fujii's seminars on color analysis and style attract large audiences throughout the United States and in Japan. Her clients include a host of major department stores including Macy's, Parisian, Carson, Pirie & Scott; and The May Company in the United States; and Takashimaya Department Stores and JALPAK, a subsidiary of Japan Air Lines, in Japan.

In her experience of selecting color palettes for her clients, Donna Fujii learned that some of them were left unsatisfied by other color analysts who had tried to fit them strictly into one of the four seasonal categories without considering their more subtle qualities, such as the amount of contrast between their skin and hair coloring.

In the classic four seasons approach, the brunette or black-haired woman with cool, pale skin is the classic Winter with a palette of cool primary colors; the ash blonde with cool skin has a Summer palette of cool light colors; the blonde with warm skin has a Spring palette of warm bright colors; and the redhead or brunette with warm skin has an Autumn palette of warm, earthy colors.

The four seasons approach places all women into one of the four seasonal categories, and puts the majority of Asian, Black and Hispanic women into the Winter and Autumn categories. However, not all women of the same season have the same color palettes, and placing them in such generalized categories ignores their individuality. For example, even though Margaret Thatcher and Princess Sarah are both Autumns, Princess Sarah has much darker and redder hair coloring, which allows her to wear richer, and more vivid and earthy colors than Mrs. Thatcher. Likewise, the diversity among Asian, Black and Hispanic women is enormous. Their skin color can range from a light porcelain, to olive, to blue black, while their hair color can span the spectrum from silver white, to brown, to blue black.

In fact, Donna Fujii's own coloring does not fit neatly into one of the four seasons. Realizing the need for a more exacting color system, she expanded upon the seasonal approach by adding the important element of contrast in a person's individual coloring, and by addressing the special qualities of women of color. In such a way, her system, the *Donna Fujii Color System*, which consists of twenty-five palettes rather than the four seasonal palettes, offers more precise color choices for all women.

This book will teach you how to determine your best colors, starting with an easy-to-understand explanation of how and why certain colors best complement your natural coloring, and includes exercises and charts to help you determine which of the twenty-five categories you are in. Once you know your best colors, the book will show you how to apply this knowledge of color in building a well-coordinated and flexible wardrobe which projects just the right image for you – without your spending a fortune. You will also learn how to choose your most flattering styles, how to enhance your own body shape, how to use makeup most effectively, and which hair styles, colors and accessories are most flattering to your face.

Read on to discover how the magic of *Color With Style* can work for you!

CHAPTER 1
COLOR AND YOUR IMAGE

Color is the essence of dressing successfully; it affects how you feel and how people respond to you.

Color attracts the eye first. It is the first thing that others see about you, and probably what they will remember about you. Within five seconds of entering a room, you have made an impression because of the colors you are wearing. Is it the impression you want to make?

If you learn to consistently select your best colors, this would be the best possible wardrobe investment. It does not cost extra, and it will reap surprising dividends. Once you understand and use the magic of colors, you will be able to harness its power to look better, feel healthier, and energize you and the people you meet. All of that from color? Yes!

YOUR COLOR INSTINCTS

Instinctively, you are drawn to the colors that look best on you. By nature, your eyes seek balance and harmony. The German colorist Johannes Itten in the early 1900's was the first to observe that his art students gravitated naturally to the hues that complimented their own natural coloring.

Unfortunately, we do not always follow our natural instincts. The color preferences of our parents, friends, and culture, and fashion trends often overwhelm our instinctive likes and dislikes. An objective of this book is to help you to relearn what you know instinctively, and thereby sharpen your ability to recognize the colors that flatter you best.

Many researchers have found that different colors produce specific reactions in people. Red is passionate and dramatic, pink is sweet and delicate, orange is energetic and stimulating, while yellow is cheerful and sunny. Green induces peace, and blue soothes. Purple is regal, and brown is dependable. Black is mysterious and sophisticated, while gray is conservative and comfortable. When you wear these colors, you give off the same impressions.

Understanding color and how it affects your appearance lets you make just the statement you want about yourself. Knowing your best colors lets you create an environment in which you look and feel the most comfortable.

Doesn't every woman know the feeling of standing in front of her packed closet, and not knowing what to wear? Color is half the answer to building a successful wardrobe. The other half is deciding the correct pieces to have in a wardrobe. In this book, I will teach what you need to know about color and how to determine the best pieces for you, so you can learn to make wardrobe decisions quickly and easily.

The Basics of Color

Each color is made up of three components: Hue, the spectral color: red, orange, yellow, green, blue, or purple; Value, or lightness, the amount of shade or tint in a color; and Intensity, the saturation or strength of a color, also known as its chroma.

Hue represents the quality by which we are able to tell one color family from another, as in the hues of color wheel. Hue is also the name of a color or color family and gives a color its distinctive, recognizable quality. Technically, differences in hue are attributable to differences in the wavelength of light waves, which allow us to see different colors.

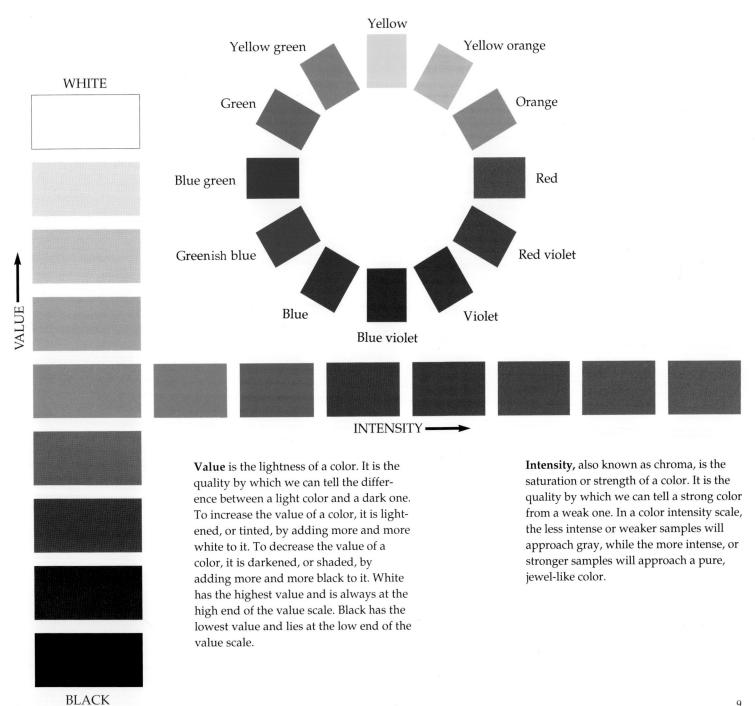

WHITE

VALUE →

Yellow

Yellow green

Yellow orange

Green

Orange

Blue green

Red

Greenish blue

Red violet

Blue

Violet

Blue violet

INTENSITY →

BLACK

Value is the lightness of a color. It is the quality by which we can tell the difference between a light color and a dark one. To increase the value of a color, it is lightened, or tinted, by adding more and more white to it. To decrease the value of a color, it is darkened, or shaded, by adding more and more black to it. White has the highest value and is always at the high end of the value scale. Black has the lowest value and lies at the low end of the value scale.

Intensity, also known as chroma, is the saturation or strength of a color. It is the quality by which we can tell a strong color from a weak one. In a color intensity scale, the less intense or weaker samples will approach gray, while the more intense, or stronger samples will approach a pure, jewel-like color.

Cool and Warm Colors

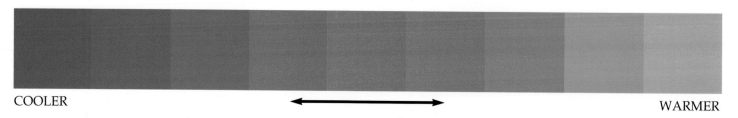

COOLER

WARMER

Generally, colors are either cool or warm. The blues – blue and violet – are the cool colors. The reds – red, orange, and yellow – are the warm colors.

Cool and warm colors should not be confused with cool-tone and warm-tone colors. If a cool color is added to another color, the result is a cool-tone color. Similarly, if a warm color is added to another color, the result is a warm-tone color. For example, green

with blue added results in a cool-tone aqua green, while green with yellow added results in a warm-tone yellow-green. Also, red with blue added results in a cool-tone magenta, while red with yellow added results in a warm-tone orange red. On the above chart, notice that mixing in additional portions of cool or warm colors will result in cooler or warmer-tone hues.

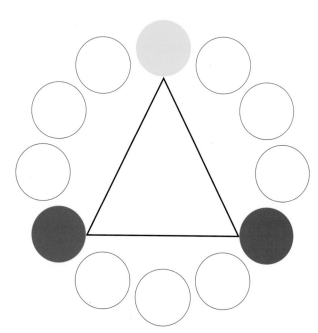

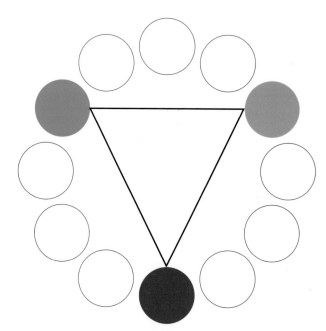

Primary Colors
Red, yellow, and blue are the primary colors because all other colors can be made from them by mixing their pigments in different combinations. Also, they are primary in the sense that they cannot be made by mixing any combination of their pigments.

Basic Colors
Together, the primary and the secondary colors include all of the pure colors of the spectrum, or the rainbow colors. They are also known as the basic colors.

Secondary Colors
Green, orange, and violet are the secondary colors. They are made from mixing the pigments of two of the primary colors. A secondary color always lies directly opposite a primary color on the 12-hue color wheel.

Color Combinations

Essentially, there are four types of
color combinations or color schemes:
Complementary, Analogous, Triad,
or Monochromatic. These will be put
to practical use in Chapter 6, where
dressing in two, three, or four-color
combinations is covered. In reading
about the different types of color com-
binations, remember that there are no
strict rules governing them.

Complementary
A complementary color
combination uses colors
which lie opposite each
other on the color wheel,
such as green and red, blue
and orange, or yellow and
violet. Complementary col-
ors tend to pull in opposite
directions, which creates a
certain tension between
them. This tension can create
a lively or dramatic effect.

Analogous
An analogous color combi-
nation uses neighboring col-
ors on the wheel, such as
green, blue-green, and blue,
or red, red-violet, and violet.
This creates a harmonious,
eye-pleasing effect due to
the close relationship
between the hues.

Triad
A triad color combination
uses any three colors (or
shades of these colors) an
equal distance apart on the
color wheel, such as purple,
orange, and green. Such
combinations may at first
appear unworkable, but in
fact can work together very
nicely, especially when
selected in the correct
shades and proportions.

Monochromatic
A monochromatic color
combination uses different
intensities of the same color,
such as light blue, medium
blue, and dark blue. It is a
simple color scheme to use,
yet it can produce attractive
and sophisticated results.

Your Natural Coloring

Your own natural coloring is made up of your skintone, hair color and eye color. There are endless variations and combinations of skin, hair and eye color so that each person's total coloration is entirely her own.

SKIN COLORING

The many variations in skin coloring come from the three skin pigments: red (hemoglobin), yellow (carotene), and brown (melanin). Everyone has each of the three skin pigments, only in different amounts. Each person's skin coloring is determined by how much red, yellow and brown skin pigment is found in her skin.

It should be noted that a skintone's coolness or warmth has nothing to do with its value, or relative lightness or darkness. While it is true that darker skin tends to be warmer due to its greater proportion of brown pigment, which allows one to tan more easily, this is not a hard and fast rule. For example, a Black woman with cool rose skintone will have a darker yet cooler skintone than a Caucasian woman with warm peach skintone. So try not to confuse the lightness, or value of skin coloring, with its coolness or warmth.

HAIR COLORING

Hair color can range from the palest blonde, white or silver, to blue black or jet black. Hair, even if it is not very long, is of major importance to a person's overall look because it is visibly prominent next to the person's face. A person's hair color naturally complements her skintone, unless it has been dyed. Like skin, hair color can range from cool to very warm, and will have a direct impact in determining one's color palette. Hair color is sometimes determined by its undertone (the color nearest the roots) but in most cases, by its highlights (the lighter color nearest the ends). For example, cool ash brown hair with warm golden blonde highlights will probably have a warm overall look.

EYE COLORING

Like skintone and hair coloring, eye coloring can also range from cool to warm. Cool eye colors include blue, violet, hazel and gray. Warm eye colors include brown, dark brown and green. Eye coloring plays a lesser role in determining one's color palette since it involves a smaller visible area than either the skin or the hair.

If the eye coloring is neutral, such as the brown or dark brown found in many Asians, Blacks and Hispanics, it will have less impact on a person's

COOL-LIGHT

These skintones have a pink undertone, and are the lightest of all. Included in this group are porcelain and rose beige.

COOL-DARK

These skintones have a pink or blue undertone, and range in the darker shades. Olive and dark brown are included in this group.

PORCELAIN	PINK	LIGHT BEIGE	ROSE BEIGE	MEDIUM OLIVE	ROSE BROWN

color palette. If the eye coloring is prominent, such as shades of blue, green, or hazel, using eye extension colors – that is, repeating the eye color in one's clothing – will highlight the eyes and can have a dramatic impact. Eye extension colors are not included in the palettes in this book, because they vary according to a person's eye coloring, and not according to her skin and hair coloring. The palettes in this book are based only on skin and hair coloring. Eye extension colors will attract attention to your eyes, and can be very flattering when worn as an accent color. In selecting eye extension colors, make sure that the color also complements your skintone.

ANALYZING YOUR NATURAL COLORING

A woman's ethnic background plays an important role in determining her likely range of natural coloring. Caucasian women often have an abundance of red and yellow rather than brown pigment in their skin. Asian women tend to have a bit more yellow and brown pigment. Hispanic women tend to have slightly more red and brown. Black women tend to have more brown. For these reasons, a different chapter is devoted to each of the four groups, so that you can easily find your own category and color palette.

In the *Donna Fujii Color System*, Exercise 1 (later in this chapter) will help you to determine whether your skin coloring is cool or warm ("Warm" includes the lukewarm and very warm skintones discussed above). In evaluating your skintone, look for the pink, blue, yellow, or golden undertone, which is the pigment just beneath the surface of the skin. If the the undertone is pink or blue, the skintone is cool. If the undertone is yellow or golden, the skintone is warm.

Exercise 2, which is at the beginning of each color analysis chapter, will help you determine whether your skin is a lighter or darker shade. You can then refer to your Color Analysis Chart to find your color category.

SKINTONE SCALE

The scale below contains examples of some of the skintones that you will be reading about when you refer to the Color Analysis Chart in your chapter. In using that chart, you may want to refer back to this scale to compare your skintone with those listed on the chart. Additional skintone samples may be found on the pages 142-143.

The skintones falling into this group have a yellow undertone, and have lighter values. Examples are peach and yellow olive.

WARM-LIGHT

Skintones with a yellow undertone and a darker value fall into this group. Dark olive brown and golden brown are examples of warm-dark skintones.

WARM-DARK

IVORY	PEACH	YELLOW BEIGE	LIGHT PEACH BROWN	PEACH BROWN	GOLDEN BRONZE

Making Colors Work for You

How do you put colors to work for you? You can wear almost every color on the color wheel, as long as you choose the best hues, values, and intensities for you.

Your palette of best colors depends on three factors: skintone, hair coloring and, to a lesser extent, eye coloring. When you are not wearing your best colors, there is a lack of balance or harmony between you and your clothes. Your clothes will clash with your natural coloring and can bring out an unhealthy yellow greenish, or sallow color in your skin. You will appear tired, and any lines or dark, uneven coloring in your face will become more apparent. Your clothes will overwhelm you, and you will appear to recede into the background.

When you are wearing your best colors, there is a balance and harmony between your natural coloring and the colors you are wearing. The colors of your skin, hair, and eyes will seem fresher and brighter, and you will look healthier and more vibrant. Your skin will appear more clear and youthful, and because of how others will react to you, you will feel an increased self-confidence in knowing that you look terrific. Others will notice *you* first, rather than the clothes you are wearing. Your clothes will play a supporting role to you, and help to bring out the best in you.

Why do certain colors flatter you

while others make you look sick or tired?

First, the color combination formed by the colors of your skin, hair, and eyes, along with the colors you are wearing, is the most significant factor. Regardless of the type of color combination so formed (See discussion of color combinations, page 11.), it will be more attractive if there is a balance and harmony between the hues, values, and intensities of its different components.

Second, the colors you are wearing can reflect back onto your skin and hair, and alter the appearance of your natural coloring. This reflection effect is more pronounced when you are wearing brighter colors. This effect is subtle, but can be a factor in determining which colors look the very best on you.

Third, the "simultaneous contrast of color" effect can operate to slightly modify the appearance of your natural coloring. This effect, which is also subtle, causes the eye to perceive slight changes in colors due to the influence of afterimages from colors viewed at the same time. Because a color's afterimage is its complementary color (For example, red's afterimage is green, and so on.), its effect will be to tint a color towards the complement of the other color that is viewed at the same time. Please note that this effect is just the opposite of the reflection effect. The importance of

each effect depends on several factors, including the colors themselves, skin and fabric textures, and the lighting.

Finally, the contrast between your skintone and hair values will help to determine which color values look the best on you. For example, if you have high contrast between your skin and hair values, with your skin being very light and your hair being very dark, you will look your best in combinations of very light and very dark values.

On the other hand, if you have low contrast, your best colors will fall into a value range that is the same as, or similar to, your own coloring. Values that are much lighter than your own coloring may look uninteresting on you, while values that are much darker may be overpowering, and make you appear washed-out.

To get you started in identifying your own natural coloring, do the exercises and study the information on contrast contained on the following pages.

Exercise 1 was designed to help you determine whether your skintone is cool or warm. Exercise 2, which is at the beginning of Chapters 2, 3, and 4, was designed to help you determine whether your skintone is a lighter or darker shade. The discussion of contrast on page 17 will explain what contrast is, and describe how it affects which colors will look the best on you.

AFTER

To bring out a healthy glow in Maria's olive skintone, I have selected a cheddar yellow jacket and top, with a black skirt. The finishing touch is a silk scarf in black, and primary red and blue, which creates an attractive focal point, and balances the brightness of her cheddar yellow top.

BEFORE

The warm beige blouse, and brown plaid skirt that Maria is wearing, wash-out her skintone and hair coloring. The result is a look that is drab, and uninteresting.

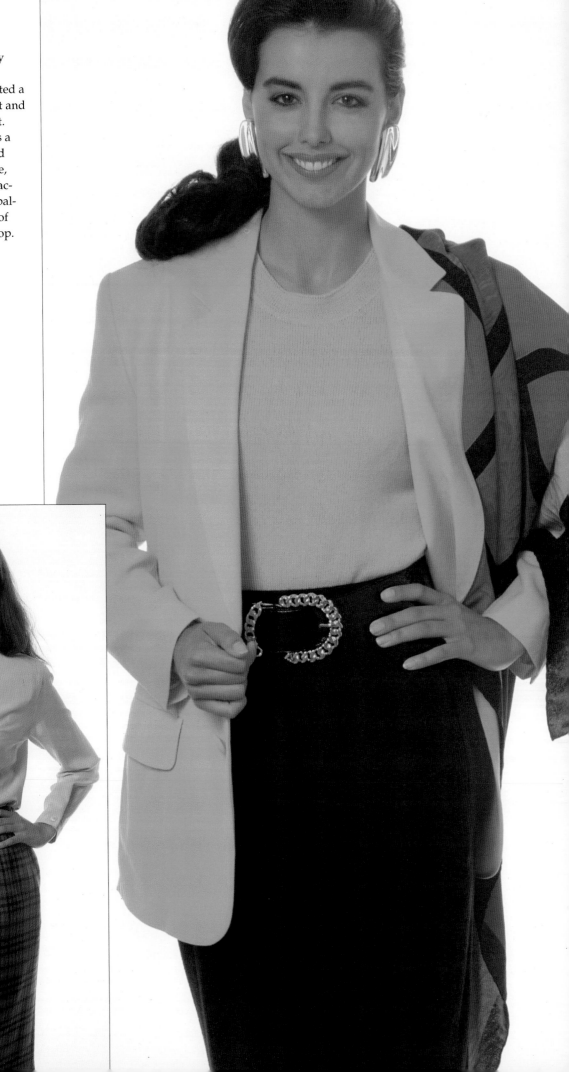

EXERCISE 1

Am I cool or warm?

The best colors for you depend on whether your skintone is based on cool colors or warm colors. This exercise will help you to determine this. In doing those portions of the exercise in which you are asked to express your color preferences, trust your instincts to help you make your selections.*

1. Face the palm of your hand up, and look at the untanned portion of your forearm in natural light. Look carefully to see whether your skin has a pink or yellow undertone, and mark your answer below.

☐ A. Yellow undertone ☐ B. Pink undertone

2. Take pieces of gold and silver fabric and drape one on each shoulder in natural light. If you do not have fabric, use gold and silver jewelry and hold them next to each cheek. Which color brings out a healthier glow in your skin?

☐ A. Gold ☐ B. Silver

3. Do you tan easily? ☐ A. Yes ☐ B. No

4. Which lipstick color do you prefer?

☐ A. Orange red ☐ B. Rose red

5. Which colors do you prefer?

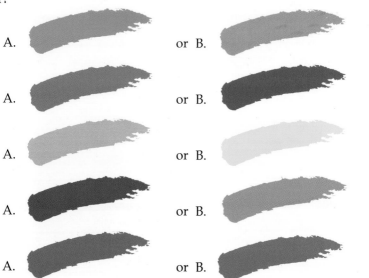

A. or B.

A. or B.

A. or B.

A. or B.

A. or B.

If you chose 3 or more A's, your answer to question 5 is A. If you chose 3 or more B's, your answer is B.

Evaluating Your Results: If 3 or more of your answers to questions 1 through 5 were A's, your skintone is most likely warm. If 3 or more of your answers were B's, your skintone is most likely cool.

Now that you have an idea of whether you have a cool or warm skintone, go on to Exercise 2 to determine your contrast.

*As this Exercise is partially preference-based, it will guide you to the best colors for your natural coloring. Therefore, if you have dyed your hair, its results may not be valid for your current look with dyed hair.

16

The Importance of Your Contrast

Your contrast plays a key role in determining the values of the colors in your palette. If you have low contrast, the colors in your palette will fall into the middle range of values. If you have high contrast, the colors in your palette will have either very low, or very high values.

Your contrast is the difference in the value (lightness or darkness) of your skin compared with that of your hair. So, if your hair is blonde, and your skintone is a tan color that is about as dark as your hair, there would be little contrast between your skintone and hair color. In this case, you would have low contrast. If your hair is black and your skin is very fair, you would have high contrast.

Compare a photo of yourself with the women in the two sets of illustrations to the right. Take note of the contrast between your skin and hair in comparison with those of the illustrated figures. Try and decide whether your skin-hair contrast is more like that of the blonde, or the brunette. If your contrast is more like the blonde, you have low contrast. If you are more like the brunette, you have high contrast.

WRONG

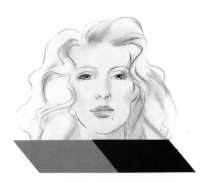

This illustration features a woman with low skin-hair contrast next to a color combination suitable for a person with high contrast. She looks drab and washed-out next to the very light and dark contrasting values of this strong color combination.

RIGHT

The low contrast woman is placed next to the color combination suitable for her. Notice how the middle range values of the color combination harmonize with and repeat the moderate values of her natural coloring.

WRONG

A woman with high contrast is placed next to a color combination suitable for a person with low contrast. Her striking natural coloring of very light and dark values overpowers the middle-range hues of the color combination.

RIGHT

The high contrast woman looks great next to the light and dark color combination. The very light and dark values of the color combination are the perfect complement to the extreme values of her natural coloring.

Skintones:

These are softer tones of red, which can enhance or detract from your skintone because of their close relationship to your skintone. You can create an attractive look by wearing a blouse or top in a Skintone, in combination with your Neutrals, blues, greens, aquas, whites, or purple. Skintones are perfect for summer dresses, mother-of-the-bride dresses, or undergarments.

Your Color Palette

Once you turn to your color category, you will find your color palette, which consists of a set of fabric swatches in the very best colors for your natural coloring. You can learn how to make the most out of your color palette simply by learning about the five basic components of most palettes: Dramatics, Reds, Skintones, Understateds, and Neutrals. Study the descriptions and explanations of each of the five components, and refer to the labeled sample color palette that is displayed along the right edge of the opposite page. In doing so, keep in mind that every palette is unique, and that the placement and size of each component varies with each palette.

Neutrals:

The Neutrals are colors which go with almost everything and form the foundation for building a wardrobe. The traditional Neutrals are black, navy, the grays, the browns, camel, taupe, beige, ivory, white, and olive green. A contemporary list of Neutrals would include copper, mauve, eggplant, mustard, forest green, and burgundy. Neutrals are used for jackets, coats, hats, shoes, and other items which must have the versatility of going with several different colors.

Dramatics:

These include blue, periwinkle blue, blue green, turquoise, teal, green, and aquamarine. Dramatics are complementary (the opposite colors on the color wheel) to the reds of most skintones, and for that reason create a certain tension with one's natural coloring. That tension translates into a high-energy, dramatic, and attention-getting look. So if you plan to wear Dramatics, get ready to be the center of attention.

Understated:

These have less color energy than the Dramatics, but more energy than the Neutrals. These colors are restrained and subtle, and project refinement and elegance. Understated colors play a supportive role to your natural coloring. Wear understated colors when you wish to create a more subdued and conservative impression. Examples of Understateds include the soft yellows, blues, greens, and lavender.

Reds:

Like the Dramatics, the bright and deep Reds also tend to attract attention to you. They can create a very romantic look, especially in dim lighting. They are great for parties, speeches, or that special evening date. Softer Reds, such as pink, rose, and coral project a more compassionate and friendly mood. Your Reds must closely match your skin color in terms of coolness or warmth, because they will flatter or undermine your skintone.

UNDERSTATEDS

DRAMATICS

SKINTONES

REDS

NEUTRALS

CHAPTER 2 THE CAUCASIAN WOMAN

Just as Nature has her own palette of colors for each season, each woman has her own palette that best complements her own natural coloring. The Caucasian woman includes all women of European heritage.

Under the classic four seasons approach, which was developed with the Caucasian woman in mind, Winter women have cool, darker coloring (particularly the hair coloring), and the Winter palette is characterized by cool, clear colors. Summers have cool, lighter coloring, and the Summer palette is characterized by cool, chalky pastels. Autumns have warm, darker coloring, and the Autumn palette is made up of muted or intense, warm earth tones. Springs have warm, light coloring, and the Spring palette is filled with warm pastels and warm, bright colors.

In my years of doing color analysis, I have found that within each season, there are clear differences in the palettes of those with a high skin-hair contrast and those with low contrast. For example, the palette of a

Winter with porcelain skin and black hair contains a range of icy pastels, while the palette of a Winter with dark olive skin and black hair does not. In my system for the Caucasian woman, the Winter with porcelain skin and black hair would be a High-Contrast Winter, while the Winter with dark olive skin would be a Low-Contrast Winter. In all, my system contains eight categories: Low-Contrast Winter, High-Contrast Winter, Low-Contrast Summer, High Contrast Summer, Low-Contrast Autumn, High-Contrast Autumn, Low-Contrast Spring, and High-Contrast Spring.

The following exercise, Exercise 2, is designed to help you determine whether your skintone is a lighter or darker shade. Please note that there is an Exercise 2 for each color group: The Caucasian Woman, The Asian Woman, The Black Woman and The Hispanic Woman. So please make sure to do the Exercise 2 that is applicable to you.

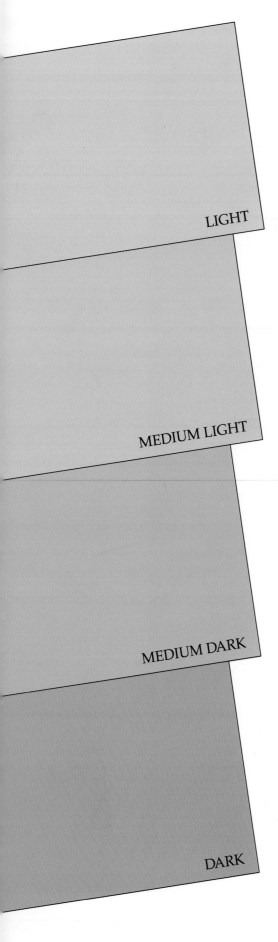

LIGHT

MEDIUM LIGHT

MEDIUM DARK

DARK

EXERCISE 2 FOR THE CAUCASIAN WOMAN

Is my skintone a lighter or darker shade?

1. Find a place with good natural light and use a hand mirror. Look at the four skintone values to the left, not for their color, but for their values or lightness. As you can see, from top to bottom, they go from lighter to darker shades.

2. Look at yourself in the mirror with these values next to your face and decide which is most like the skintone value of your face.

3. If you selected either light or medium light, your skintone is a lighter shade; If you selected either medium dark or dark, your skintone is a darker shade.

4. Now you know whether your skintone is a lighter or darker shade. You should already know from Exercise 1 whether your skintone is cool or warm. Now refer to the following two charts.

Which is my color category?

The top chart is for blondes and the bottom chart is for brunettes and redheads. The two charts set forth the eight color categories for the various combinations of four skintone groups and fourteen hair colors. Once you determine your skintone and match it to your hair color, the chart will tell you which category you should belong to.

1. Find your skintone along the top of the chart. (For example, if you learned from Exercise 1 that your skintone is cool and from Exercise 2 that your skintone is a lighter shade, you are a cool-light on the chart.)

2. You may verify whether you fall into a skintone category on the chart by referring back to the skintone samples on pages 12-13, or on pages 142-143.

3. After you find your skintone on the chart, match it with your hair color, and find your category.

4. Double-check your selection by turning to your category, and comparing your coloring with that of the model. If your coloring is different from hers, check the models for similar categories and find the one whose coloring is most like yours. If one of the other models has coloring just like yours, you have probably found your category. If none of them has your exact coloring, refer back to the category designated by the chart.

COLOR ANALYSIS CHART FOR BLONDES

	SKINTONE			
	COOL-LIGHT	COOL-DARK	WARM-LIGHT	WARM-DARK
	PORCELAIN	ROSE BEIGE	IVORY	GOLDEN
	PINK	DARK BEIGE	PEACH	GOLDEN BRONZE
	LIGHT OLIVE	DARK OLIVE	YELLOW BEIGE	BROWN OLIVE
HAIR				
ASH BLONDE	L C SUMMER	L C SUMMER	L C AUTUMN	L C AUTUMN
FLAXEN BLONDE (GOLD AND ASH)	L C SUMMER	L C SUMMER	L C AUTUMN*	L C AUTUMN
BLONDE WITH BROWN	L C SUMMER	L C SUMMER	H C SPRING	L C AUTUMN
GOLDEN BLONDE	L C SUMMER	L C SUMMER	L C SPRING	L C AUTUMN
HONEY BLONDE	L C SUMMER	L C SUMMER	L C SPRING	L C AUTUMN
STRAWBERRY BLONDE	L C AUTUMN	L C AUTUMN	L C AUTUMN	L C AUTUMN
CREAMY WHITE	L C SUMMER	L C SUMMER	L C SPRING	L C AUTUMN

* If your blond hair has more gold than ash, you are a Low-Contrast Spring instead of Low-Contrast Autumn.

COLOR ANALYSIS CHART FOR BRUNETTES AND REDHEADS

	SKINTONE			
	COOL-LIGHT	COOL-DARK	WARM-LIGHT	WARM-DARK
	PORCELAIN	ROSE BEIGE	IVORY	GOLDEN
	PINK	DARK BEIGE	PEACH	GOLDEN BRONZE
	LIGHT OLIVE	DARK OLIVE	YELLOW BEIGE	BROWN OLIVE
HAIR				
RED AUBURN	H C AUTUMN	H C AUTUMN	H C AUTUMN	H C AUTUMN
LIGHT BROWN	L C SUMMER	L C SUMMER	H C SPRING	H C SPRING
MEDIUM BROWN	H C SUMMER	H C SUMMER	H C SPRING	H C SPRING
DARK BROWN	H C WINTER	H C WINTER*	L C WINTER	L C WINTER
BLACK	H C WINTER	H C WINTER*	L C WINTER	L C WINTER
BLACK-BROWN	H C WINTER	H C WINTER*	L C WINTER	L C WINTER
SILVER GRAY	L C SUMMER	H C WINTER	H C SPRING	H C WINTER

* If you have an olive skintone and dark brown, black-brown or black hair, you are a Low-Contrast Winter instead of a High-Contrast Winter.

UND.

DRAMATICS

UNDERSTATED

SKIN.

REDS

NEUTRALS

LOW-CONTRAST WINTER

The Low-Contrast Winter woman typically has an olive to dark olive skintone, but she can also have a beige, ivory, or peach skintone. She often has a slightly golden undertone. She can tan quickly, often to a dark olive or golden bronze. Her hair color can range from dark brown to black.

She is very fortunate in that her palette is made up of a combination of cool and warm colors. The other palettes are generally made up of exclusively cool or warm colors. Accordingly, she can choose to wear cool or warm colors, depending on her wardrobe, makeup, or mood, or the occasion. Due to her very dark hair color, she can wear the vivid cool-based colors that are also in the High-Contrast Winter palette, including black and navy blue. On the other hand, the warm-based colors in her palette, such as orange-red, golden yellow, and dark browns go perfectly with her olive or warmish skintone.

Her best metal is gold, and her best white is pure white. Famous Low- Contrast Winters include Cher and Sophia Loren.

Skin: Olive, brown olive, dark olive, beige, ivory, peach.
Hair: Black, black-brown, dark brown, black with gray or white, dark brown with gray or white.
Eyes: Light to dark brown, black-brown, dark red-brown, dark blue-violet, gray-green, olive green, hazel.
Great color combinations: Purple and yellow, turquoise and violet, black and red, black and golden yellow, red and dark brown.

Do's:
If your hair is turning white or gray, brown will no longer be a good neutral for you, but you can add a large range of grays to your palette. Also, yellow will clash with your hair color and tend to bring out an undesirable sallow color in your skin. You can wear silver accessories better than gold, because silver will flatter the white or gray in your hair.

Don'ts:
Do not wear any muted, dull colors; or icy pastels and light gray, which can make your skin appear sallow.

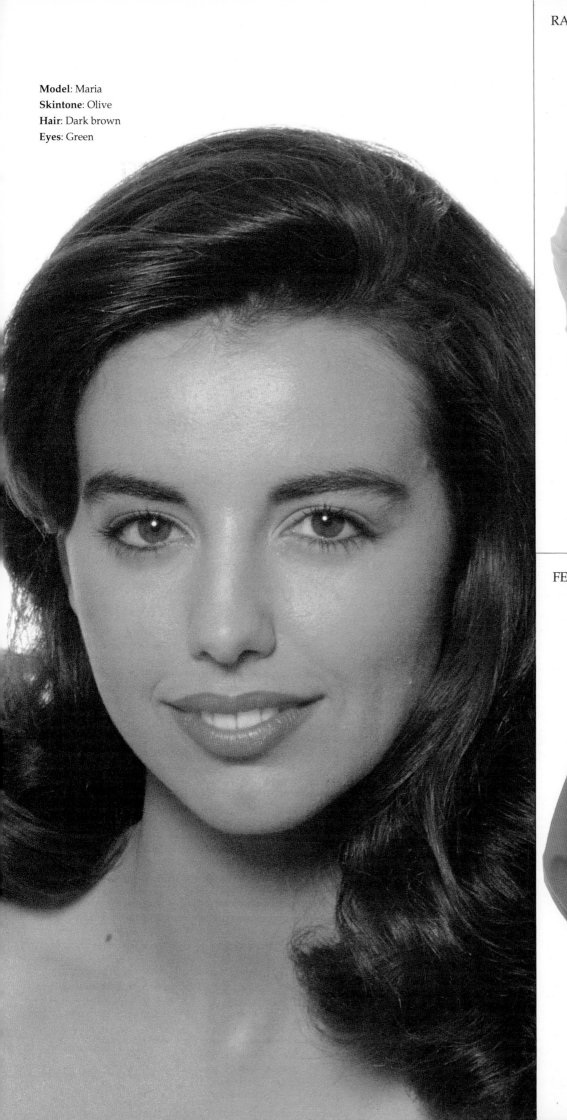

Model: Maria
Skintone: Olive
Hair: Dark brown
Eyes: Green

RADIANT

FESTIVE

25

Model: Kim
Skintone: Porcelain with pink
Hair: Black-brown
Eyes: Hazel

STRIKING

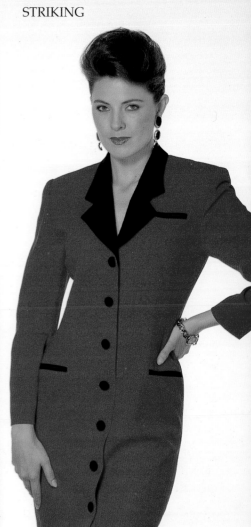

DRAMATIC

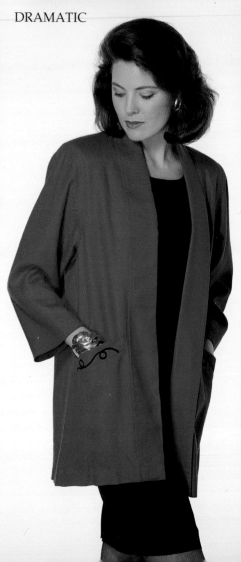

Model: Kim
Skintone: Porcelain with pink
Hair: Black-brown
Eyes: Hazel

HIGH-CONTRAST WINTER

The High-Contrast Winter has the striking, icy look of a classic Winter in the four seasons approach. Her skin-tone is cool and fair, often with a pink undertone, while her hair is usually black or dark brown. She has the highest contrast of any woman.

Black, or black and white are very flattering on her because they repeat her total skin- hair contrast. Clear, primary colors and cool, icy pastels look smashing on her. When wearing these colors, she gives off a self-confident and dramatic look. The High-Contrast Winter woman is most similar to the High-Contrast Summer woman in that both have a cool, high-contrast look. The difference is that the High-Contrast Winter has an even higher skin-hair contrast and accordingly, a palette with a more diverse range of values.

Her best metal is silver and her best white is pure white. Famous High-Contrast Winters include Elizabeth Taylor and Paloma Picasso.

Skin: Pink undertone. Porcelain, pink, ruddy with pink, rose beige, ruddy with red, light olive, olive.

Hair: Black, blue-black, black with brown, red, or burgundy highlights; black-brown, dark brown, silver gray and white, black with gray or white.

Eyes: Light to dark brown, black-brown, gray-blue, blue, dark blue-violet, gray-green, olive green, hazel.

Great color combinations: Black and white, vivid blue and turquoise, purple and fuchsia, navy and magenta, teal blue and violet.

Do's:

1. If you have snow-white hair and light olive skin, you can use all the colors in this palette except the yellows.

2. If you have snow-white or silver gray hair, and cool, fair skin, you would be a Low-Contrast Summer, because the intense, vivid colors in this palette would be too strong for you.

Don'ts:

Do not wear warm-based colors such as camel, orange, red-orange, yellow-gold, mustard green, brown, and tan; and all muted and middle range color values, as they will appear dull and uninteresting.

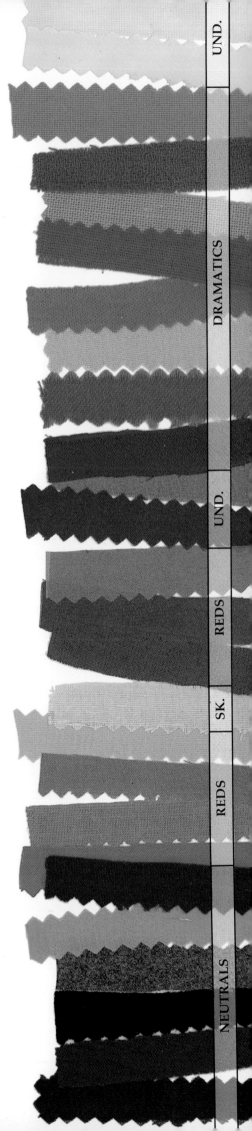

UND.

DRAMATICS

UND.

REDS

SK.

REDS

NEUTRALS

REFINED

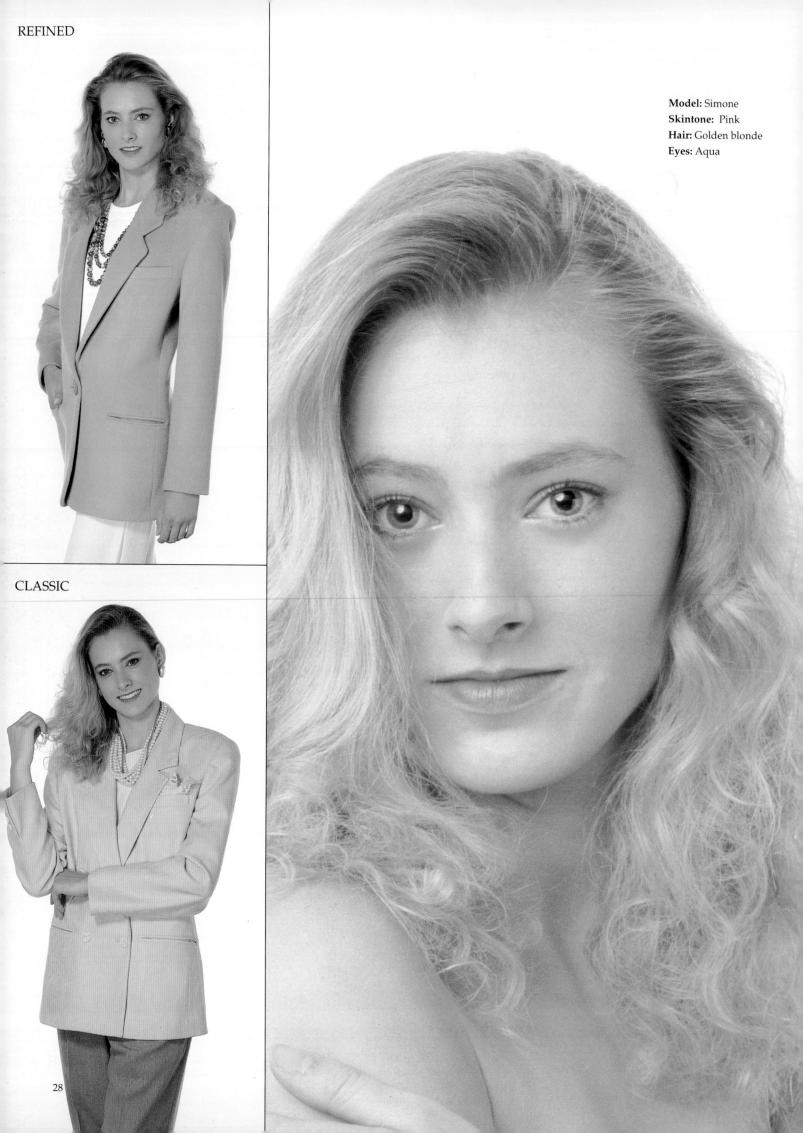

CLASSIC

28

LOW-CONTRAST SUMMER

The Low-Contrast Summer woman has cool, fair skintone and light-colored hair ranging from ash blonde to light ash brown, silver-gray or white. She does not tan well and burns easily. Her overall look is soft and light, due to her low skin-hair contrast. Her eyebrows can be very faint. The skillful use of makeup can help to give her a more distinctive look.

Her palette is cool and light (tinted with white); and muted, to blend with her own soft, natural coloring. Her colors are typical of those found in the French Impressionist paintings. In selecting her wardrobe, she must always be careful not to overwhelm her soft coloring with colors which are too vivid or bright. She looks her best when wearing a blend of cool, tinted colors in a subtle but appealing combination.

Her best metal is silver. She can also wear light gold well if she has a slight golden undertone in her skin or has blonde hair. Her best white is off white. Famous Low-Contrast Summers include Candice Bergen and the late Princess Grace Kelly.

Skin: Pink undertone. Porcelain, pink, ivory, ivory with a hint of yellow, rose beige, ruddy with red, ruddy with pink.

Hair: Platinum blonde, ash blonde, flaxen blonde, smoky blonde, ash brown, grayish brown, very fine light brown, silver gray, creamy white.

Eyes: Blue, gray-blue, soft gray, olive green, gray-green, aqua, hazel, soft cool brown, grayed brown.

Great color combinations: Lavendar and periwinkle, pink and gray, mint green and lilac, taupe and ivory, gray-blue and fuchsia, creamy white with any pastel; monochromatics (medium to light tones of the same color) such as medium blue with pastel blue.

Do's:

1. If you are a Low-Contrast Summer blonde, light to medium shades of beige, or wheat tones will accent your hair coloring and can be versatile neutrals for you.

2. In using tan tones, avoid a washed-out look by adding an accent color such as pastel pink or aqua; or add textures, prints or accessories to create more a interesting, and higher-contrast look.

Don'ts:

Do not wear vivid, strong colors; or colors with a yellow undertone, such as yellow-green, orange, red-orange, yellow-gold or black and white in combination.

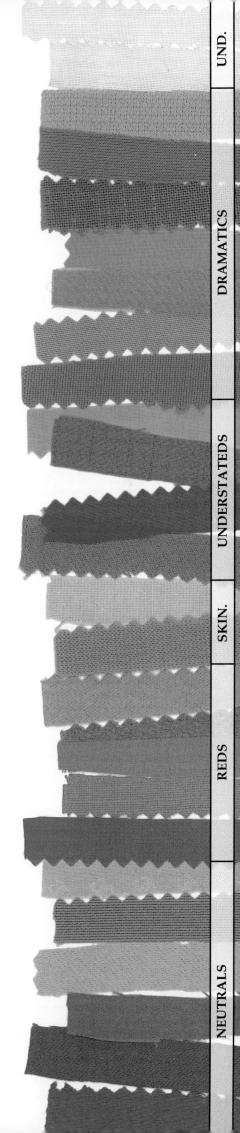

UND.

DRAMATICS

UNDERSTATEDS

SKIN.

REDS

NEUTRALS

CASUAL

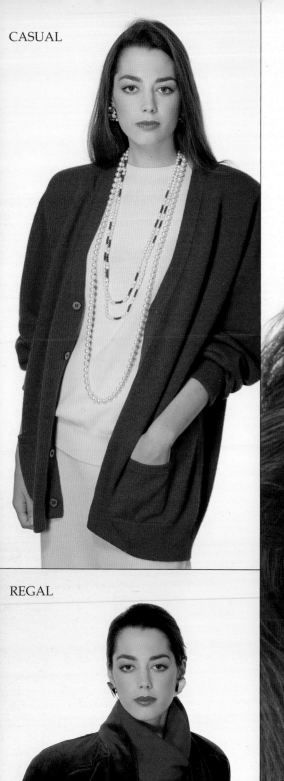

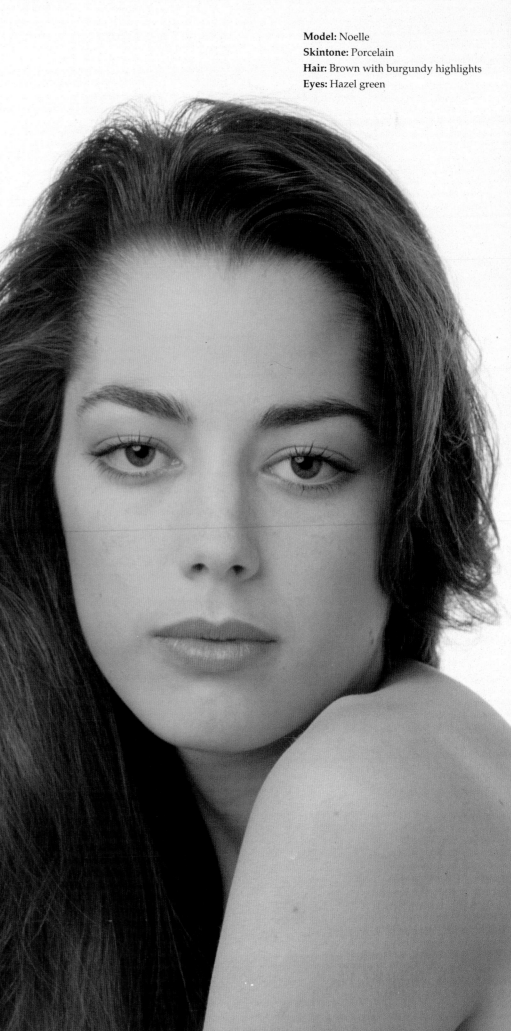

Model: Noelle
Skintone: Porcelain
Hair: Brown with burgundy highlights
Eyes: Hazel green

REGAL

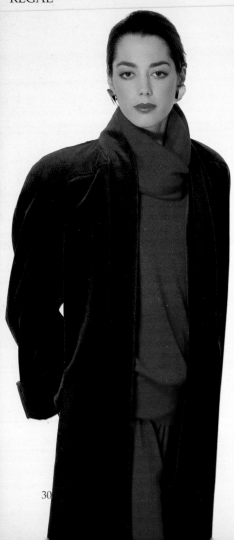

HIGH-CONTRAST SUMMER

The High-Contrast Summer woman has the cool, light skintone of a High-Contrast Winter, but her hair color is lighter and softer, ranging from a medium ash brown to a burgundy brown. Also, her overall look is softer than that of a High-Contrast Winter. She does not tan easily.

Even though there is a definite softness to her overall look, her palette includes some deeper and more intense colors. Her palette is generally cool, with saturated jewel-tone colors. Neutrals such as rosewood, cocoa brown and charcoal blend well with highlights in her brown hair. Other colors which look terrific on her include dusty rose, rose-coral, dark teal blue, ruby red, and emerald green.

Her best metals are silver or pewter, and her best white is off white. Famous High-Contrast Summers include Queen Elizabeth and Jane Seymour.

Skin: Pink undertone. Porcelain, rose beige, can have light to medium brown freckles; ruddy, possibly uneven complexion; can have a slight yellow tint on the surface of the skin.

Hair: Ash brown, burnt umber, grayish brown, chestnut brown, burgundy brown.

Eyes: Blue, gray-blue, soft gray, green, gray-green, hazel, aqua, soft cool brown.

Great color combinations: Emerald green with rose red, plum and mauve, magenta and purple, teal blue and wine, cognac and grape, monochromatics of almost any hues.

Do's:

If your hair coloring is a darker burgundy brown, you can wear black as a dominant color, especially in the evening, because under artificial lighting, your hair will appear darker than it is. For a more dramatic look, add a little darker eye makeup.

Don'ts:

Do not use extremely bright colors such as tangerine orange, lime green or golden yellow.

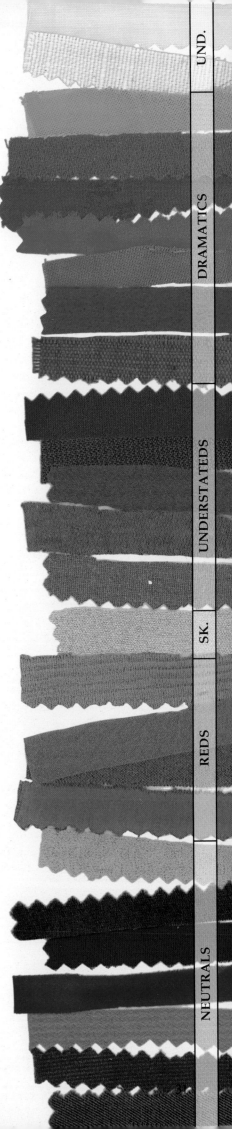

UND.

DRAMATICS

UNDERSTATEDS

SK.

REDS

NEUTRALS

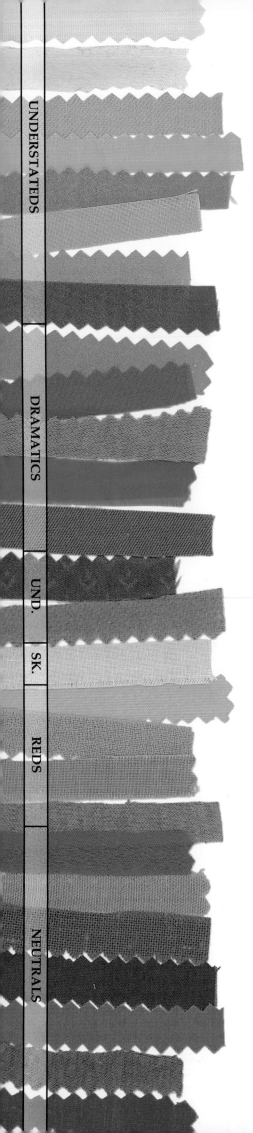

UNDERSTATEDS

DRAMATICS

UND.

SK.

REDS

NEUTRALS

LOW-CONTRAST AUTUMN

The Low-Contrast Autumn woman's skintone can range from a very light ruddy with freckles, to a warm peach, and usually has a slight golden undertone. Her hair can range from a soft ash blonde or brassy blonde, to a strawberry blonde or light red.

Soft warm coral and salmon blend well as her lipstick and nail colors. Warm, muted, earthy colors with golden undertones characterize her palette. She looks terrific in a full range of greens from sage to olive. Her best reds are peach, salmon and terra-cotta. She is similar to a Low-Contrast Spring in that her overall look is warm and light, but the Low-Contrast Spring's overall look is light and clear. Also, the Low-Contrast Autumn's palette is more muted throughout.

Her best metals include gold, Black Hills gold, brass and copper. Her best white is ivory. Famous Low-Contrast Autumns include Margaret Thatcher and Shirley MacLaine.

Skin: Golden undertone. Light beige, ivory, ruddy, ivory or peach with freckles, yellow beige.

Hair: Strawberry blonde, ash blonde, light red, light auburn, light golden brown, creamy white.

Eyes: Light to dark brown, golden brown, amber, green with gold, pale green, olive green, hazel, aqua, teal blue.

Great color combinations: Sage green and salmon, peach and teal blue, olive green and terra cotta, tobacco brown and soft yellow, ivory and peach.

Do's:

When wearing neutrals such as beige or camel, add one of your earthy reds or greens near your face to spice up your look.

Don'ts:

1. Do not wear pure white, black, magenta reds, or vivid, blue-based colors.

2. If your hair is brassy, do not use shiny fabrics like satin because the reflection will make your hair appear dull. Instead, use textured fabrics, which tend to absorb light.

Model: Amanda
Skintone: Ruddy with yellow
Hair: Strawberry blonde
Eyes: Blue

NATURAL

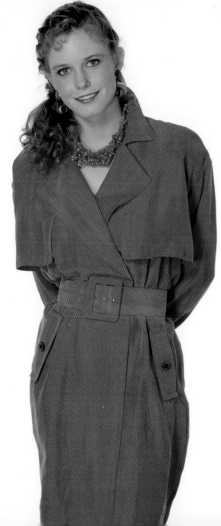

HIGH-CONTRAST AUTUMN

The High-Contrast Autumn Woman's distinctive feature is her very warm hair color which can range from a vivid red to a medium to dark auburn. Her skintone can be a cool ruddy with red, or a warm light beige to dark olive. Due to her warm hair color, her overall look is warm to very warm.

Her warm palette can be described as rich, earthy and intense, with a golden undertone. Forest green, rust, and rich browns look terrific on her. She is distinct from a Low-Contrast Autumn in that her hair coloring is darker and more brilliant, giving her a higher-contrast look. Deep rust tone lipstick and nail polish blend nicely with her warm complexion.

Her best metals are yellow gold, copper and bronze. Her best white is ivory. Famous High-Contrast Autumns include Princess Sarah and Bette Midler.

Skin: Golden or pink undertone. Ivory, ivory with freckles, peach, ruddy with peach, pink or red; dark beige, golden bronze.

Hair: Medium to dark red, strawberry, copper, brown with red highlights, orange brown, golden brown, auburn, dark brown.

Eyes: Brown, dark brown, red-brown, golden brown, amber, green, olive green, hazel, aqua, teal blue.

Great color combinations: Forest green and gold, peacock blue and rust, tomato red and dark brown, salmon and teal green.

Do's:

1. You can add black to your palette if your hair is a dark auburn, and your skintone is dark beige or golden bronze.

2. If you have gray or silver hair, substitute medium to charcoal gray in place of camels and browns; the grays will look better with your cooler hair color.

Don'ts:

Do not use cool-based colors and light grays.

UNDERSTATEDS

DRAMATICS

SKINTONES

REDS

NEUTRALS

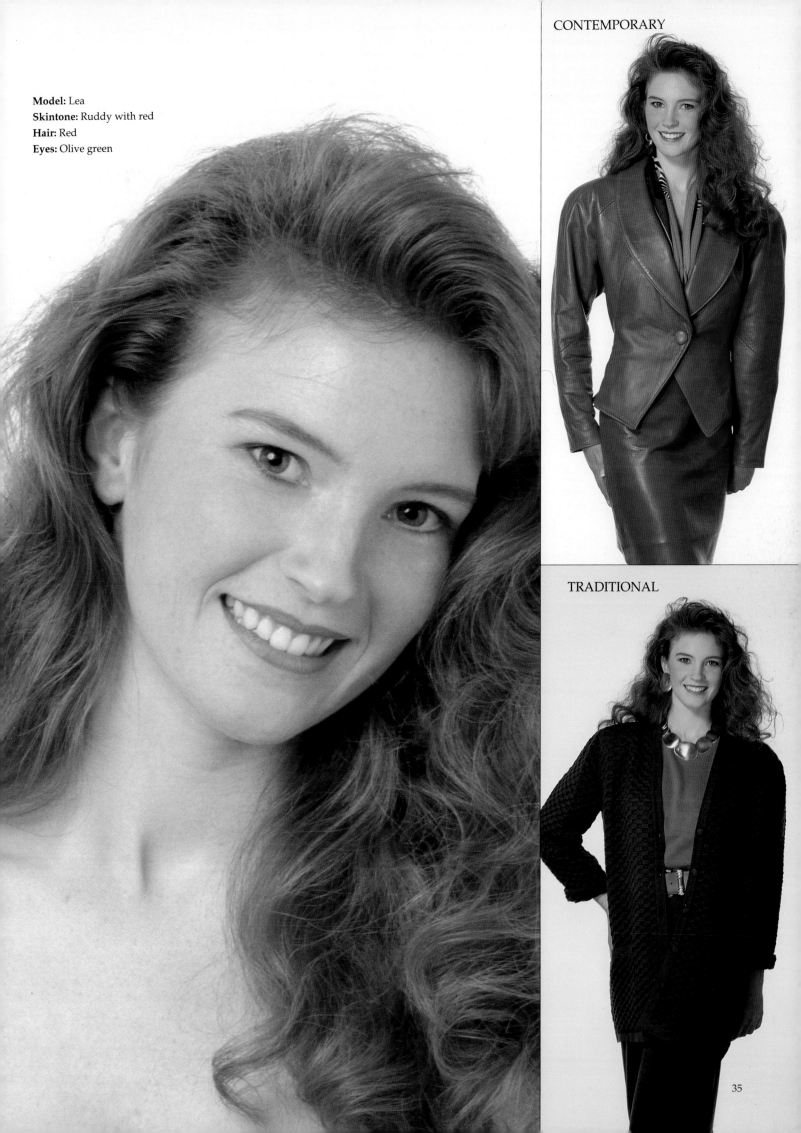

Model: Lea
Skintone: Ruddy with red
Hair: Red
Eyes: Olive green

CONTEMPORARY

TRADITIONAL

UND.

DRAMATICS

SK.

REDS

NEUTRALS

LOW-CONTRAST SPRING

The Low-Contrast Spring woman has a light, clear skintone with a golden undertone. Her skintone is warmish but fair, and can range from ivory to peach to beige or yellow beige. Her hair coloring might be ash blonde, golden blonde, strawberry blonde, or honey blonde.

Her palette includes warm pastels, and clear, low to medium intensity colors. The colors in her palette are yellow-based and are similar in intensity to those of the Low-Contrast Summer woman's, except that they are warm rather than cool. Colors and textures which reflect light back to her face, such as off white, neon acids, shiny metals and satin, can enhance her light, low-contrast look.

Her best metal is gold and her best whites are off white and ivory. Famous Low-Contrast Springs include Barbara Walters and Zsa Zsa Gabor.

Skin: Golden undertone. Ivory, peach, ivory or peach with freckles, beige, and yellow beige.

Hair: Golden blonde, flaxen blonde, honey blonde, strawberry blonde, ash blonde, gray, creamy white.

Eyes: Blue, blue-gray, teal blue, aqua, hazel, soft green, green, light brown, golden brown.

Great color combinations: Aqua and lavendar, periwinkle and rose pink, muted violet and mint, bright green and yellow, blue green and peach.

Do's:

1. If you are a blonde, olive green and khaki green would be great neutral colors for you.

2. Trend colors such as acid green, yellow and pink can look terrific on you, especially in active sportswear.

Don'ts:

Do not wear magenta reds; or dark tones such as dark brown, eggplant purple, and burgundy; or black and white in combination.

Model: Kim
Skintone: Peach
Hair: Ash blonde
Eyes: Blue

ELEGANT

MODERN

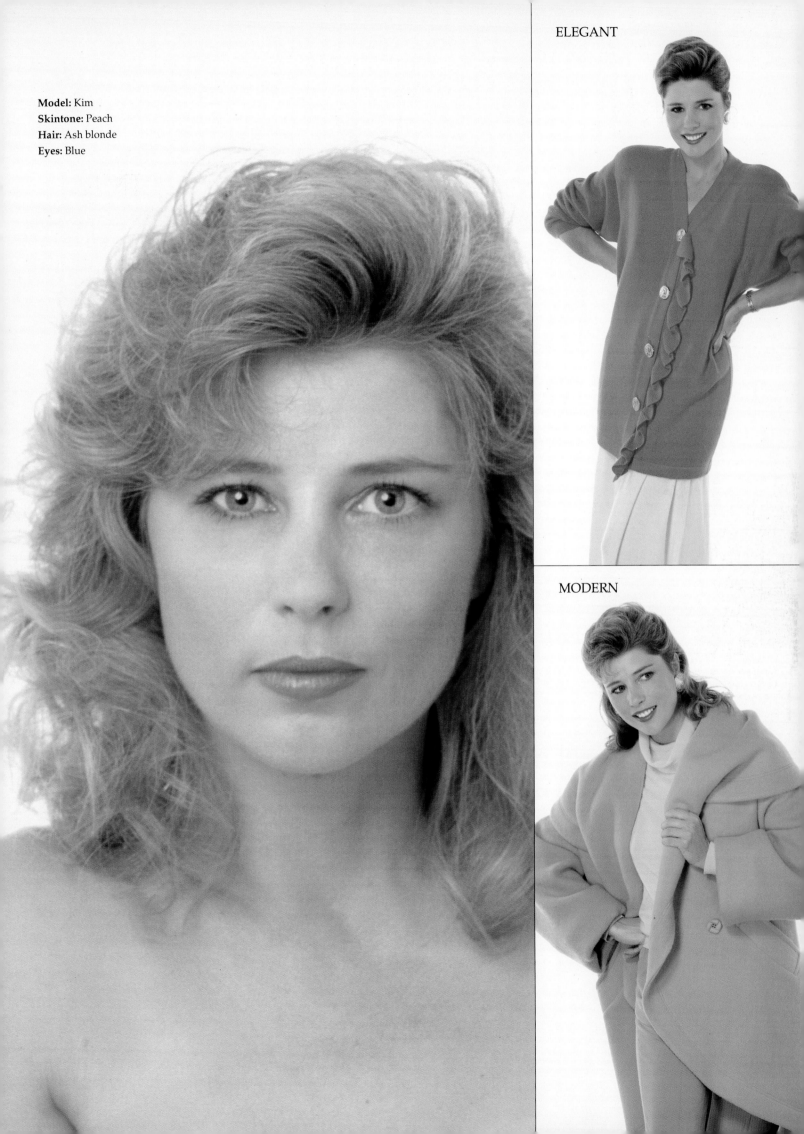

ROMANTIC

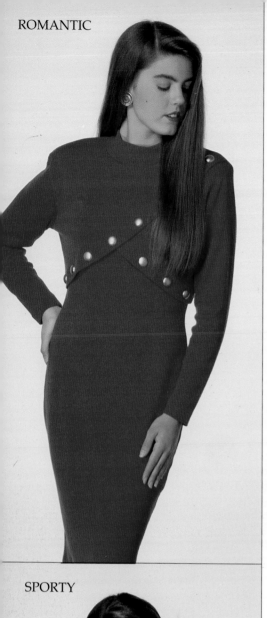

Model: Taya
Skintone: Yellow beige
Hair: Light brown
Eyes: Hazel

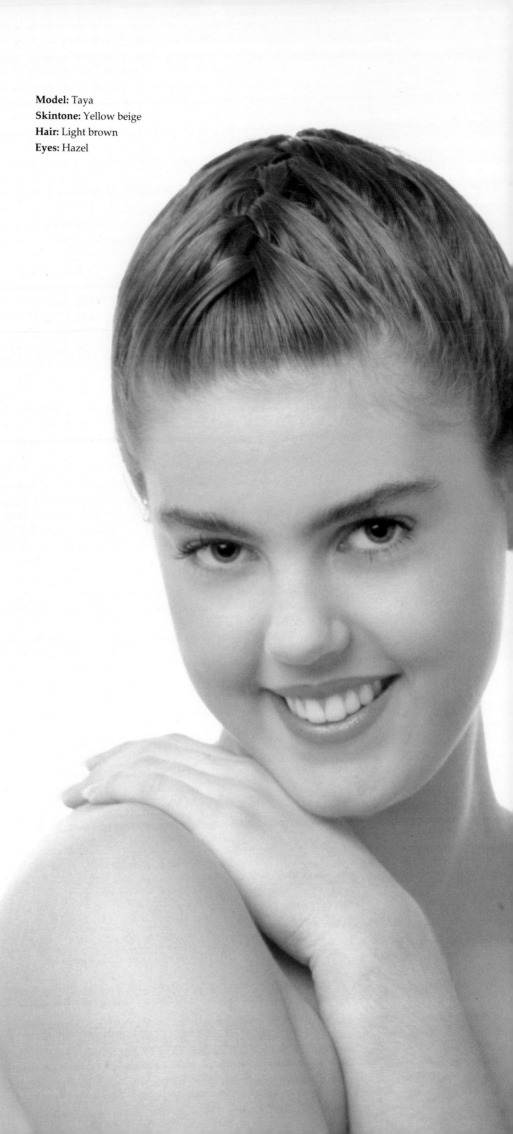

SPORTY

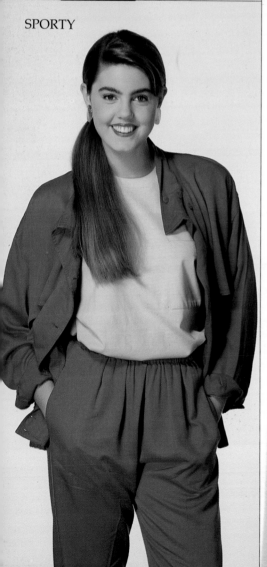

HIGH-CONTRAST SPRING

The High-Contrast Spring woman has a warm glow which is highlighted by her warm, light skintone and her brown hair. She can have an ivory to dark beige skintone and her hair color can range from blonde with brown to medium brown. She can tan quickly.

Her palette is clear and bright. Her skin has just enough warmth to glow when placed next to the bright colors in her palette. Her higher skin-hair contrast gives her the drama to stand up to the intense colors in her palette. If her hair were lighter, like that of a Low-Contrast Spring, the intense colors of this palette would be too dominant, and make her appear washed-out.

Her best lipstick colors are a bright orange red to a medium peach, and her best metal is gold. Her best whites are pure white and off white. Famous High-Contrast Springs include Sally Fields and Jane Pauley.

Skin: Golden undertone. Ivory, peach, beige, yellow beige, dark beige, cheeks can be a rosy pink.

Hair: Light brown, brown, brown with gold or red highlights, silver gray or white.

Eyes: Blue, steel blue, teal blue, aqua, green, green with gold, hazel, light brown, brown with gold.

Great color combinations: Bright blue and yellow, orange and green, brown and coral, navy and peach, periwinkle and salmon.

Do's:

When a High-Contrast Spring woman turns gray or silver, the camel and brown from your palette will no longer compliment your hair color. In their place, use warm grays.

Don'ts:

Do not wear colors with blue undertone such as blue reds, or any muddy colors.

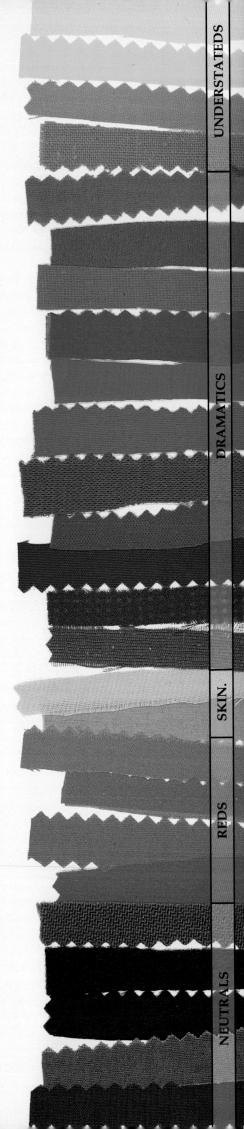

CHAPTER 3
THE ASIAN WOMAN

The Asian woman originates from every corner of the Far East, and her diverse Asian ancestry can be Japanese, Chinese, Korean, Filipina, Okinawan, Indochinese, or any of the many other East Asian or Southeast Asian ethnic groups. She can also be of mixed or partial Asian ancestry. The Asian woman is characterized by the subtle yet distinct variations in her skin and hair coloring.

My color system for Asians has nine different palettes named for various qualities of light, one of which is a perfect fit for every Asian woman. Due to the unique qualities of Asian natural coloring, these nine palettes are distinct from the eight palettes for the Caucasian woman, discussed in Chapter 2. Her skintone can range from the fairest cool porcelain to the deepest warm tones of golden bronze, while her hair coloring can range from light brown, to blue black, to silver gray. Due to her darker hair coloring, the Asian woman generally looks great in black, navy, and white. Her palette of best colors ranges all the way from the deep and cool tones of the Midnight palette, to the bright and warm tones of the Sunlight palette.

The Starlight, Midnight, Moonlight and Frost palettes are cool, and vary from the deep tones of Midnight, to the light, icy tones of Frost. The warm palettes are Sunrise, Sunlight, Sunset and Twilight, and range from the very tinted Sunrise to the very dark Sunset. The Horizon palette is a combination cool and warm.

Which category an Asian woman falls into depends on her skin and hair color. For Asian women, eye coloring is not a big factor in determining their palette, because most have eyes that are neutral in hue, ranging from light brown to black. Even in the unusual case in which she has green or hazel eyes, her palette would not be significantly affected, except for the addition to her palette of eye extension colors.

If this chapter applies to you, proceed to Exercise 2 for the Asian Woman, to determine whether your skintone is a lighter or darker shade. You will then be able to find yourself on the Color Analysis Chart for the Asian woman, which can be found on the following page.

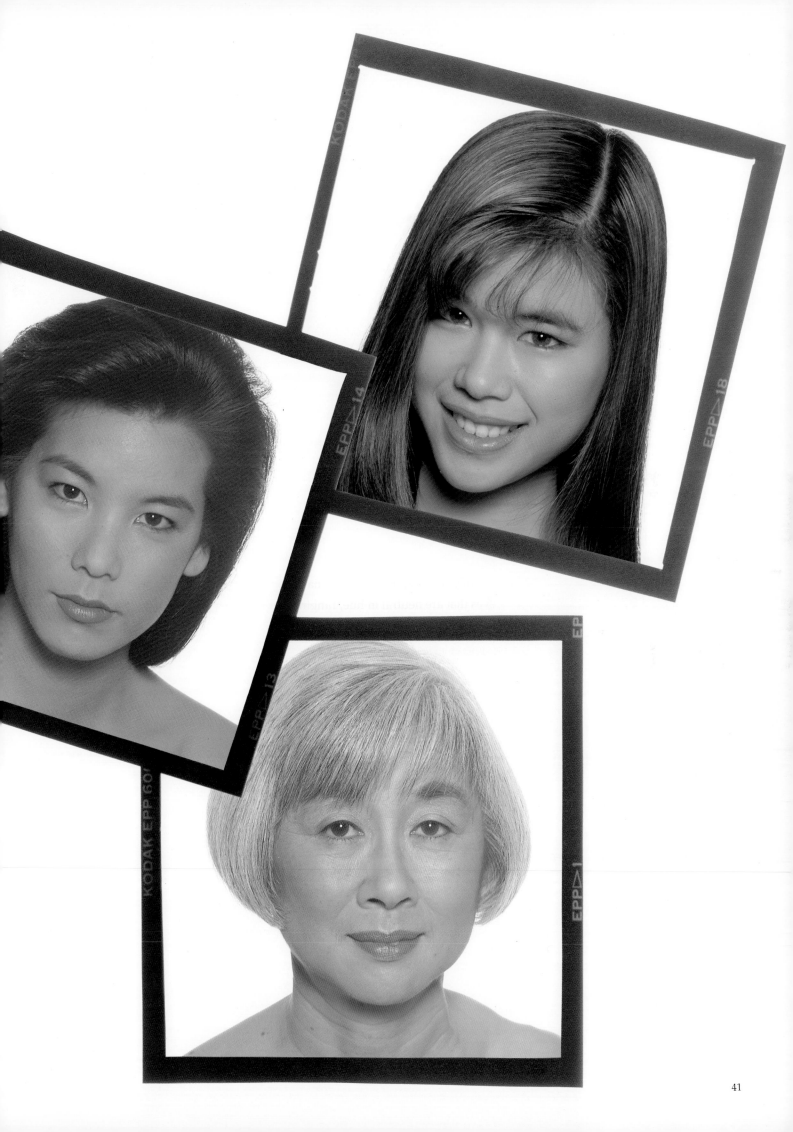

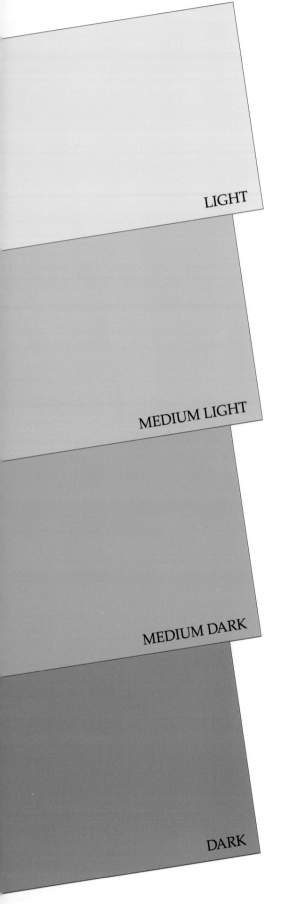

LIGHT

MEDIUM LIGHT

MEDIUM DARK

DARK

EXERCISE 2 FOR THE ASIAN WOMAN

Is my skintone a lighter or darker shade?

1. Find a place with good natural light and use a hand mirror. Look at the four skintone samples to the left, not for their color, but for their value or lightness. As you can see, from top to bottom, they go from lighter to darker shades.

2. Look at yourself in the mirror with these values next to your face and decide which is most like the skintone value of your face.

3. If you selected either light or medium light, your skintone is a lighter shade; if you selected either medium dark or dark, your skintone is a darker shade.

4. Now you know whether your skintone is a lighter or darker shade. You should already know from Exercise 1 whether your skintone is cool or warm. Refer to the following chart to find your category.

Which is my color category?

The Color Analysis Chart for Asians sets forth the nine distinct color categories for the various combinations of four skintone groups and nine hair colors. Once you determine your skintone and match it to your hair color, the chart will tell you which category you fall into.

1. Find your skintone along the top of the chart. (For example, if you learned from Exercise 1 that your skintone is cool and from Exercise 2 that your skintone is a lighter shade, you are a cool-light on the chart.)

2. You may verify whether you fall into a skintone category on the chart by referring back to the skintone samples onpages 12-13, or on pages 142-143.

3. After you find your skintone on the chart, match it with your hair color, and find your category.

4. Double-check your selection by turning to your category, and comparing your coloring with that of the model. If your coloring is different from hers, check the models for similar categories and find the one whose coloring is most like yours. If one of the other models has coloring just like yours, you have probably found your category. If none of them has your exact coloring, refer back to the category designated by the chart.

COLOR ANALYSIS CHART FOR THE ASIAN WOMAN

SKINTONE			
COOL-LIGHT	COOL-DARK	WARM-LIGHT	WARM-DARK
PORCELAIN	BEIGE	IVORY	GOLDEN BRONZE
PINK	OLIVE	LIGHT YELLOW BEIGE	OLIVE BROWN
ROSE BEIGE	DARK OLIVE	PEACH	
LIGHT OLIVE		YELLOW OLIVE	

HAIR				
BLUE BLACK	MIDNIGHT	MIDNIGHT	MIDNIGHT	MIDNIGHT
BLACK	STARLIGHT	STARLIGHT	STARLIGHT	SUNSET
BURGUNDY BLACK	STARLIGHT	STARLIGHT	HORIZON	SUNSET
DARK BROWN	HORIZON	SUNLIGHT	HORIZON	SUNSET
MEDIUM BROWN	HORIZON	SUNLIGHT	SUNLIGHT	SUNSET
LIGHT BROWN	SUNRISE	SUNRISE	SUNRISE	SUNSET
BLACK W/ WHITE	MOONLIGHT	MOONLIGHT	MOONLIGHT	SUNSET
BROWN W/ WHITE	TWILIGHT	TWILIGHT	TWILIGHT	TWILIGHT
WHITE/GRAY	FROST	FROST	FROST	TWILIGHT

STARLIGHT

Starlight describes the classic Asian woman with milky-white skin and jet black hair. She generally has a cool skintone with a pink undertone, but her skin may also be ivory, light olive, or have a slight yellow cast.

The most distinctive feature of the Starlight woman is her black, or very dark hair. Whether it is pure black, soft black, or burgundy black with a hint of red, her hair contrasted with her fair skin gives her a very high-contrast look of elegance and refinement.

Her palette is cool because it blends beautifully with the coolness of her skintone. At the same time, her palette includes very light and very dark values, which blend perfectly with the extreme values of her high-contrast look. Her best colors include those with cool undertones, and sharp, clear colors of very light or very dark values.

The best makeup colors for the Starlight woman are magenta red, rose pink, rich blue red, or fuchsia pink.

Her best metals are silver, platinum and pewter. Her best white is pure white.

Skintone: Pink or pink yellow undertone. Porcelain, pink, rose beige, light to dark olive, beige.

Hair: Black, soft black, burgundy black, black brown, black brown with white, black with white.

Great color combinations: Black and white, magenta and black, purple and fuchsia, pink and navy blue, turquoise and blue.

Do's:

1. To enhance your refined look, you should wear clothing of fine-grained textures, smooth and even surfaces, and tightly-woven fabrics. Cashmere, silk, crisp cottons, and fabrics with an elegant and luxurious look will be a perfect match for you.

2. If your skintone is slightly yellow-olive, you can wear gold as well as silver.

Don'ts:

Do not wear colors with a yellow undertone such as camel, rust, beige or muted tones; or jewelry of wood, brass, or copper.

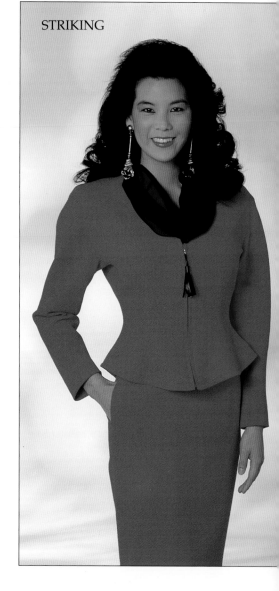

STRIKING

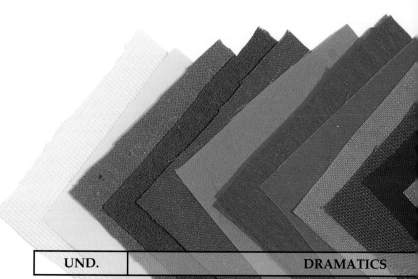

UND.

DRAMATICS

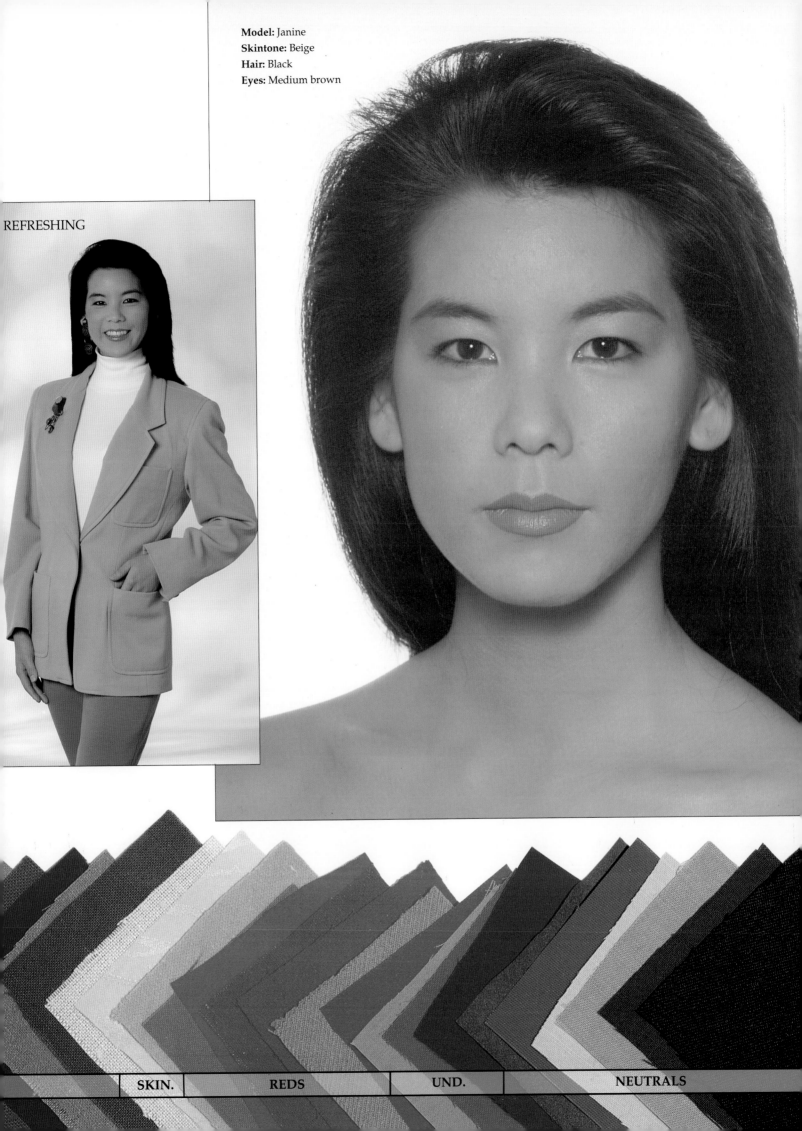

Model: Janine
Skintone: Beige
Hair: Black
Eyes: Medium brown

REFRESHING

SKIN. | REDS | UND. | NEUTRALS

MIDNIGHT

The Midnight woman's distinctive feature is her dramatic blue black hair, for which she has been named.

Her skintone may have a pink to a yellow undertone, and may vary from a cool porcelain to a very warm golden bronze. Her blue black hair may be natural or dyed, and may also have a touch of burgundy, gray, or white.

If her skintone is fair, she would have a high-contrast look due to the great contrast between her fair skin and her very dark hair. If her skintone is golden bronze, she would have a low-contrast look.

The colors in her palette have rich, dark values, and are cool, pure, and intense. As such, they flatter the striking depth of her hair color. Jewel-toned colors like ruby, garnet red, jet black, and lapis are her hallmark. There are very few pastels in her palette because pastels appear washed-out next to the depth and coloration of her blue black hair.

The best makeup for the Midnight woman would be matte eyeshadows, and lipstick and nail polish in cranberry red, deep blue red, natural, mauve pink, or rose red.

Her best metals are silver, pewter and gunmetal. Her best white is pure white.

Skintone: Pink or yellow undertone. Porcelain, rose beige, light olive, beige, yellow olive, dark olive, brown olive, golden bronze.

Hair: Blue black, natural or dyed; blue black with some gray or white, burgundy black.

Great color combinations: Purple and mauve, navy and burgundy, black and charcoal gray, teal blue and pine green.

Do's:
Wear yellow only in small amounts, rather than from head to toe.

Don'ts:
Do not wear colors with a warm yellow undertone, such as brown, pumpkin orange, lime green, or beige. Also, do not wear frosted eyeshadow or lipstick, or shiny or iridescent fabrics.

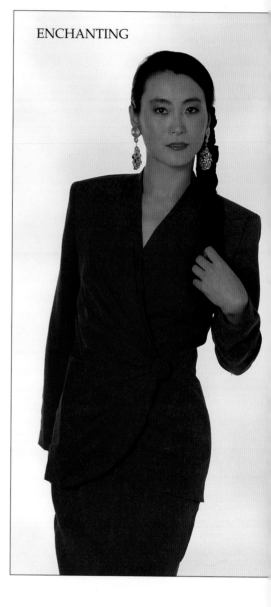

ENCHANTING

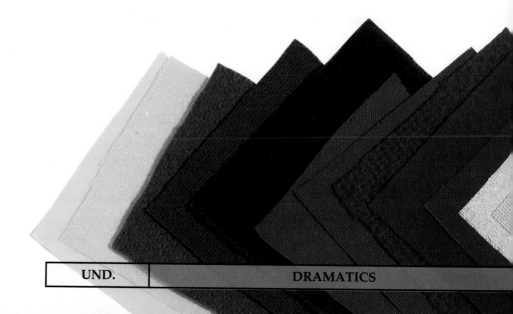

UND. DRAMATICS

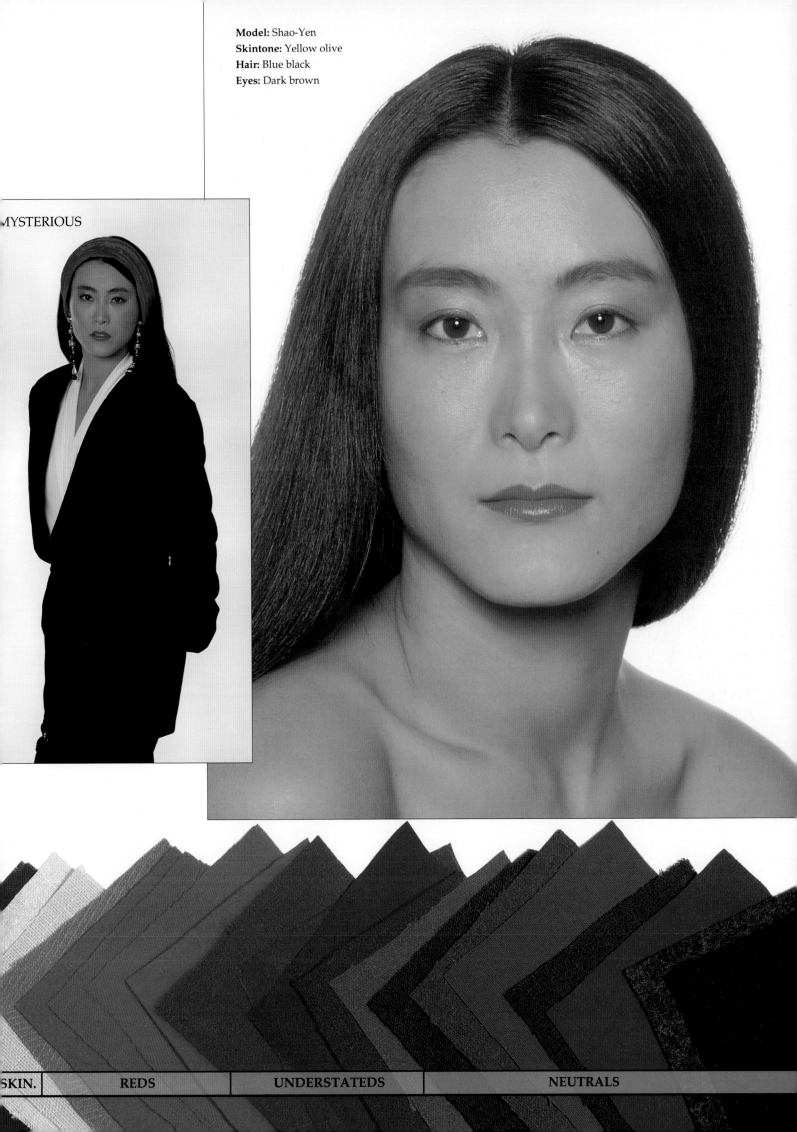

Model: Shao-Yen
Skintone: Yellow olive
Hair: Blue black
Eyes: Dark brown

MYSTERIOUS

SKIN. | REDS | UNDERSTATEDS | NEUTRALS

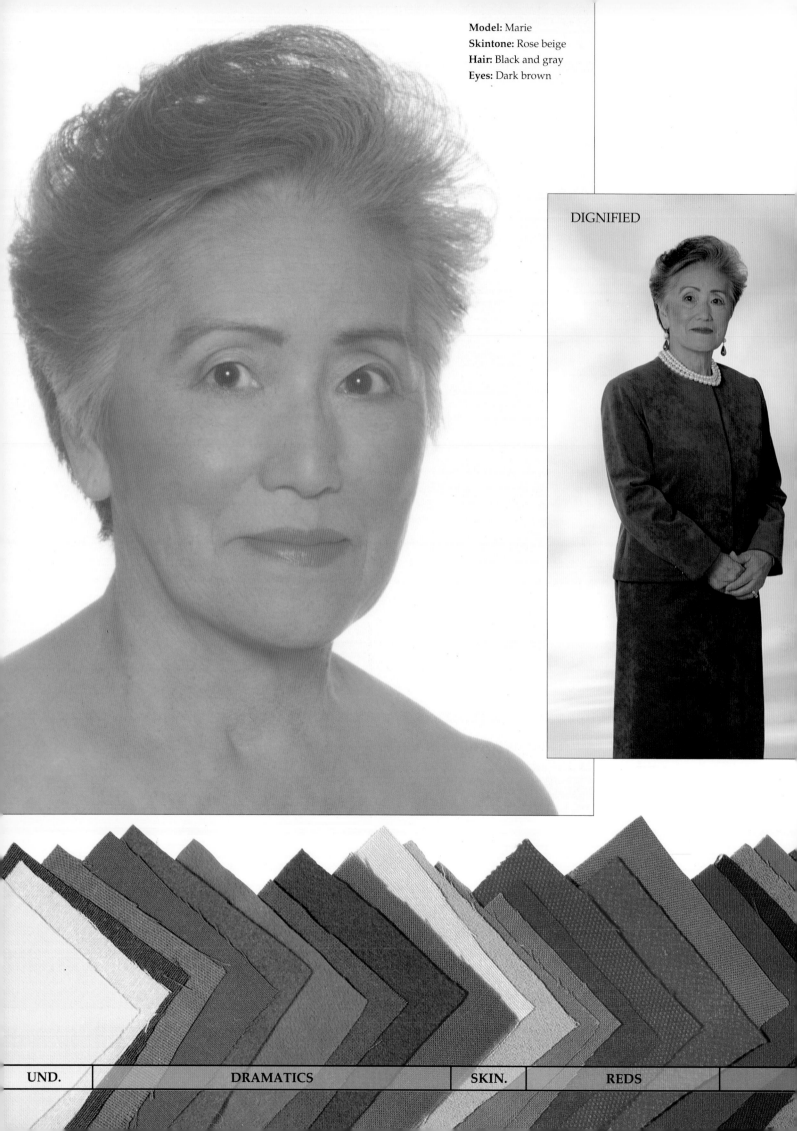

Model: Marie
Skintone: Rose beige
Hair: Black and gray
Eyes: Dark brown

DIGNIFIED

UND.	DRAMATICS	SKIN.	REDS	

MOONLIGHT

STATELY

The Moonlight woman is distinguished by her black-and-gray, or black-and-white hair, and olive complexion.

Her olive skintone would allow her to wear some of the bright, vivid colors of the Starlight palette. However, she is a mature woman, and prefers the less intense, and dusty colors of the Moonlight palette. In addition, the large amount of gray in her hair gives her a less dramatic look than if her hair were all black.

The colors in her palette fall mostly within the moderate ranges of the value scale. The Moonlight palette is most like that of a Frost, which is also cool and subdued. The difference is that the Frost palette is very light or tinted, just like the Frost woman's gray or white hair. The Moonlight palette is darker and relatively more intense, which works perfectly with the Moonlight woman's darker hair color.

Lipstick and nail polish colors that look great on a Moonlight are rose and magenta red.

Her best metals are silver, gunmetal, and pewter. Her best white is pure white.

Skintone: Golden or pink undertone. Rose beige, light olive, olive, beige, light yellow beige, yellow olive, dark olive.

Hair: Black or soft black with white or gray.

Great color combinations: Dark periwinkle and magenta, emerald green and purple, lavender and navy, charcoal gray and red.

Do's:
You can use gold as an accessory away from the face, but use silver near the face.

Don'ts:
Do not wear muted warm colors such as rust, olive green, or mustard.

NDERSTATEDS NEUTRALS

FROST

Femininity, gentleness, and grace best describe the Frost woman. She is named for her silver or white hair, which dominates her overall look, and gives her a cool, low-contrast look. Her skin has a cool pink, ivory, or yellow olive tone.

Cool, blue-based pastels are prominent in the Frost woman's palette. Darker colors would dominate the light, natural coloring of a Frost, and make her appear dull and washed-out.

An objective of color selection is to have others notice you before they notice your clothes. The soft and light palette of a Frost accomplishes this objective very nicely by supporting her subtle natural coloring.

Frosted or iridescent makeup is ideal for the Frost woman. Her best lipstick, blush and nail polish colors are misty pink, orchid, dusty rose, muted mauve, frost pink, and lavender pink.

Her best metals are silver and platinum. Her best whites are pure white and off-white.

Skintone: Pink to slight yellow undertone.
Porcelain, pink, ivory, light to medium olive.
Hair: Silver gray or white.
Great color combinations: Charcoal gray and light blue, raspberry and lavender, turquoise and white, light periwinkle and pink.

Do's:

1. Monochromatic combinations such as purple and lavender will look great on you.

2. Try wearing soft textures, such as angora, cashmere and mohair, which will flatter the texture and color of your hair.

Don'ts:

Do not wear colors with a yellow undertone such as yellow greens, earthtone colors, brassy gold, or copper; or wood jewelry, ethnic accessories, and rough textures such as tweed.

REFINED

UND.

DRAMATICS

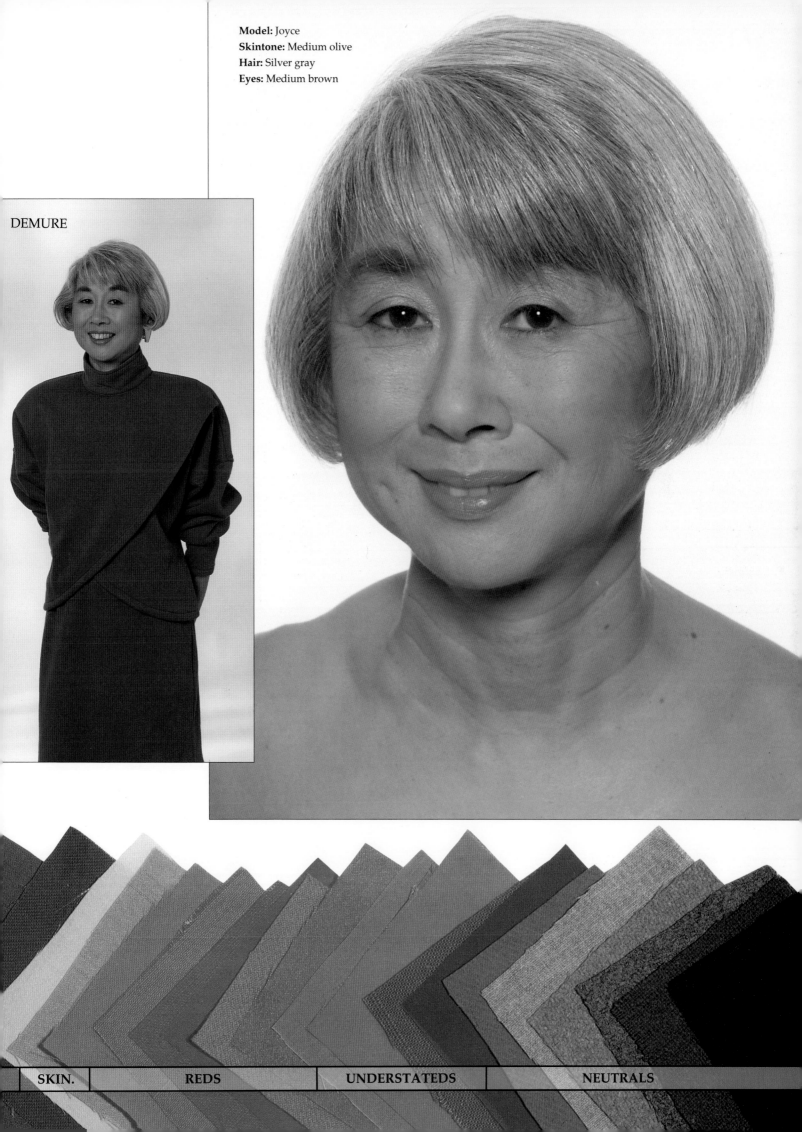

Model: Joyce
Skintone: Medium olive
Hair: Silver gray
Eyes: Medium brown

DEMURE

| SKIN. | REDS | UNDERSTATEDS | NEUTRALS |

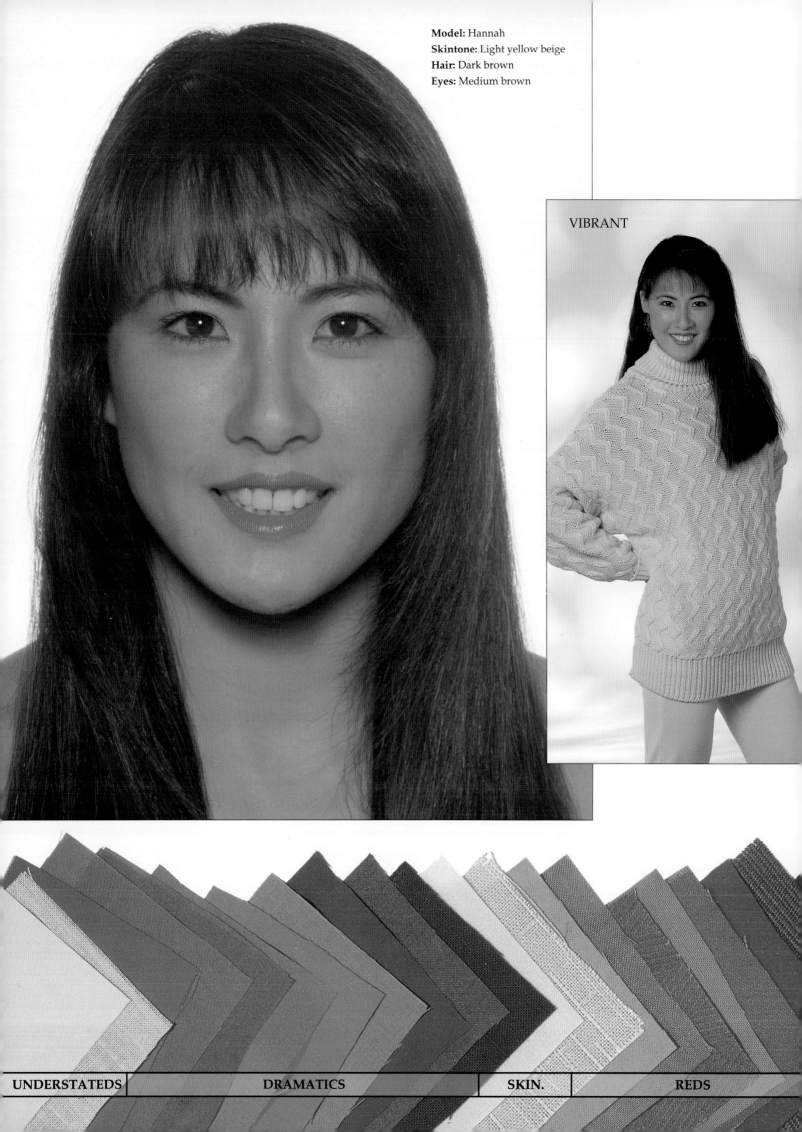

Model: Hannah
Skintone: Light yellow beige
Hair: Dark brown
Eyes: Medium brown

VIBRANT

| UNDERSTATEDS | DRAMATICS | SKIN. | REDS |

HORIZON

REFRESHING

The Horizon woman has a unique look which is neither cool nor warm. Her skintone has a pink, or slight yellow undertone, and can range from pink or ivory, to slightly olive with a yellowish cast. Her hair color can go from soft black, to medium to dark brown, to dark reddish brown.

Due to her lukewarm skintone, she can look great in either cool or warm hues, allowing her the versatility of wearing either cool or warm colors. Her skin-hair contrast is medium to high.

Her palette contains a combination of blue-based and yellow-based hues. These would include coral, pink, chartreuse, dark olive, and taupe.

A Horizon's best lipstick and nail colors include melon red, cantaloupe, clear red, or ginger rose.

She can wear both gold and silver, depending on her outfit. Her best whites are pure white and off-white.

Skintone: Pink or slight yellow undertone. Beige, light yellow beige, ivory, light olive.
Hair: Brown black, dark brown, reddish brown.
Great color combinations: Dark blue and yellow, taupe and melon, periwinkle blue and salmon, navy and chartreuse.

Do's:
You can achieve a more formal look by wearing your hair up, which will make it appear darker. Then wear black and white in combination.

Don'ts:

1. Do not wear muted, warm colors such as mustard yellow and celery green, because they will make your skin appear sallow.

2. Do not wear lavender and mauve lipstick or blush, which are too cool for your warmish skintone.

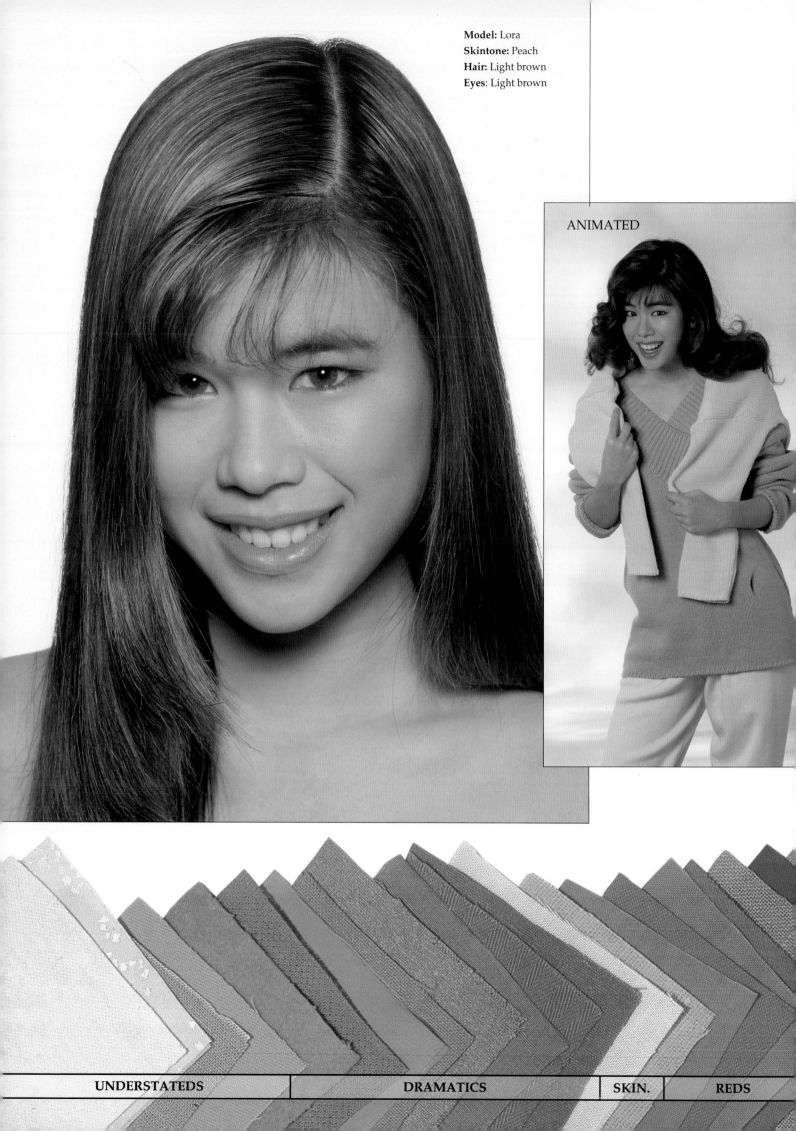

Model: Lora
Skintone: Peach
Hair: Light brown
Eyes: Light brown

ANIMATED

UNDERSTATEDS DRAMATICS SKIN. REDS

SUNRISE

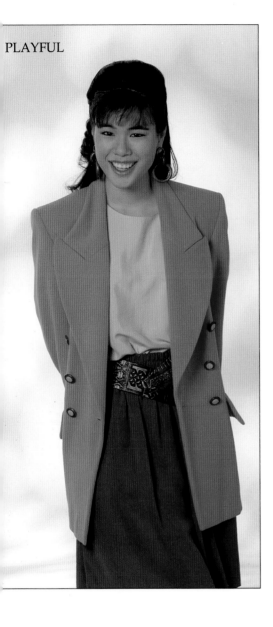

PLAYFUL

The Sunrise woman is characterized by her light, delicate, overall look. Her skin has a pink or yellow undertone, and can range from an ultra cool porcelain, to a warm peach, or light yellow beige. Her hair is light brown or light reddish brown, which gives her a warm overall look. There is a low contrast between her fair skin and light brown hair.

The Sunrise palette is also light, creating a comfortable balance between her natural coloring and her outfit. Her palette, along with that of a Frost, is the lightest, or most tinted of all of the Asian palettes. The difference between the two palettes is that Frost is cool, while Sunrise is warm.

The Sunrise palette has warm to lukewarm colors of the lighter values, which are bright, fresh, and crisp.

The Sunrise woman's best makeup colors have yellow undertones, and include coral red, salmon, peach, coral rose, and apricot.

Her best metal is shiny gold, while her best whites are off-white and ivory.

Skintone: Usually pink but sometimes yellow undertone. Porcelain, pink, rose beige, olive, beige, ivory, peach, light yellow beige.

Hair: Light brown, light reddish brown, orange brown.

Great color combinations: Taupe and peach, mint green and skintone, dark olive green and coral red.

Do's:

To achieve a higher-contrast, more striking look, combine darker and lighter colors, keeping the lighter color next to your face.

Don'ts:

1. Do not wear intense or electric blue tones; or blue-based makeup such as burgundy red lipstick, dark blush or nail polish.

2. Stay away from heavily textured fabrics, which will tend to overwhelm your delicate look.

SUNLIGHT

The Sunlight woman has the warm glow of the summer sun, from the light yellow beige or yellow olive of her skin, to her warm brown hair. Her skin has a yellow undertone, as does her light to dark brown hair.

She is similar to a Sunrise, except that a Sunlight's skintone has more warmth, and her hair can range to a darker shade of brown. A Sunlight can wear brighter and more intense hues than a Sunrise, due to the Sunlight's higher skin-hair contrast.

A Sunlight can wear warm colors without any danger of appearing sallow, because the warmth of her dark hair supports her skintone to keep it natural and healthy looking. She is best complemented by warm, yellow-based undertones, such as vivid orange red, grass green and yellow. Her palette is warm, bright, and intense.

Her best makeup colors are red, poppy red, and shades of deep rose.

Her best metals are gold and brass, and her best white is pure white.

Skintone: Yellow undertone. Peach, light yellow beige, light olive, olive.
Hair: Light brown, medium brown, burgundy brown, dark brown, burgundy black.
Great color combinations: Purple and yellow, electric blue and turquoise, red and navy, plum and violet.

Do's:

Since you are able to wear a large range of reds, make sure that the red you wear matches your makeup red.

Don'ts:

1. Do not wear pastels such as icy blue, light gray and mint green.

2. Stay away from frosted lipsticks, and icy pastels as a makeup colors.

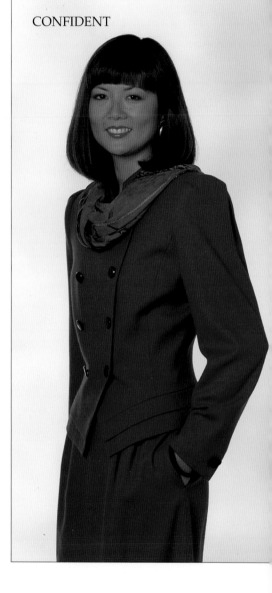

CONFIDENT

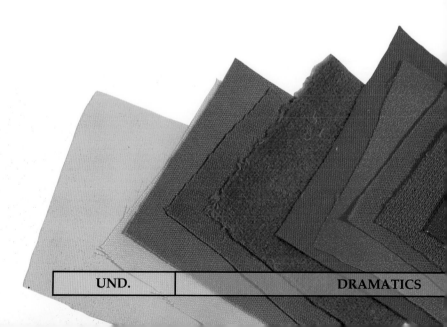

UND.		DRAMATICS

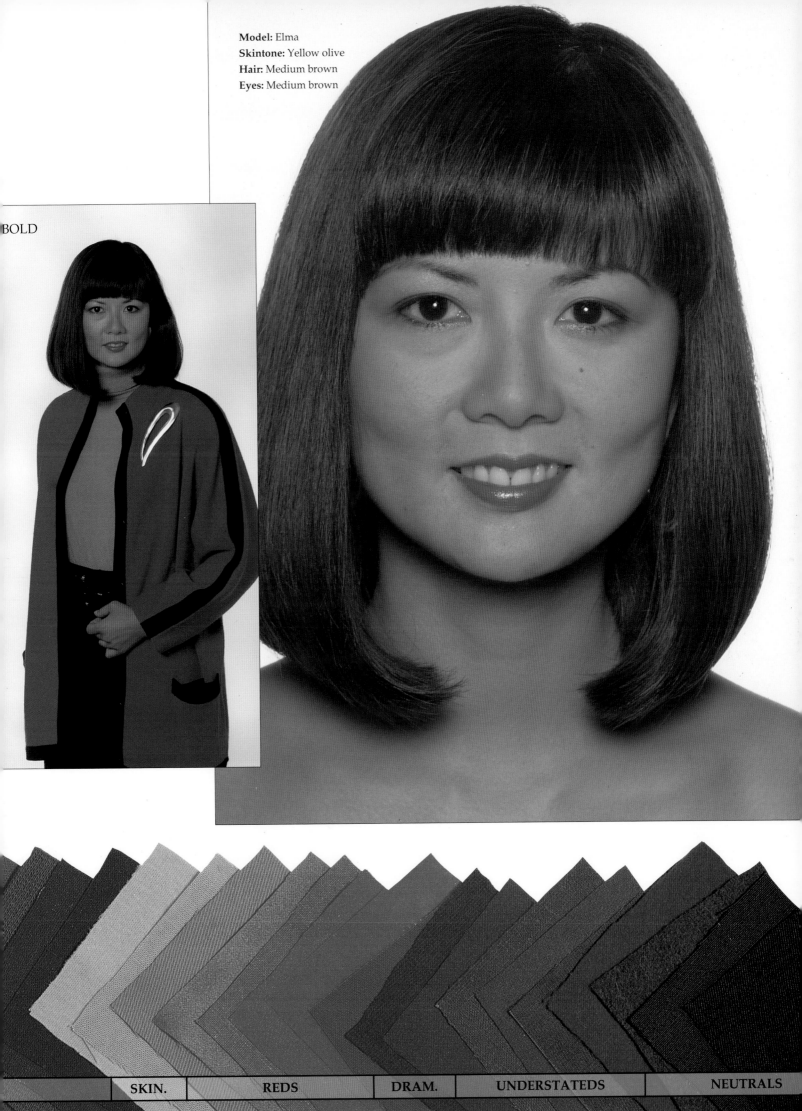

Model: Elma
Skintone: Yellow olive
Hair: Medium brown
Eyes: Medium brown

BOLD

| SKIN. | REDS | DRAM. | UNDERSTATEDS | NEUTRALS |

SUNSET

The Sunset woman has the very warm look of a golden desert sunset. She has a darker, golden bronze skintone, and orange brown to black hair, sometimes giving her a Polynesian look.

Her very warm overall look allows her to look her best in warm, spicy, and festive colors. Her palette is very warm and moderately dark in tone. Her blues, reds, and greens have a good deal of yellow added, and her yellows have red added for an even warmer look.

The Sunset palette works primarily because of her skintone, which blends well with the palette's very warm hues. Her hair coloring is secondary in importance to her skintone. The Sunset palette might be considered the warm equivalent of Midnight, which is also dark and saturated, but on the cool side.

Her best makeup colors have a warm, red base, and include pure red, berry red, sienna, or rust red.

Her best metals are gold, copper, and bronze. Her best white is ivory.

Skintone: Dark olive brown, golden bronze.
Hair: Black, burgundy black, dark brown, burgundy brown, medium brown, light brown, orange brown.
Great color combinations: Red and purple, yellow and orange, teal and violet, orange red and blue.

Do's:

1. For greater impact, try adding a bright red to a dark brown suit.

2. If your hair starts to gray, remove the browns and yellows from your palette, and add warm grays such as medium to charcoal gray.

Don'ts:

1. Do not wear colors with a cool, muted, or blue undertone such as pastels of blues and greens, light grays, and lilac.

2. Stay away from frosted pastel lipsticks and nail polish.

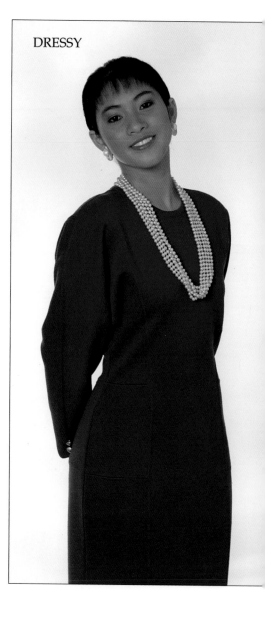

DRESSY

UND.　　　DRAMATICS　　　SKIN

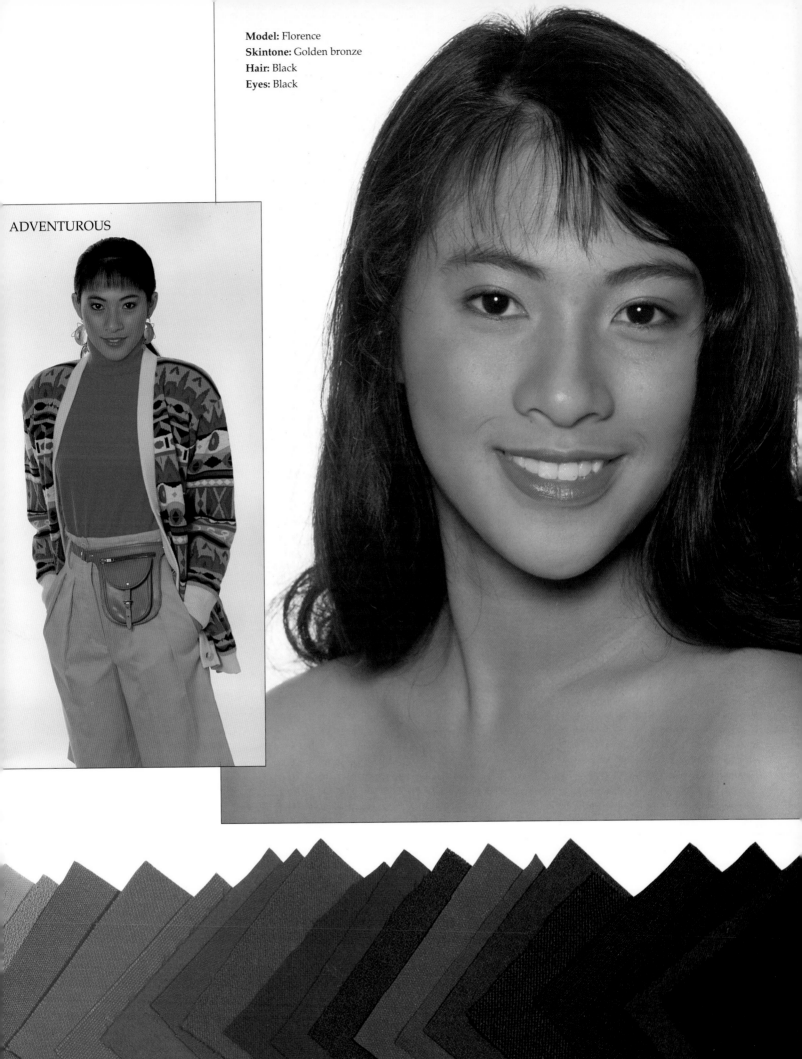

Model: Florence
Skintone: Golden bronze
Hair: Black
Eyes: Black

ADVENTUROUS

REDS	UNDERSTATEDS	NEUTRALS

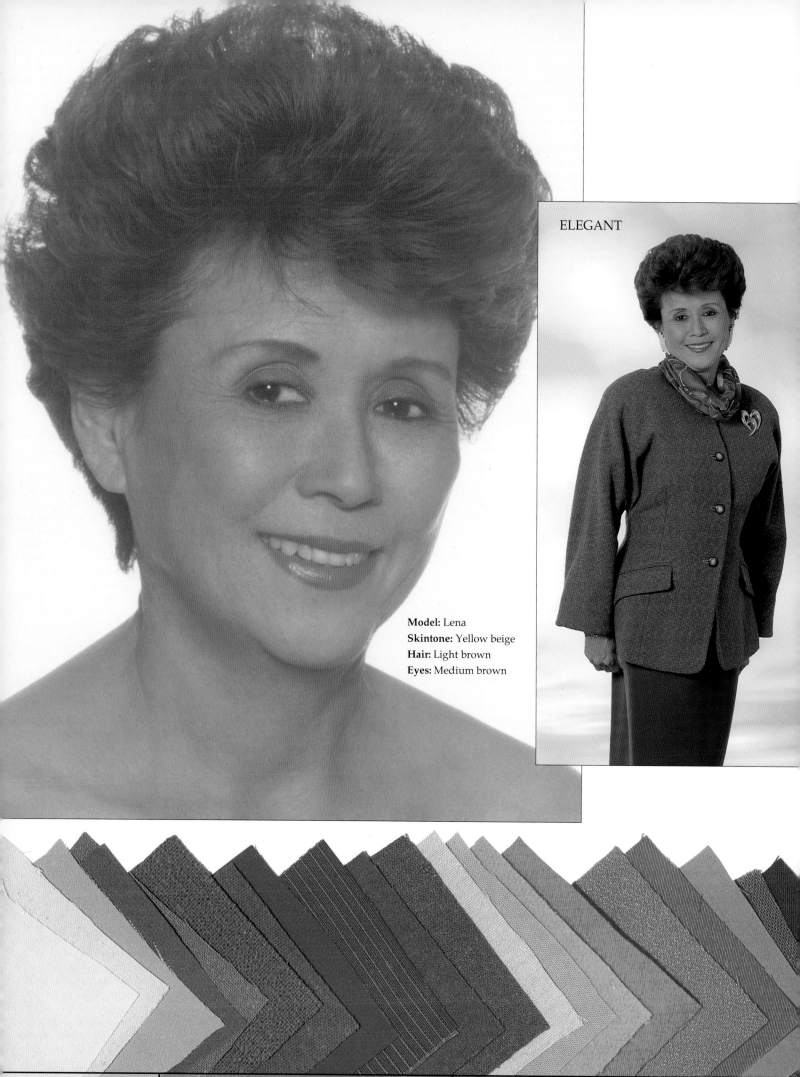

ELEGANT

Model: Lena
Skintone: Yellow beige
Hair: Light brown
Eyes: Medium brown

UNDERSTATEDS DRAMATICS SKIN. REDS UNDER

TWILIGHT

REFINED

The Twilight woman is character-ized by her brown hair, which may be blended with gray or white. Like a Frost or Moonlight, she is mature and has a preference for the more subdued hues, even though brighter, more intense hues would also look great on her.

Her palette is warm, because warm hues are the most flattering to her warm hair coloring and overall look. Her look and her palette are lighter than those of a Sunlight but not as light as a Sunrise.

The Twilight palette is warm and moderate, blending nicely with her overall look, and includes dusty warm colors, such as salmon and soft coral red.

Her best makeup colors are the soft reds, such as coral red, and terra-cotta.

Her best metal is gold and her best white is off-white.

Skintone: Pink or yellow undertone. Porcelain, pink, rose beige, olive, beige, peach, light yellow beige, dark olive, golden bronze.
Hair: Brown with white, dark brown with white.
Great color combinations: Charcoal taupe and coral red, medium blue and light yellow, periwinkle blue and peach pink, lavender and rose.

Do's:
Try furry textures such as angora, cashmere or mohair, which will blend well with the look of your hair.

Don'ts:
Do not wear cool, intense colors such as fuchsia or electric blue.

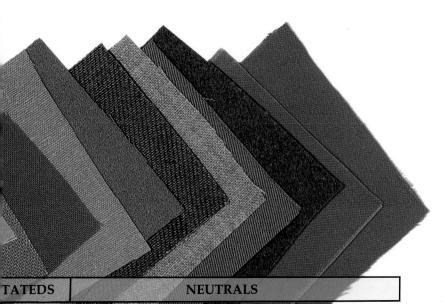

TATEDS | NEUTRALS

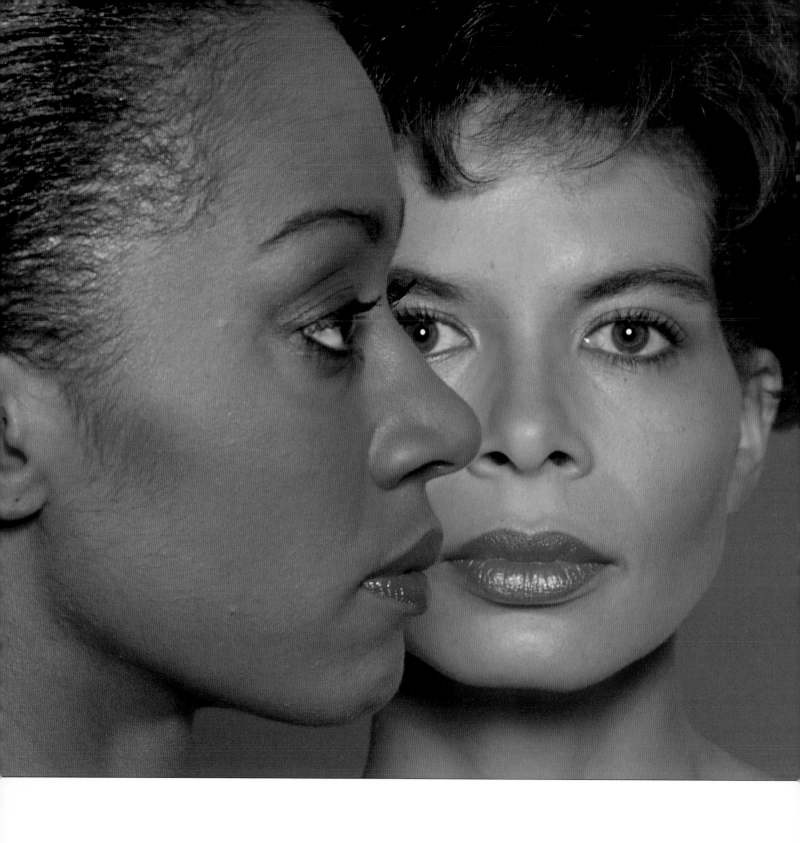

CHAPTER 4
THE BLACK WOMAN

The Black Woman has an African heritage, which is occasionally shared with a European, Asian, or Latin background. She enjoys a great diversity in her natural coloring, particularly if she is not exclusively of African descent. However, she always has that special quality that leaves no doubt that she is a Black woman through and through.

Like the Seasonal and Asian Women, the Black Woman's palette is determined by her skintone, hair color, and the contrast between her skin and hair colors. Her skintone, which can range from a light yellow brown, to a rose brown, to a blue black, is a key to defining her palette. Her hair color is also an important factor. Her eye color, which usually ranges in the neutral tones of light brown to black, is a lesser factor.

As you will discover on the following pages, the Black woman's palettes cover a large range of colors. Pastels, which are very light and reflective, tend to look washed-out next to most Black women's deeper coloring. However, pastels can work if her skintone is very light.

The four categories for the Black woman are as follows, Mahogany, Ebony, Golden, and Copper. A Mahogany has a cool and light over-all look, and has cool, fair skintone and dark hair coloring. An Ebony has a cool and dark look characterized by a red undertone in her skintone, which can be a deep brown, and she has dark hair. A Golden has a warm and light look featuring a lighter skintone with a yellow undertone, and blonde, red, or light brown hair. A Copper has a warm and dark look distinguished by medium to dark brown skin with a yellow undertone, and dark hair coloring.

If this chapter applies to you, proceed to Exercise 2 for the Black Woman, which will help you to determine whether your skintone is a lighter or darker shade. You will then be able to find yourself on the Color Analysis Chart for the Black Woman, which can be found on the following page.

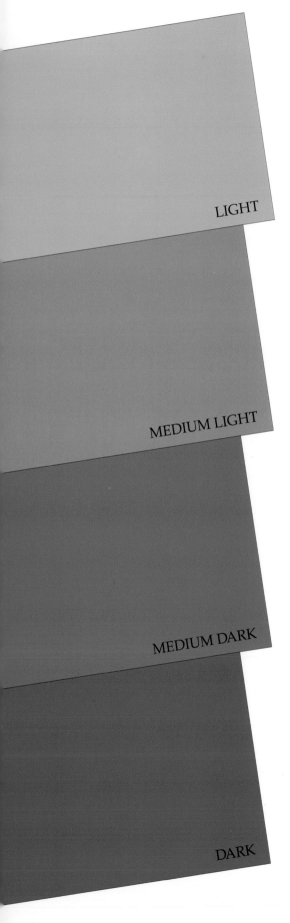

LIGHT

MEDIUM LIGHT

MEDIUM DARK

DARK

EXERCISE 2
FOR THE
BLACK WOMAN

Is my skintone a lighter or darker shade?

1. Find a place with good natural light and use a hand mirror. Look at the four skintone values to the left, not for their color, but for their values or lightness. As you can see, from top to bottom, they go from lighter to darker shades.

2. Look at yourself in the mirror with these values next to your face and decide which is most like the skintone value of your face.

3. If you selected either light or medium light, your skintone is a lighter shade. If you selected either medium dark or dark, your skintone is a darker shade.

4. Now you know whether your skintone is a lighter or darker shade. You should already know from Exercise 1 whether your skintone is cool or warm. Now refer to the following chart, find your skintone and hair color, and then find your category.

Which is my color category?

The Color Analysis Chart for the Black Woman sets forth the four distinct color categories for the various combinations of four skintone groups and seven hair colors. Once you determine your skintone and match it to your hair color, the chart will tell you which category you should select.

1. Find your skintone along the top of the applicable chart. (For example, if you learned from Exercise 1 that your skintone is cool, and from Exercise 2 that your skintone is a lighter shade, you are a cool-light on the chart.)

2. You may verify whether you fall into a skintone category on the chart by referring back to the skintone samples on pages 12-13, or on pages 142-143.

3. After you find your skintone on the chart, match it with your hair color, and find your category.

4. Double-check your selection by turning to your category, and comparing your coloring with that of the model. If your coloring is different from hers, check the models for similar categories and find the one whose coloring is most like yours. If one of the models has coloring just like yours, you have probably found your category. If none of them has your exact coloring, go back to the category designated by the chart.

COLOR ANALYSIS CHART FOR THE BLACK WOMAN

SKINTONE			
COOL-LIGHT	COOL-DARK	WARM-LIGHT	WARM-DARK
LIGHT OLIVE BROWN	DARK OLIVE BROWN	LIGHT YELLOW BROWN	MEDIUM TO DARK YELLOW BROWN
ROSE BROWN	DARK ASH BROWN	PEACH BROWN	RUDDY WITH YELLOW BROWN
MEDIUM BROWN	DARK RED BROWN	LIGHT GOLDEN BROWN	MEDIUM TO DARK GOLDEN BROWN
LIGHT BROWN	BLUE BLACK		

HAIR				
BLACK	MAHOGANY	EBONY	COPPER	COPPER
BLUE BLACK	MAHOGANY	EBONY	COPPER	COPPER
DARK BROWN	MAHOGANY	EBONY	COPPER	COPPER
MEDIUM BROWN	MAHOGANY	EBONY	GOLDEN	COPPER
LIGHT BROWN	COPPER	COPPER	GOLDEN	COPPER
RED	GOLDEN	GOLDEN	GOLDEN	GOLDEN
BLONDE	GOLDEN	GOLDEN	GOLDEN	GOLDEN

MAHOGANY

The Mahogany woman has a cool and light overall look, highlighted by her lighter skintone, and darker hair coloring.

Her skin has a red undertone, and can range from light to medium olive brown. She might have a rose tint on her cheeks. Her hair color can range from a medium brown, to black brown, to black, and can have reddish or burgundy highlights. She might be of mixed racial origin, which may account for her lighter skintone.

The skintone of a Mahogany can easily be mistaken as warm, but her best colors are definitely cool-based. Due to the high contrast between her lighter skin and dark hair color, her palette contains the full range of light to dark cool-based colors, except the icy pastels.

Her best lipstick and blush colors are the cooler ranges of red, such as clear red, ruby red, magenta, raspberry and rose.

Her best metal is silver and her best white is pure white. Famous Mahoganys include Diana Ross.

Skintone: Red undertone. Light olive brown, light brown, medium brown, rose brown. Has a rose tint on her face, usually on her cheeks.

Hair: Medium brown, dark brown, blue black, black, silver gray.

Great color combinations: Navy and rose, black and white, cobalt blue and magenta, plum and mauve.

Do's:
If your skintone has a slight yellow tint, you can use gold as a metal, in addition to silver.

Don'ts:
Do not use warm-based, muted or dull colors; or beige, camel, or brown.

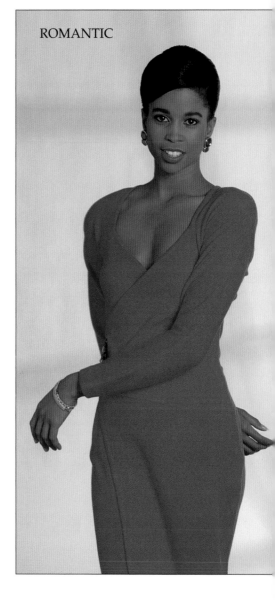

ROMANTIC

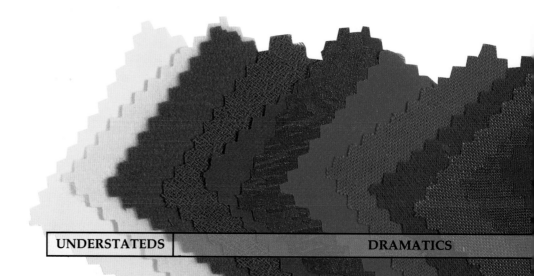

| UNDERSTATEDS | DRAMATICS |

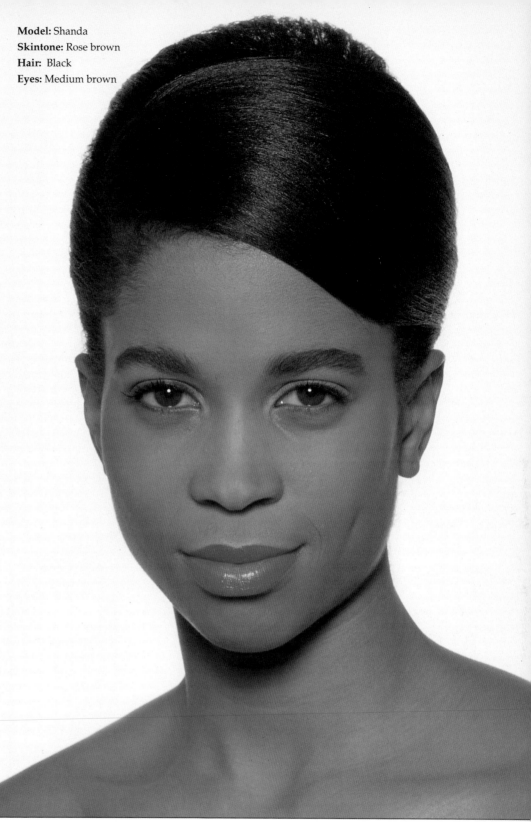

Model: Shanda
Skintone: Rose brown
Hair: Black
Eyes: Medium brown

EXQUISITE

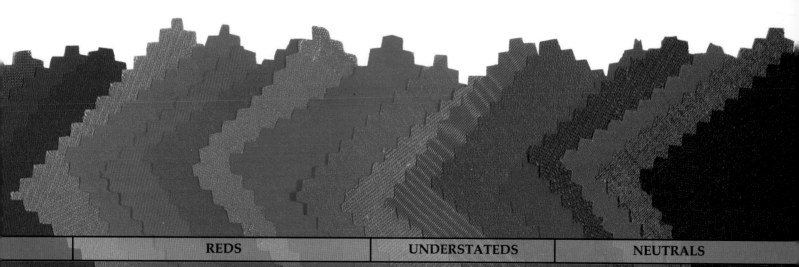

| REDS | UNDERSTATEDS | NEUTRALS |

EBONY

The Ebony woman has the deepest skintone of the four Black categories. She is characterized by her cool, darker skintone, which can range from dark olive brown to blue black.

The classic Ebony has black hair, but her hair can also range to as light as medium brown. The depth of her skintone cools her look, even if she has warm, dark brown hair, so that her palette is decidedly cool, deep, and intense.

She looks great in jewel-tone, pure, rich, and darker colors, such as ruby red, royal blue, dark purple and black. Without makeup she can appear colorless and blended.

Her best lipstick and blush colors are raspberry, cognac, mauve, berry or magenta. She should avoid shiny surfaces such as satin, that will be too reflective for her face, which can have a matte or dry look.

Platinum, pewter, and unpolished silver are the metals which best compliment her cool look. Her best white is pure white. Famous Ebonys include Whoopi Goldberg and Tracy Chapman.

Skintone: Dark complexion with red undertone. Dark olive brown, dark ash brown, dark red brown, and blue black. Can appear to have a matte or dry look.

Hair: Black, blue black, dark brown, and medium brown.

Great color combinations: Magenta and navy, dark purple and ruby red, charcoal gray and black, emerald green and violet.

Do's:

1. Try clothes and jewelry with interesting ethnic designs and textures, which can add an artistic touch to your look.

2. When wearing dark neutrals, add a rich contrast color near your face.

Don'ts:

1. Do not use pastels, warm-based earth tones, browns, beiges, mustard yellows, off-white, and creams.

2. Avoid using yellow as a main color because its reflective qualities will bring out any unevenness in your complexion.

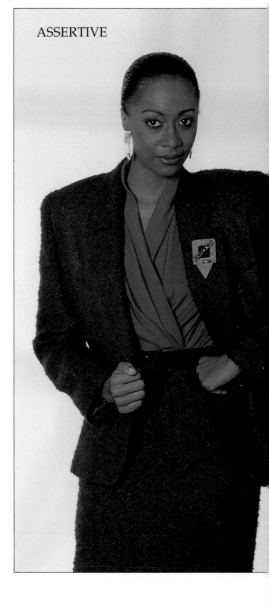

ASSERTIVE

UNDERSTATEDS | DRAMATICS

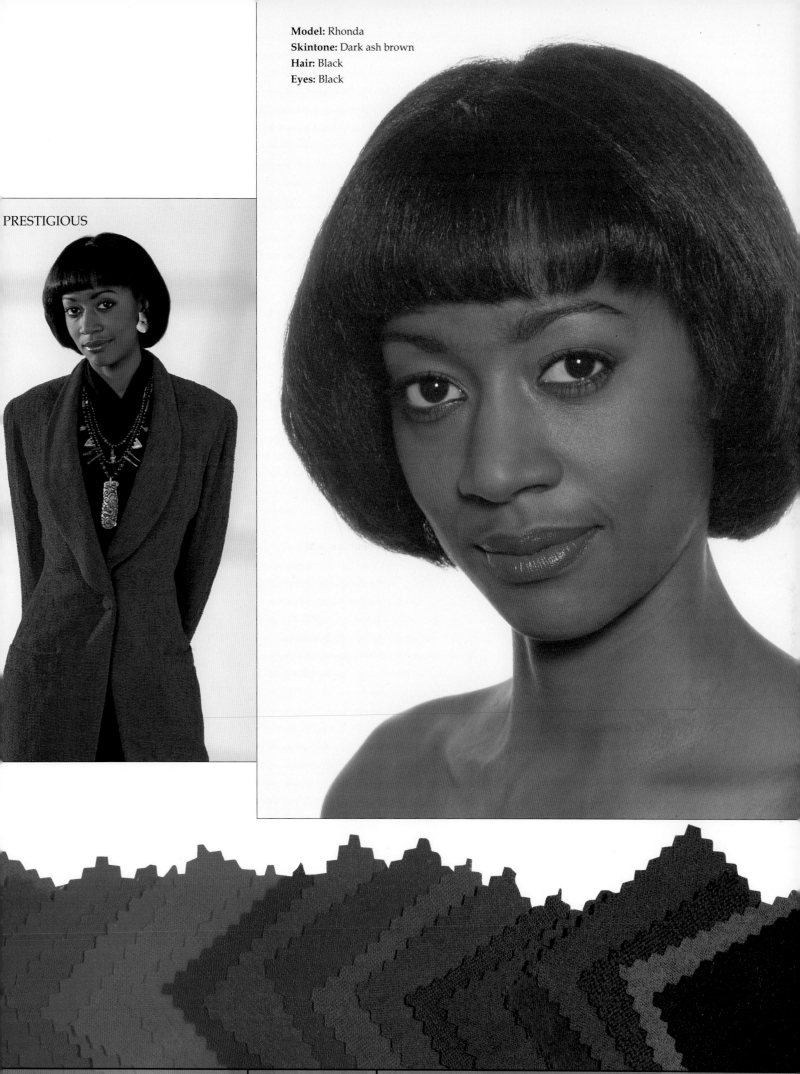

Model: Rhonda
Skintone: Dark ash brown
Hair: Black
Eyes: Black

PRESTIGIOUS

REDS UNDERSTATEDS NEUTRALS

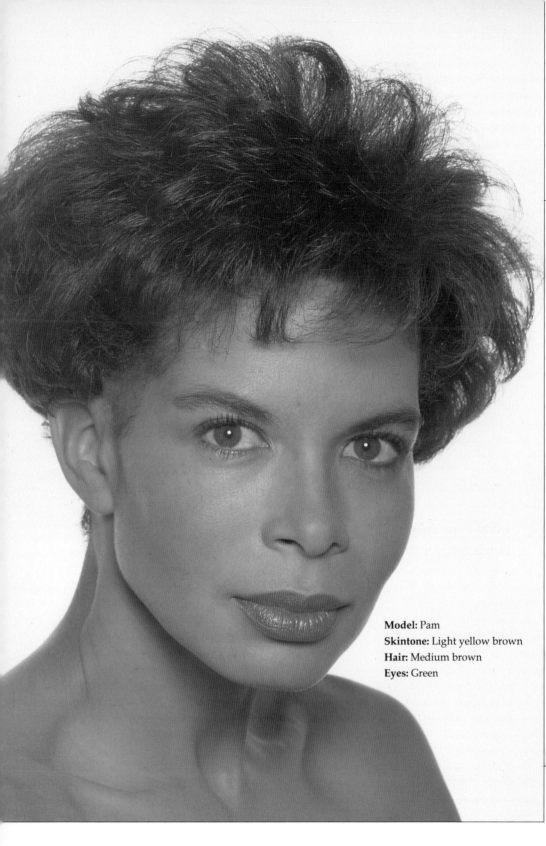

Model: Pam
Skintone: Light yellow brown
Hair: Medium brown
Eyes: Green

LEISURELY

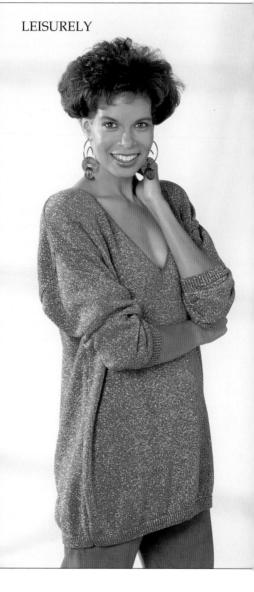

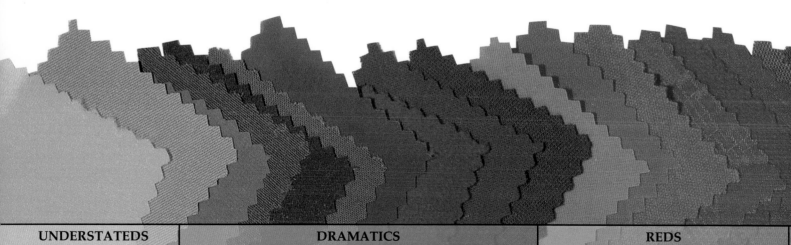

| UNDERSTATEDS | DRAMATICS | REDS |

GOLDEN

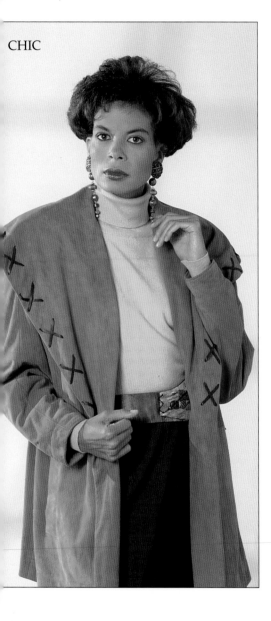

CHIC

The distinctive feature of a Golden woman is her skin color, which can go from light yellow brown, to light golden brown.

Her warm, light skintone dominates her look and gives her the healthy glow of pure gold. She can be of mixed racial origin, with perhaps some European background. Her hair color, which can range all the way from blonde, red, auburn, to brown, also plays an important role.

The warm-based Golden palette works beautifully for her because it blends nicely with her own warm look. Her palette is always warm but diverse, ranging all the way from muted to bright. Spice tones such as cinnamon, paprika, and saffron are the perfect complement to her.

Like her palette, her lipstick and blush should have a yellow-orange base, such as apricot and salmon.

Her best metals are gold, brass, and copper. Her best whites are off-white or ivory. Famous Goldens include Shari Belafonte Harper and Dionne Warwick.

Skintone: Fair complexion with golden undertone. Light yellow brown, peach brown, light golden brown.

Hair: Most commonly is light to dark brown, but can be red, blonde, or black. When she gets older she might gray into a taupe, or gray brown.

Great color combinations: Camel and coral, orange and olive green, brown and cheddar yellow, tomato red and brown, orange and yellow orange.

Do's:

1. Use off-white and cream instead of gray white as a neutral.

2. Try wearing your earthtone colors in ethnic prints and jewelry.

Don'ts:

Do not use cool-based pastels, light grays, or blue-based reds.

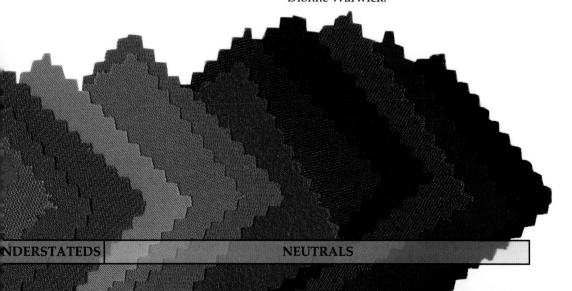

NDERSTATEDS NEUTRALS

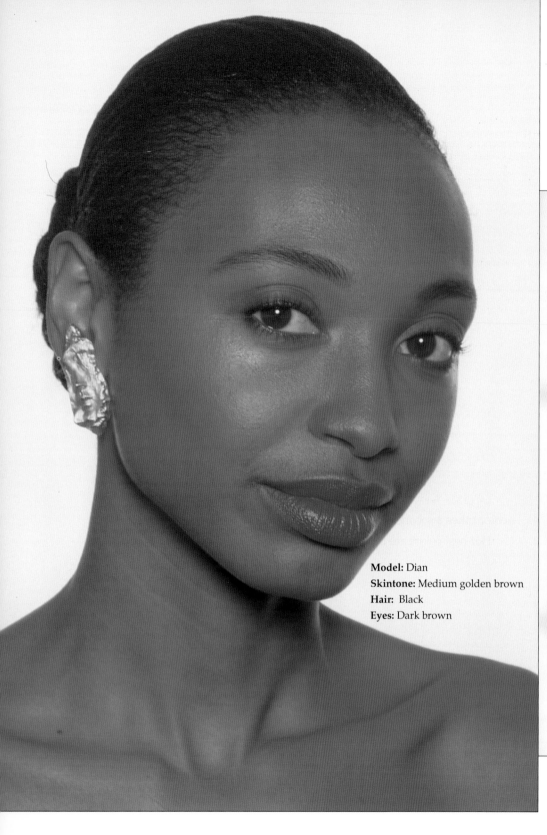

Model: Dian
Skintone: Medium golden brown
Hair: Black
Eyes: Dark brown

STUNNING

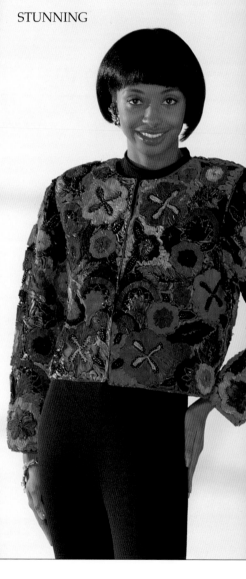

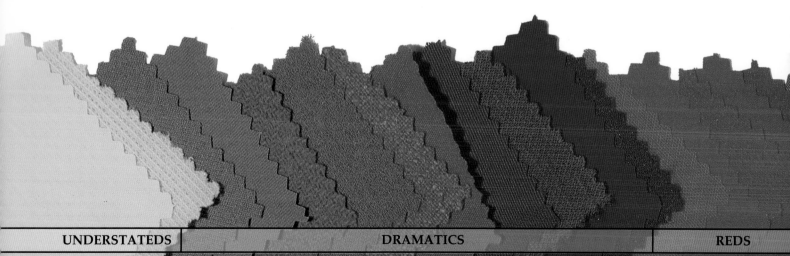

UNDERSTATEDS DRAMATICS REDS

COPPER

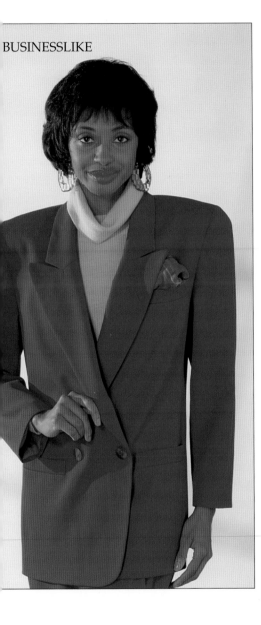

BUSINESSLIKE

The Copper woman has the warm, deep glow of the metal after which this category has been named.

Her skintone is definitely warm, with a distinct golden undertone, and ranges in the darker values, from medium yellow brown to dark golden brown. She can also have a ruddy skintone with a yellow brown cast. Her hair color can range from medium to dark brown, to blue black. The glowing warmth of her skintone dominates her look, so that her hair color takes a secondary role.

Her best colors are bright, clear, and vivid, and never muddy or dull. Her best neutrals are black and navy blue.

Her best lipstick and blush colors are clear red and orange red. Gold is her most becoming metal. Her best white is ivory. Oprah Winfrey is a Copper.

Skintone: Medium to dark with golden undertone. Medium yellow brown, dark yellow brown, medium golden brown, dark golden brown, ruddy with yellow brown. Skin may have an oily look.

Hair: Medium to dark brown to black, possibly with reddish or burgundy highlights.

Great Color Combinations: Red and black, navy and green, orange and yellow, red and violet, electric blue and black.

Do's:

1. Complement the reflective quality of your skintone by wearing sparkling fabrics and jewelry, and sequins.

2. When using brown as a neutral, add a vivid red or yellow color next to your face.

3. For a striking look try some new, vivid, three-color combinations.

Don'ts:

1. Avoid cool-based pastels, or dull, muted colors. Stay away from beige, cream, light gray, light green, and light blue.

2. Avoid frosted blue and gray eye shadow, which can make your skin appear sallow.

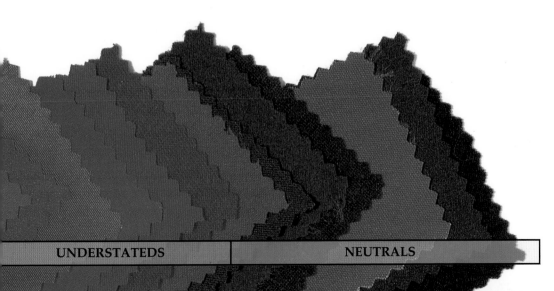

UNDERSTATEDS	NEUTRALS

CHAPTER 5
THE HISPANIC WOMAN

The Hispanic woman represents a blending of Native North or South American and Spanish heritages. She is not from one country, or even from one continent. By nature, she is from various races and cultures that are very different from each other in almost every way. For this reason it would be impossible to describe a typical Hispanic or Latin woman, just as it would be impossible to describe a typical Caucasian woman. But all Hispanic women have the unmistakable qualities of Latin spirit and femininity that set them apart from all the others.

Like her diverse racial background, the Hispanic woman also enjoys great diversity in her natural coloring. Her skin color, which is the key to determining her palette, ranges from rose beige to dark brown. Her hair color, also an important factor, ranges from blonde to black. Her eye color is also a factor, and can range from hazel, green, or blue, to light and dark brown. If her eye color is hazel, green, or blue, she can add to her wardrobe, accent items in the same color.

Almost all Hispanic women can wear black, because most are dark-haired brunettes and have enough contrast to look terrific wearing it.

However, if her hair is very light brown or blonde, she will lack the contrast to stand up to the depth of black.

Hispanic women can look great in a wide range of colors. In fact, there are very few colors that are not contained in one of the Hispanic palettes. My system places Hispanic women into one of four categories: Rose, Onyx, Topaz, or Bronze.

A Rose has a cool and light overall look, highlighted by a fair skintone with red undertone, and dark hair. An Onyx has a cool and dark look, with deep red brown skintone and dark hair. A Topaz has a warm and light look, characterized by blonde, red or light brown hair and skintone with a yellow undertone. A Bronze has a warm and dark look, featuring warm-skintone and dark hair coloring.

If this chapter applies to you, proceed to Exercise 2 for the Hispanic Woman, which will help you determine whether your skintone is a lighter or darker shade. You will then be able to find yourself in the Color Analysis Chart for the Hispanic Woman, which can be found on the page following Exercise 2.

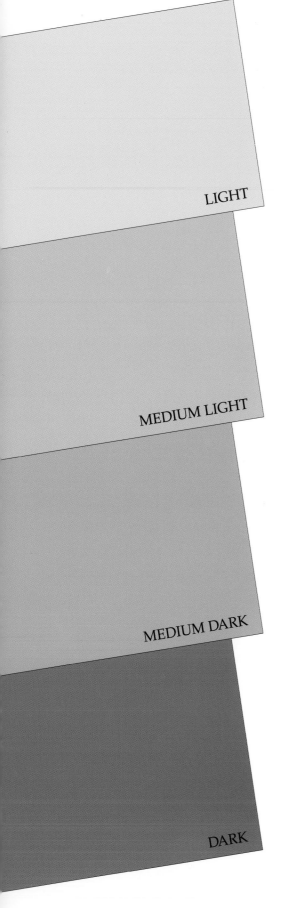

LIGHT

MEDIUM LIGHT

MEDIUM DARK

DARK

EXERCISE 2 FOR THE HISPANIC WOMAN

Is my skintone a lighter or darker shade?

1. Find a place with good natural light and use a hand mirror. Look at the four skintone samples to the left, not for their color, but for their value or lightness. As you can see, from top to bottom, they go from lighter to darker shades.

2. Look at yourself in the mirror with these values next to your face and decide which is most like the skintone value of your face.

3. If you selected either light or medium light, your skintone is a lighter shade. If you selected either medium dark or dark, your skintone is a darker shade.

4. Now you know whether your skintone is a lighter or darker shade. You should already know from Exercise 1 whether your skintone is cool or warm. Refer to the Color Analysis Chart on the following page, and then find your category.

Which is my color category?

The Color Analysis Chart for the
Hispanic Woman sets forth the four
distinct color categories for the
various combinations of four
skintone groups and seven hair
colors. Once you determine your
skintone and match it to your hair
color, the chart will tell you which
category you fall into.

1. Find your skintone along the top
of the applicable chart. (For example,
if you learned from Exercise 1 that
your skintone is cool and from
Exercise 2 that your skintone is a
lighter shade, you are a cool-light
on the chart.)

2. You may verify whether you fall
into a skintone category on the chart by
referring back to the skintone samples
on pages 12-13, or on pages 142-143.

3. After you find your skintone on
the chart, match it with your hair
color, and find your category.

4. Double-check your selection by
turning to your category, and com-
paring your coloring with that of the
model. If your coloring is different
from hers, check the models for simi-
lar categories and find the one whose
coloring is most like yours. If one of
the models has coloring just like
yours, you have probably found your
category. If none of the models has
your coloring, go back to the category
designated by the chart.

COLOR ANALYSIS CHART FOR THE HISPANIC WOMAN

	SKINTONE			
	COOL-LIGHT	COOL-DARK	WARM-LIGHT	WARM-DARK
	LIGHT BEIGE	OLIVE	YELLOW OLIVE	YELLOW OLIVE BROWN
	ROSE BEIGE	RED BROWN	LIGHT PEACH BROWN	OLIVE BROWN
	LIGHT OLIVE	DARK BROWN	LIGHT BROWN	GOLDEN BROWN
HAIR				
BLACK	ROSE	ONYX	BRONZE	BRONZE
BLUE BLACK	ROSE	ONYX	BRONZE	BRONZE
DARK BROWN	ROSE	ONYX	BRONZE	BRONZE
MEDIUM BROWN	ROSE	BRONZE	BRONZE	BRONZE
RED	TOPAZ	TOPAZ	TOPAZ	TOPAZ
LIGHT BROWN	TOPAZ	TOPAZ	TOPAZ	TOPAZ
BLONDE	TOPAZ	TOPAZ	TOPAZ	TOPAZ

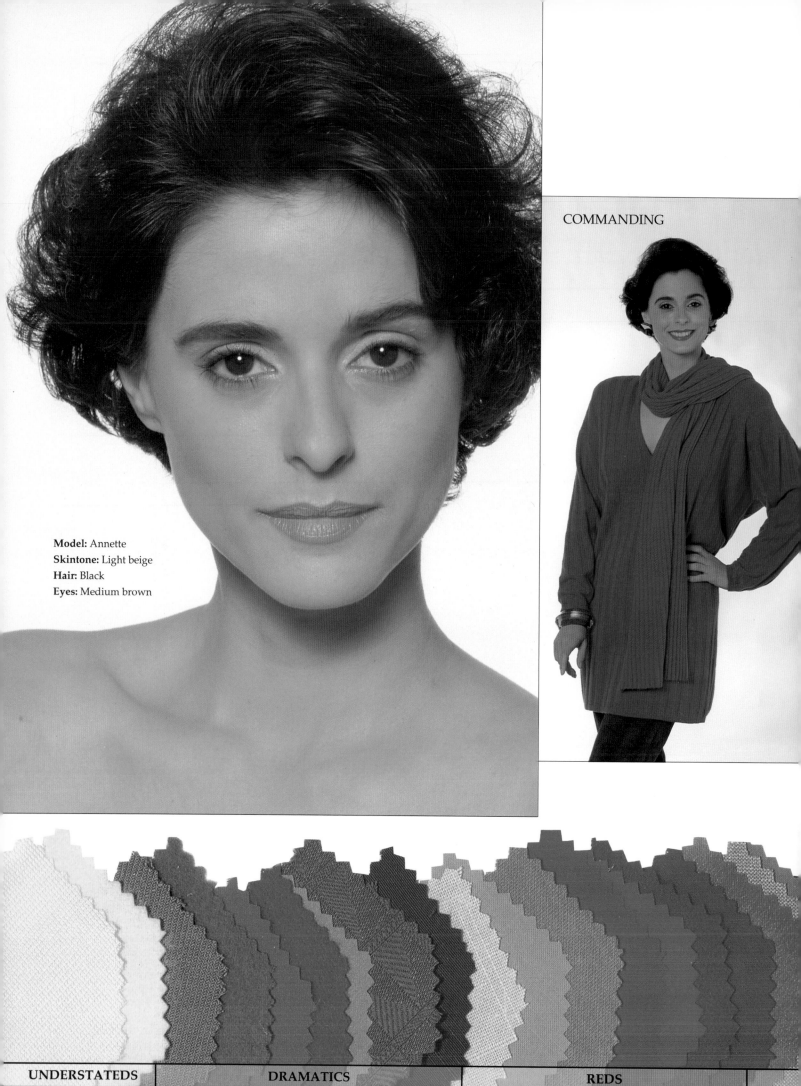

Model: Annette
Skintone: Light beige
Hair: Black
Eyes: Medium brown

COMMANDING

UNDERSTATEDS DRAMATICS REDS

ROSE

ENTHUSIASTIC

The coolness of a red rose aptly symbolizes the woman who falls into this category. Like a rose, she is cool and delicate, and rich, intense, cool colors are her perfect complement.

The Rose woman's light skintone has a pink or slight yellow undertone, and can range from light beige to light olive with a slight yellow tint. She does not tan as easily as other Hispanics, but she does not burn easily, either. Her hair color can range from a dark brown to black. There is a high contrast between her fair skintone and dark hair color.

Her palette has cool-based, intense colors which range in value from very light to very dark. Her high contrast accounts for the wide range of values in her palette.

Her best lipstick and blush colors are the cool-based reds, such as magenta, ruby red, and rose.

Her best metal is silver, and her best white is pure white.

Skintone: Pink or slight yellow undertone. Light beige, rose beige, beige, light olive.
Hair: Dark brown, brown with red highlights, black, blue black, silver gray.
Great color combinations: Turquoise and blue, magenta and black, purple and fuchsia, teal blue and rose.

Do's:
If your skintone has a slight yellow tint, you can wear gold as well as silver.

Don'ts:
Do not use warm-based, muted, dull, or low-intensity colors.

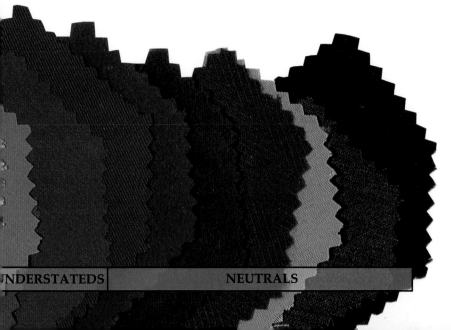

UNDERSTATEDS NEUTRALS

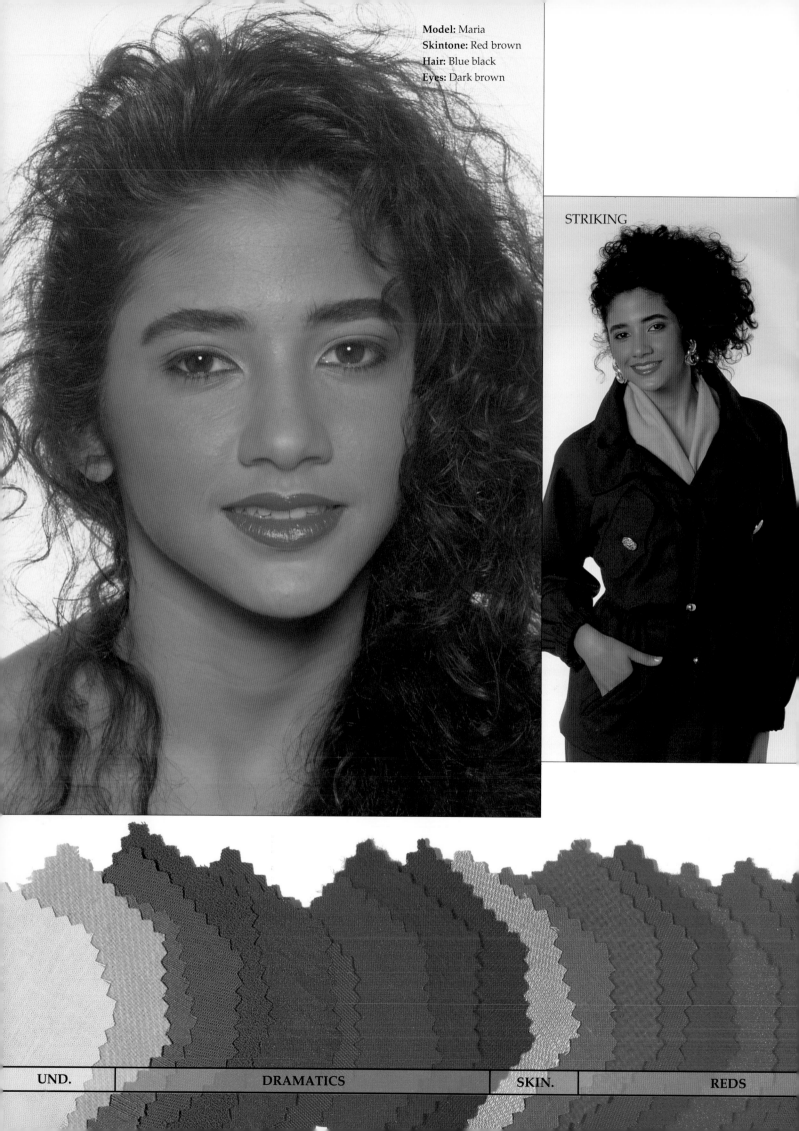

Model: Maria
Skintone: Red brown
Hair: Blue black
Eyes: Dark brown

STRIKING

| UND. | DRAMATICS | SKIN. | REDS |

ONYX

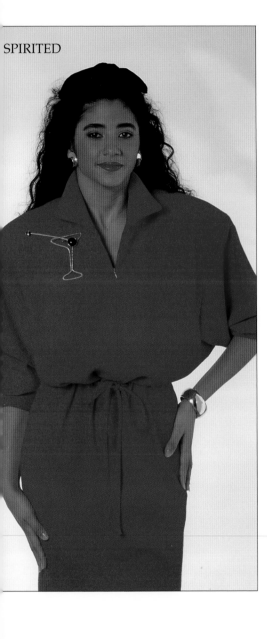

SPIRITED

The rich depth of onyx characterizes the cool, dark overall look of the Onyx woman. Her distinctive look is set off by her cool, deep skintone, which can go from an olive to dark brown.

Her skintone is the darkest of the Hispanic categories, and can have a red to a slight yellow undertone. Her hair color can range from blue black to silver gray, giving her a cool, striking look. Her contrast is lower than that of a Rose because her skintone is darker, creating less contrast with her hair color.

Her palette contains mainly intense, cool-based, dark colors, and no pastels. Her palette also contains a few vivid warm colors but only in the yellows and oranges.

The Onyx woman's best makeup colors are cranberry, deep blue red, and blueberry.

Her metals are silver and gold, and pure white is her best white.

Skintone: Red to slight yellow undertone. Medium olive, dark olive, red brown, dark brown.
Hair: Black, blue black, dark brown, silver gray.
Great color combinations: Red and black, bright blue and white, navy and purple, charcoal and violet, and dark periwinkle and magenta.

Do's:
Black or white will look terrific in combination with any of the colors in your palette.

Don'ts:

1. Do not use warm muted colors, such as mustard beige, and camel, which can make the olive skintone appear sallow.

2. If your hair is silver gray, do not use gold.

UNDERSTATEDS NEUTRALS

TOPAZ

The Topaz woman is characterized by her blonde, light brown, red, or auburn hair, which gives her a very warm overall look.

Her warm, light hair color gives her a very warm glow regardless of her skin tone. Her skin color which can range from cool and light all the way to warm and dark, is not a significant factor in determining her palette. If her skin color is cool and dark, this will create a color conflict with her warm-tone hair color, and her palette will be limited to warm, intense colors.

The Topaz woman's very warm overall look distinguishes her from a Bronze, who has darker hair coloring and a look that is not quite as warm. The Topaz palette contains very warm, rich, intense, and earthy hues, not unlike that of a High Contrast Autumn.

Her makeup colors are also very warm with a orange red base, such as rust and cinnamon.

Her best metals are gold and copper, and her best white is ivory.

Skintone: Peach, light brown, yellow olive, brown olive, golden brown.
Hair: Golden, light brown, red, auburn.
Great Color Combinations: Forest green and rust, teal blue and mustard, copper and black, brown and tomato red.

Do's:

1. When your hair turns gray, use taupe and medium gray to charcoal gray for your neutrals, instead of the camels and browns.

2. You can add black to your palette if your skintone is a darker shade and your hair color is a medium shade.

Don'ts:
Stay away from light, cool-based colors such as the light grays and icy blues.

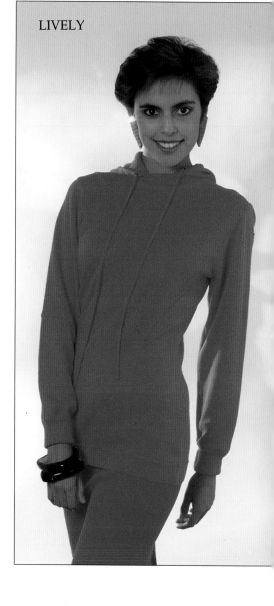

LIVELY

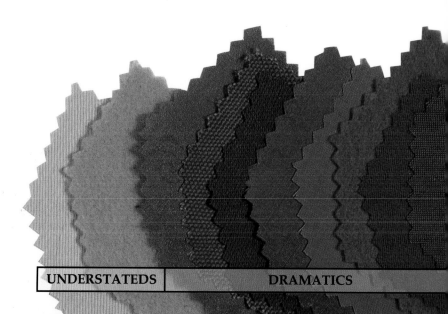

UNDERSTATEDS DRAMATICS

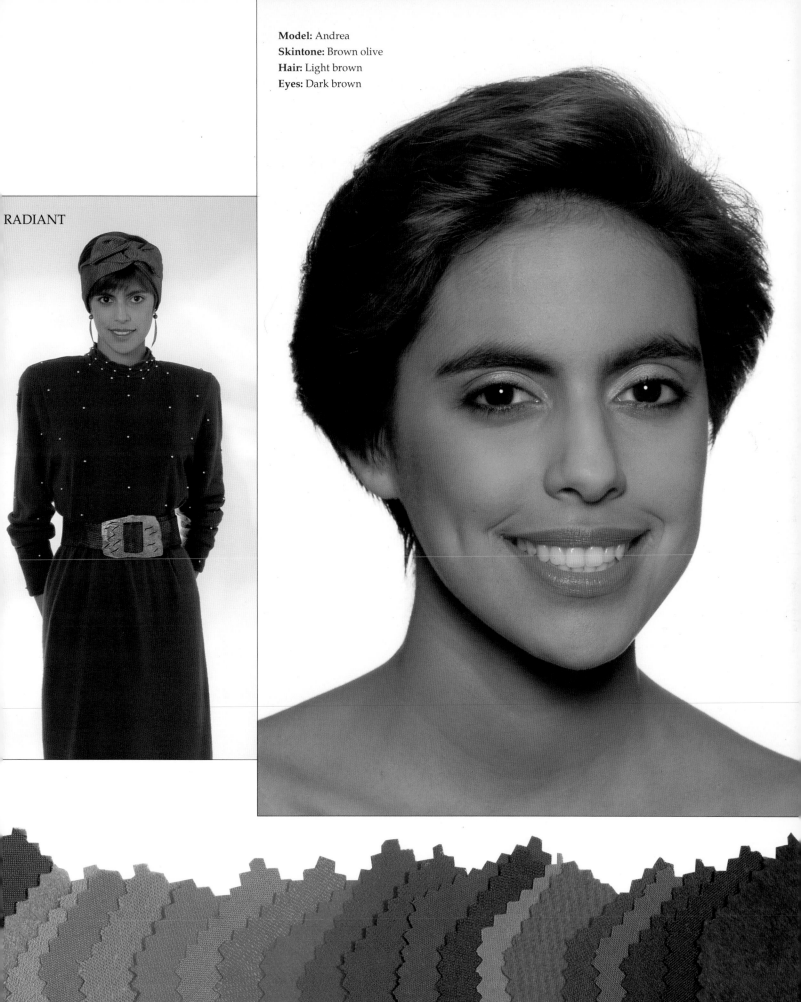

Model: Andrea
Skintone: Brown olive
Hair: Light brown
Eyes: Dark brown

RADIANT

| SKIN. | REDS | UNDERSTATEDS | NEUTRALS |

BRONZE

The Bronze woman's distinctive feature is her warm skintone, which has a golden cast, and ranges from yellow olive to a golden brown. She tans very easily. Her hair color can be medium brown, dark brown, black, blue black, or gray.

Unlike an Onyx, the Bronze woman's skintone is golden enough that warm colors will not cause her to look sallow. For this reason, her palette contains bright, warm-based colors similar to that of a Low Contrast Winter, but contains no cool pastels or muted colors.

A Bronze has less contrast than a Rose because of her darker skintone, but more contrast than a Topaz. If she has a dark olive complexion and brown hair, she should use blush and lipstick in order to avoid looking too blended.

Makeup colors that work best for her are also warm and bright, such as poppy and clear red.

Her best metals are gold and copper, and her best white is ivory.

Skintone: Yellow olive, light brown, light peach brown, yellow olive brown, olive brown, golden brown.
Hair: Black, brown, brown with red highlights, blue black, or gray.
Great color combinations: Red and bright brown, blue and green, deep periwinkle blue and coral red, purple and violet, yellow and green.

Do's:

If you have brown skin and brown hair, you can wear the dark browns, but add a bright color such as red to brighten up your look.

Don'ts:

1. Do not use icy pastels or muted colors, which will look washed-out and too cool for your warm, darker overall look.

2. If you have dark brown skin and very black hair, stay away from the browns, which can make you look drab and washed out.

DRAMATIC

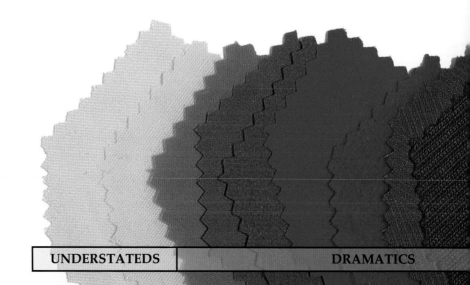

UNDERSTATEDS DRAMATICS

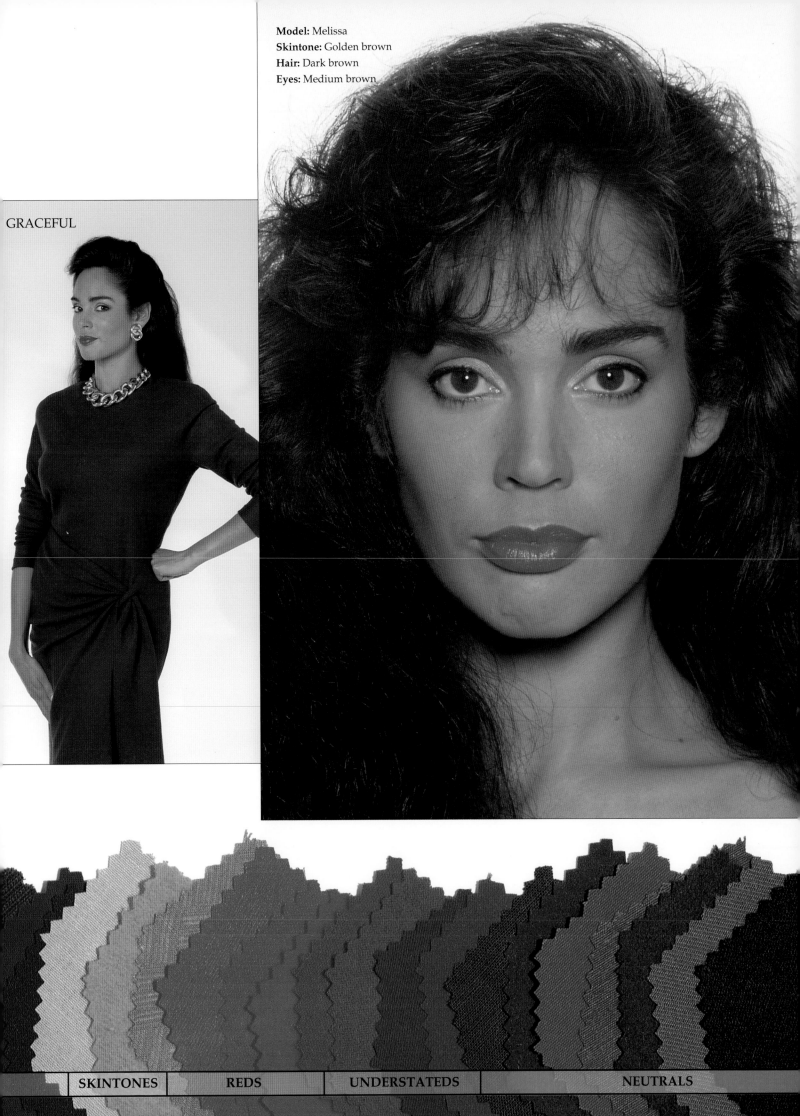

GRACEFUL

Model: Melissa
Skintone: Golden brown
Hair: Dark brown
Eyes: Medium brown

| SKINTONES | REDS | UNDERSTATEDS | NEUTRALS |

CHAPTER 6
COLOR YOUR WARDROBE

Now that you have learned what your best colors are, you are ready to learn how to use them to build your wardrobe.

Hasn't every woman experienced having an important business or social event coming up, looking into her packed closet, and having nothing to wear? This chapter will solve your wardrobe problems by giving you a systematic approach to selecting your next outfit or separates. If you follow my system, every item that you buy will instantly become an integrated, working part of your wardrobe. Thus, even if you have fewer clothes in your closet, you will have much more to wear!

This chapter will teach you how to use my easy-to-follow wardrobe system to achieve your new, well-coordinated wardrobe, without spending a lot of money.

Building Your Wardrobe

The best way to build your wardrobe is to build wardrobe units, one at a time. A wardrobe unit is a basic grouping of clothes that consists of from 8 to 12 different items, all color-coordinated with each other.

First, you must decide whether your initial wardrobe unit will be for career, casual, travel, evening, or perhaps some combination of these types of apparel. Start off by taking note of your lifestyle and your current wardrobe, so that you can determine your most pressing wardrobe needs. For example, you may find that you have plenty of casual wear, but very little career wear for a new job. In this case, you may decide that your first unit will be devoted to career wear. You can later devote a second unit to casual or sportswear. With some careful planning and pre-shopping, you could even cover business, evening, and travel wear, in one versatile unit.

Second, you need to choose two or three colors that go well with each other. In selecting your color combinations, choose versatile colors from your palette. The color combinations featured in this chapter should help to give you ideas for your first wardrobe unit.

Third, in selecting your separates, make sure that their fabrics and shapes work well together. Look for styles that will not be out-of-date in five years, especially in your suits and coats. Finally, you should look at your clothes as an investment, so always invest in quality fabrics and construction.

The Wardrobe Unit

The basic unit from which to start building your wardrobe should consist of the following pieces:

1. The three basic components: a jacket, skirt, and slacks. If they are the same color, and are made of the same fabric, they will have more versatility.

2. Two to three tops, camisoles, or blouses, color coordinated with the jacket, skirt, and slacks. One can be in a white or off-white, a second in a solid, and a third in a print.

3. A one or two-piece dress in a solid or print. Keep the style simple, so that it will be versatile enough for you to dress it up or down by adding other pieces and accessories.

4. A second jacket or cardigan sweater that can go over everything. It can be in the same color scheme, or in an accent color. It can also have a pattern.

5. A coat for the cooler seasons. Again, for the sake of longevity, choose a classic style and good quality fabric. The armhole should be big enough to accommodate any width sleeve, and the hem length should cover your longest hemlines.

6. Accessories: The finishing touches, the 'glue' that holds your outfit together and makes your personal statement.
- Shoes: Flats, heels, sandals, and boots in your best neutrals.
- Handbags: Use neutral colors that coordinate with your outfit or shoes.
- Belts: Invest in good quality and stay with your best neutrals.
- Scarves: Use color accents to liven up an outfit.
- Jewelry: Necklaces, earrings, bracelets, watches in your best metals.

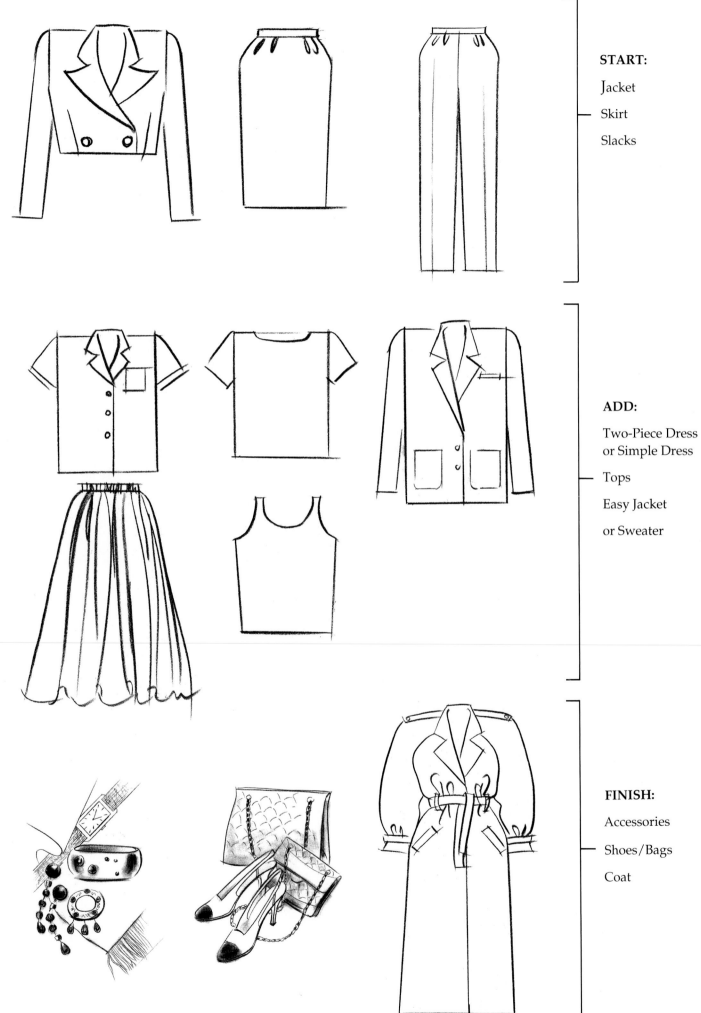

START:

Jacket

Skirt

Slacks

ADD:

Two-Piece Dress
or Simple Dress

Tops

Easy Jacket

or Sweater

FINISH:

Accessories

Shoes/Bags

Coat

89

Career Wardrobe Building

There are no strict rules that govern dressing for the career woman of the '90s. In the '80s the woman's business suit became the standard for the female executive. Today, the business suit look is no longer as dominant as it once was. Happily, women are no longer subjected to such a limited choice in their business wear. However, by nature, career dressing will always be relatively conservative, because one's primary objective in career dressing is to appear professional and businesslike. To me, career dressing means dressing conservatively while maintaining a sense of style and femininity.

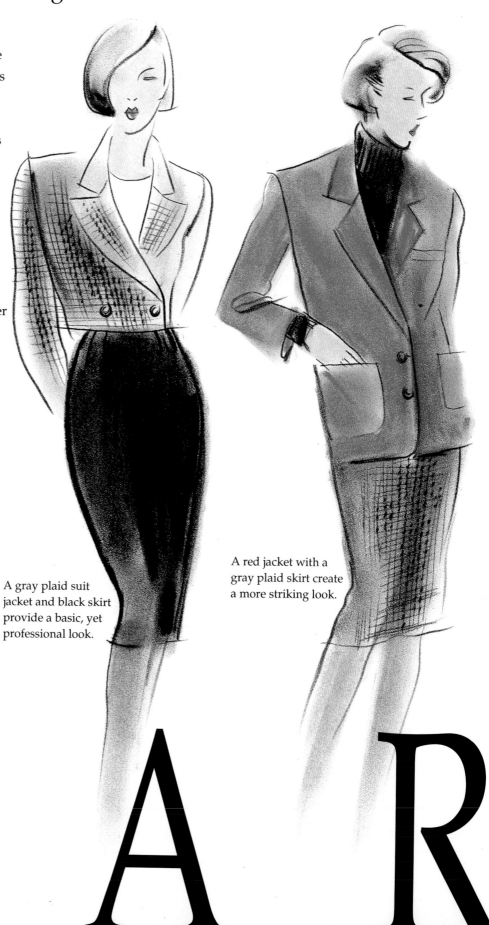

A gray plaid suit jacket and black skirt provide a basic, yet professional look.

A red jacket with a gray plaid skirt create a more striking look.

C A R

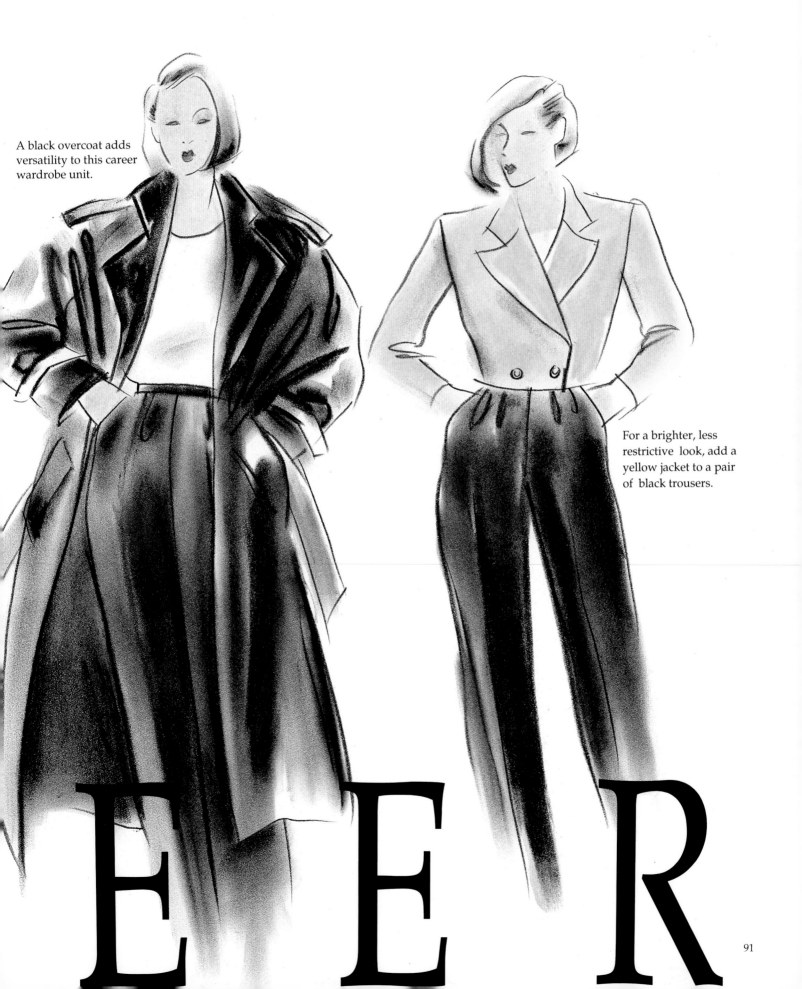

A black overcoat adds versatility to this career wardrobe unit.

For a brighter, less restrictive look, add a yellow jacket to a pair of black trousers.

E E R

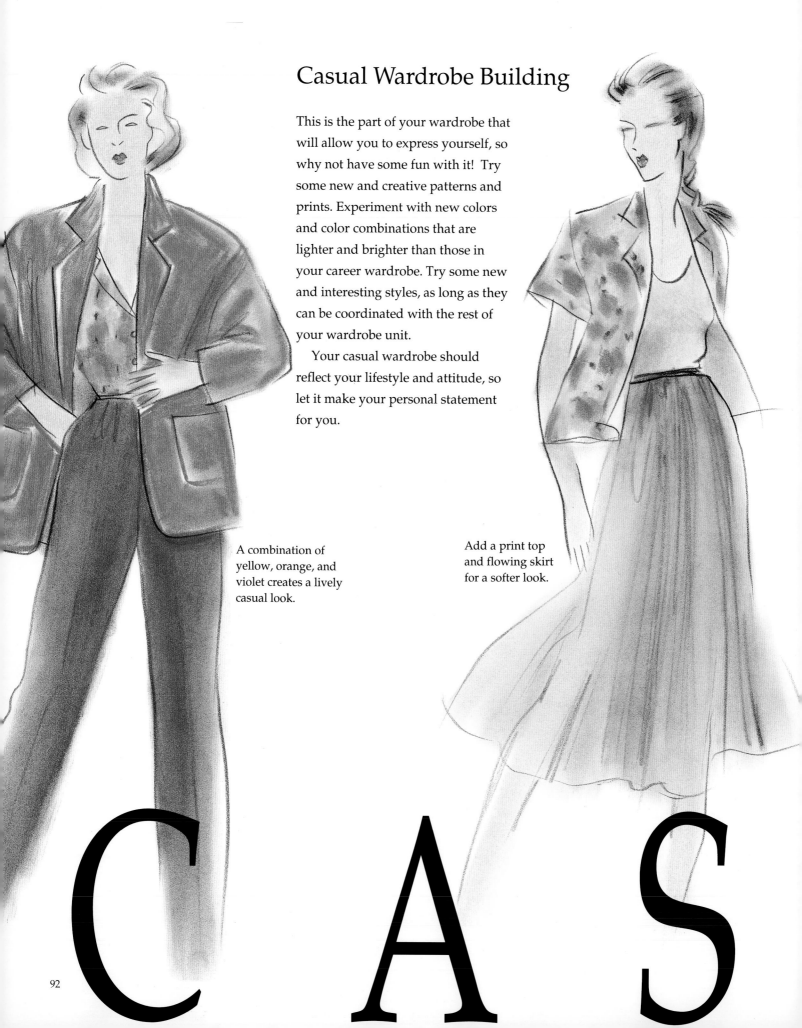

Casual Wardrobe Building

This is the part of your wardrobe that will allow you to express yourself, so why not have some fun with it! Try some new and creative patterns and prints. Experiment with new colors and color combinations that are lighter and brighter than those in your career wardrobe. Try some new and interesting styles, as long as they can be coordinated with the rest of your wardrobe unit.

Your casual wardrobe should reflect your lifestyle and attitude, so let it make your personal statement for you.

A combination of yellow, orange, and violet creates a lively casual look.

Add a print top and flowing skirt for a softer look.

C A S

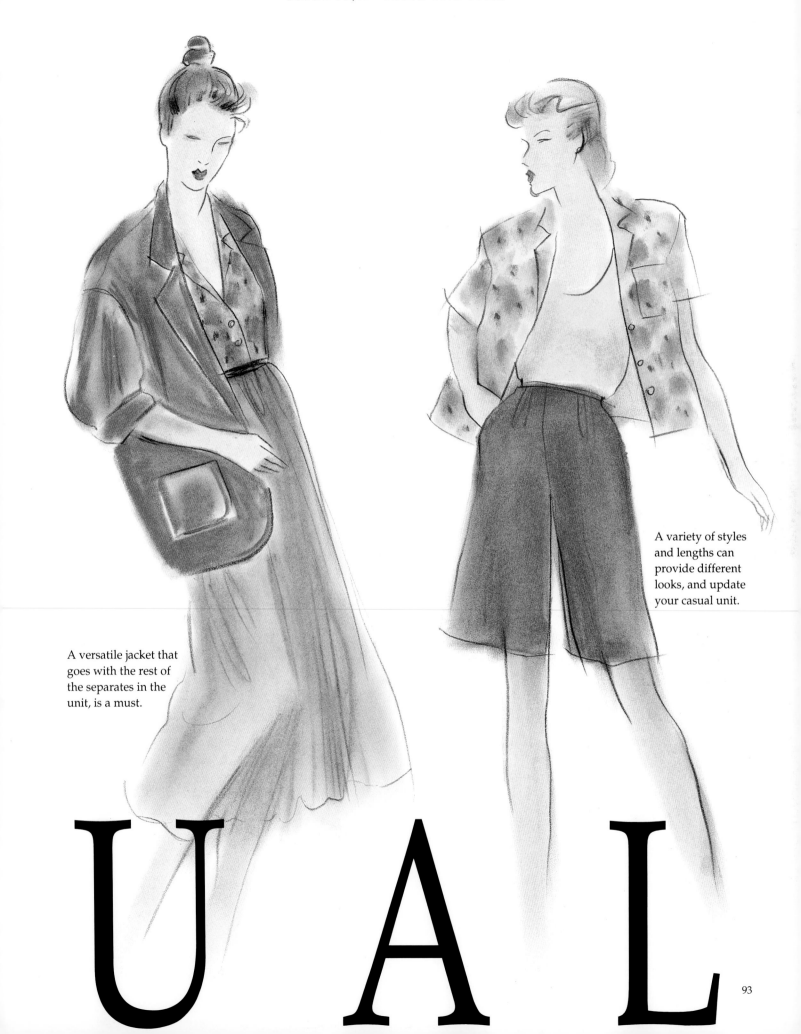

A variety of styles
and lengths can
provide different
looks, and update
your casual unit.

A versatile jacket that
goes with the rest of
the separates in the
unit, is a must.

U A L

Contrast Illusions

As mentioned in the discussion of the importance of contrast on page 17, contrast is the difference between two values, or degrees of lightness. Whenever you combine very light and very dark separates of highly contrasting values, you should be aware of how the illusion created by this contrast affects how you look.

In general, white, or very light values will appear larger and closer than they really are. On the other hand, black, or very dark values will appear smaller. By taking care in selecting the values of your separates, and their placement on your body, you can use these illusions to enhance your figure, or avoid an undesirable effect.

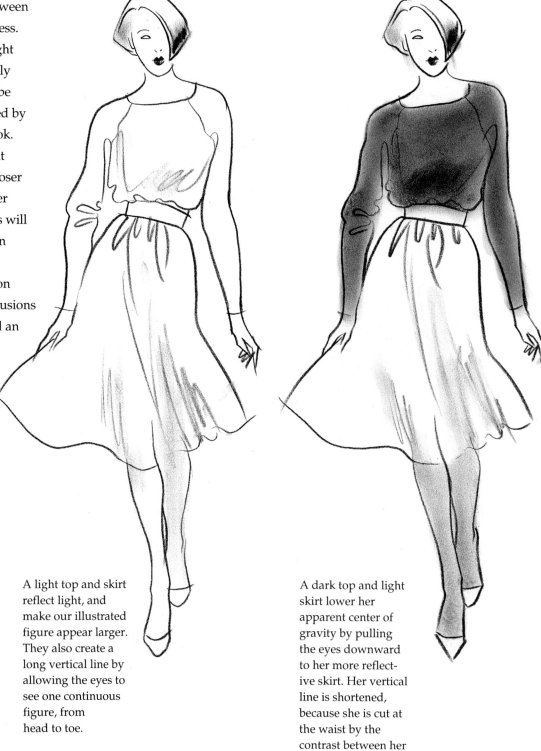

A light top and skirt reflect light, and make our illustrated figure appear larger. They also create a long vertical line by allowing the eyes to see one continuous figure, from head to toe.

A dark top and light skirt lower her apparent center of gravity by pulling the eyes downward to her more reflective skirt. Her vertical line is shortened, because she is cut at the waist by the contrast between her top and skirt.

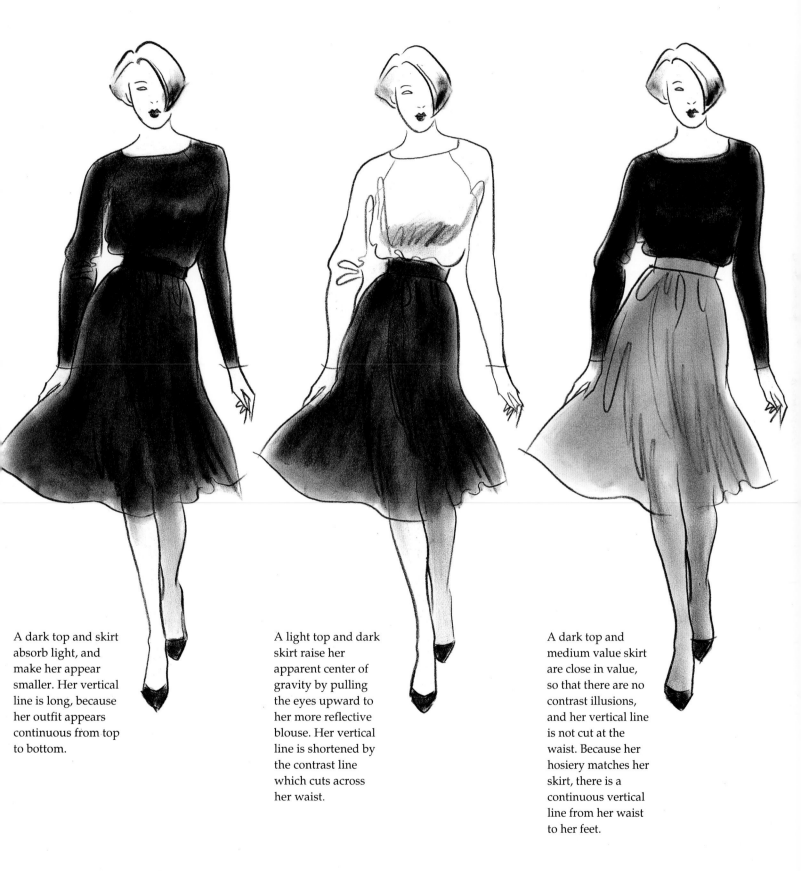

A dark top and skirt absorb light, and make her appear smaller. Her vertical line is long, because her outfit appears continuous from top to bottom.

A light top and dark skirt raise her apparent center of gravity by pulling the eyes upward to her more reflective blouse. Her vertical line is shortened by the contrast line which cuts across her waist.

A dark top and medium value skirt are close in value, so that there are no contrast illusions, and her vertical line is not cut at the waist. Because her hosiery matches her skirt, there is a continuous vertical line from her waist to her feet.

One Color Dressing

- Wearing one color from head to toe, especially one of the neutral colors, can be quite elegant. It can give the illusion of height and slimness, but make sure that you add interesting accessories and textures.
- When wearing a vivid hue rather than a neutral, it will stand on its own with only simple accessorizing and neutral shoes, hosiery and handbag.

Monochromatic Color Dressing

- Dressing in the same hue, but in lighter and darker values of that hue, is monochromatic color dressing. Combining lavender and purple would be an example of this. Using this technique, one can achieve many creative and attractive looks.

TAUPE

MONOCHROMATICS OF PURPLE

Combining Two or More Colors

- Combine two cool or two warm colors. Do not mix cool and warm colors.
- If you are combining two colors, always add a third piece of clothing or accessory to match one of the colors as the finishing touch.

- Combine colors of the same intensity, especially if combining more than two colors.

- Combine colors in unequal proportions, using the darker color for the larger portion, and the brighter color for the smaller portion.

PUMPKIN AND
PURPLE

TURQUOISE GREEN,
SHOCKING PINK, AND
PASSIONATE PURPLE

LIPSTICK RED,
NEON GREEN,
LEMON, AND
COBALT

Two-Color Combinations

Neutral with Accent

- For a versatile and eye-catching look, try combining a neutral with an accent color.

- Select an outfit in a hue from the expanded list of neutrals in Chapter 1, page 18.

- Make your neutral outfit come alive by adding an accessory such as a scarf, in a brighter accent color.

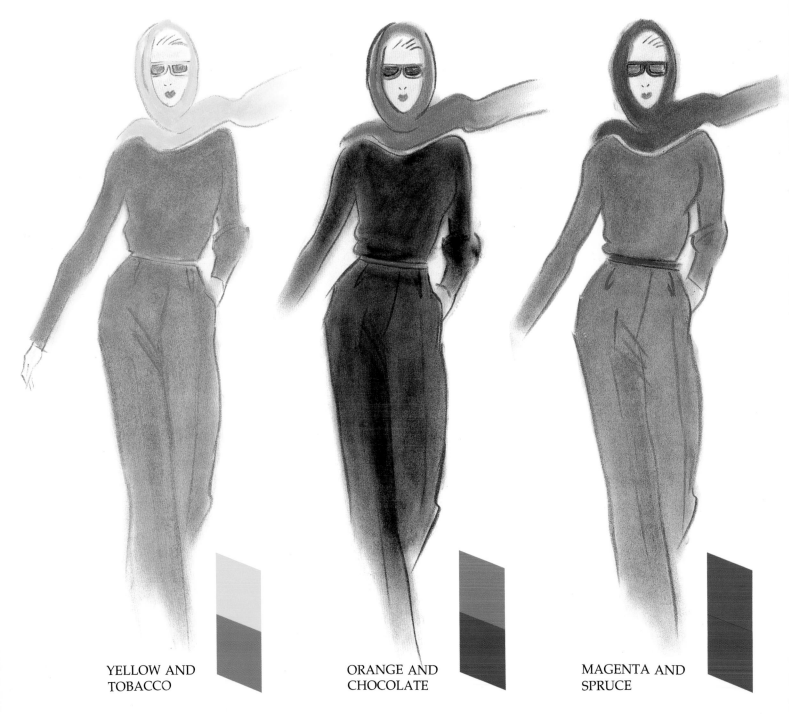

YELLOW AND
TOBACCO

ORANGE AND
CHOCOLATE

MAGENTA AND
SPRUCE

Two-Color Combinations

Complementary Colors

- Combine two complementary colors, not in equal proportions, but in proportions of about one-third to two-thirds.

- Since complementary colors are opposite each other on the color wheel, using them in combination can create a dramatic effect.

- Try combining hues from the color wheel, such as yellow and purple, or yellow green and magenta. In doing so, make sure that you select colors that are in your palette.

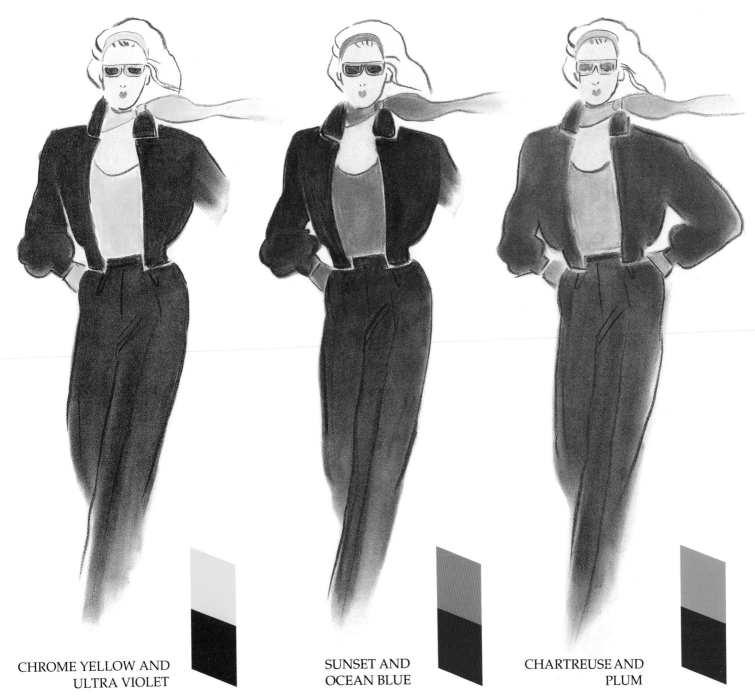

CHROME YELLOW AND ULTRA VIOLET

SUNSET AND OCEAN BLUE

CHARTREUSE AND PLUM

Three-Color Combinations

Analogous Colors

- Analogous colors are also known as related colors, because of their close proximity to each other, and natural sequence on the color wheel.

- Analogous colors used in combination should be of the same or similar intensities, such as blue, blue green, and blue violet.

- Combine two analogous colors with a neutral for an attractive and versatile three-color combination.

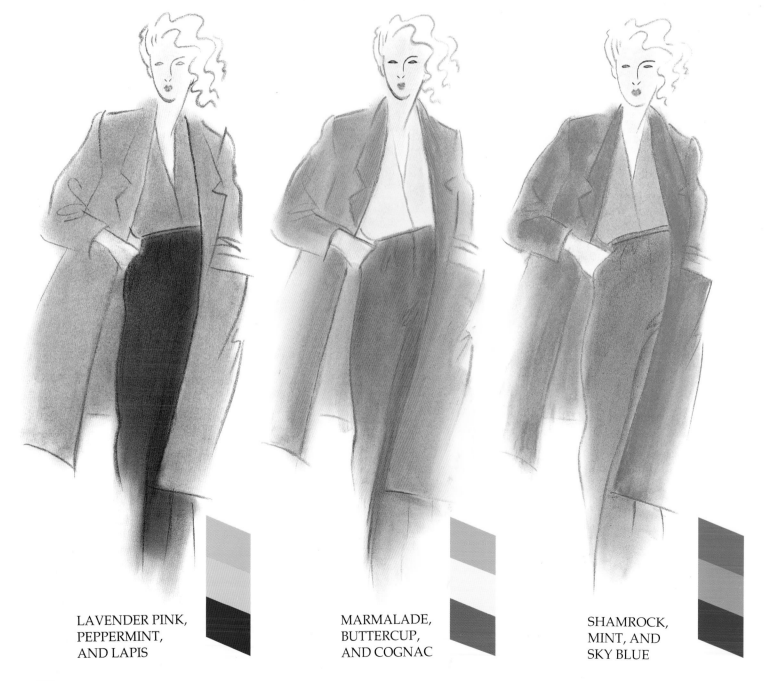

LAVENDER PINK, PEPPERMINT, AND LAPIS

MARMALADE, BUTTERCUP, AND COGNAC

SHAMROCK, MINT, AND SKY BLUE

Three-Color Combinations

Triad Colors

- Triad color combinations consist of hues that are an equal distance apart on the color wheel, for example, orange, green, and violet, or red, yellow, and blue.

- To create balance and harmony in any given triad color combination, always use hues of the same value and intensity.

- Use your color palette in selecting combinations of triad hues in your best values and intensities.

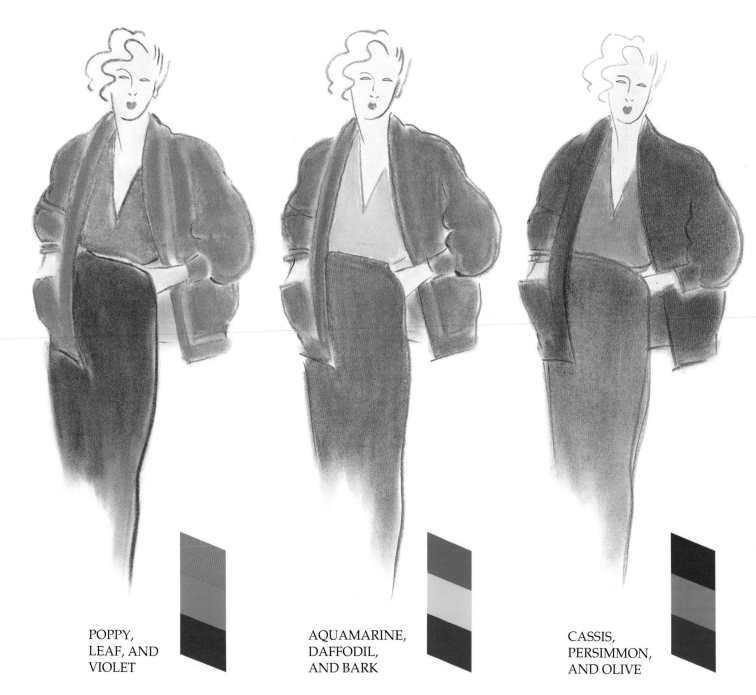

POPPY,
LEAF, AND
VIOLET

AQUAMARINE,
DAFFODIL,
AND BARK

CASSIS,
PERSIMMON,
AND OLIVE

The Psychology of Color

Different colors have long symbolized different objects or emotions. At the same time, studies have shown that colors have different psychological effects on people. Whatever the occasion, you may wish to wear a certain color or color combination in order to create the desired impact. In selecting any of these colors, please make sure that you refer to your palette, so that you will be wearing the best hue, value, and intensity for you.

RED

symbolizes fire and blood, and stands for excitement and physical strength. It has a great deal of energy and intensity, and can also create a very romantic, passionate or dramatic mood.

PINK AND PEACH

are delicate, feminine, compassionate and calming. They project less energy than red.

ORANGE

stands for fire and sunlight. Orange is like red, but toned down in intensity. It can reflect friendliness and liveliness. It combines nicely with brown to create an earthtone autumn look.

YELLOW

is the color depicting sunshine. It connotes radiance, warmth, and receptivity, and brings out an approachable and cheerful look. In selecting your shade of yellow, be aware that the wrong yellow can make your complexion appear sallow.

GREEN

induces a feeling of stability, balance, naturalness, and tranquility. When used near your face, green can also create tension and drama. Be careful when wearing yellow green, which can bring out a sallow color when worn next to certain olive skintones.

BLUE

represents the sky and water. The light blues are calming, while the dark blues such as navy, give off a feeling of power and authority. Navy is one of the most versatile neutrals.

PURPLE

stands for the mystical, sensitivity, uniqueness, and artistry. In ancient times, it suggested wealth and royalty because as a dye, it was rare, and expensive to produce. Purple can be very flattering for olive or deep brown skintones, because it is the complement of the yellow in the skintone.

BROWN

is associated with the ground, dirt, and earth. It creates a feeling of comfort, sincerity, and casualness. Brown is a great neutral for brunettes with a warm skintone.

BLACK

stands for the night, power, mystery, and dignity. Because of its versatility, it has been one of the most important fashion colors. If you have black or brunette hair, you can wear black better than others. If black is not your best color, and you still want to wear it, try wearing a more flattering color next to your face, adding bold, sparkling jewelry, darkening your makeup colors, or wearing a dress with a lower neckline. You can also pull your hair back and wear a black hair ornament, which will help to tie the black into your overall look.

GRAY

is a neutral that is not based on any hue. It is a mixture of black and white. It connotes peace, calmness, reliability, and conservatism. Dark gray signifies power and authority.

PURE WHITE

can be too reflective for some complexions because it can emphasize unevenness or ruddiness. Everyone should have some tops in their best white, which will frame and brighten up the face.

WHITE

is symbolic of light. It stands for purity, cleanliness, innocence, and goodness.

CHAPTER 7 ENHANCING YOUR FIGURE

Fashion trends come and go with the seasons, leaving many women with a closet full of outfits that are out-of-date by the following season, or the following year. Fashion trends also lead many women to buy the latest styles, which look great on the models, but all too often, simply do not work for the rest of us. As a result, they end up wasting money on fashions that do not even flatter them!

The solution is to know your physical assets, and to select attractive styles that best enhance those assets. After you select an attractive and appealing style line, you can then accessorize it, or otherwise adapt it to the latest look.

In this chapter, you will learn how to evaluate your figure, and then to identify which style lines work best for you and your figure type. Remember, all women have their good points, and all women have their flaws. Smart dressing means maximizing your assets and minimizing your flaws in a way that makes your total package both stylish and attractive.

In doing the self-evaluations in this chapter, be honest with yourself, so that the results will be accurate, and lead you on the right path. If you do this, you will be very pleased with the results!

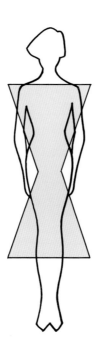

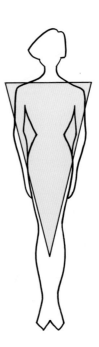

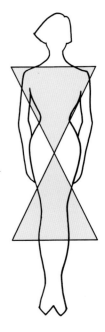

Average
The ideal figure, which is well proportioned and balanced in every way. Her shoulders and hips are in proportion and she has a well-defined waistline. Because she can show off her entire figure, she is able to wear almost any style. For this reason, this book does not include a section for the average figure.

Wedge
Broad shoulders, full bust, heavy upper arms, narrow to average hips. Her objective is minimizing her upper torso, while at the same time emphasizing her hips. Flattering design lines include V-necks and vertical or asymmetric design lines.

Hourglass
Large in the shoulders, and curvaceous in the bust and hips. She has a well-defined and longish waistline. If she is slender and at least of medium height, she can wear almost any style. If her figure is more full, she should wear styles that minimize her curves.

EXERCISE 3

Which is my figure type?

1. Stand in front of a full-length mirror without any clothes on. Look at the proportions of your body, focusing on your shoulders, bust, waist, and hips. Assuming that the ideal figure is average in all proportions, decide whether your body proportions are narrow, average, or wide. Then fill out the chart to the right.

	NARROW	AVERAGE	WIDE
Shoulders	☐	☐	☐
Bust	☐	☐	☐
Waist	☐	☐	☐
Hips	☐	☐	☐

2. Study the results of your figure analysis, and compare them with each of the figure types discussed on this page. You may want to have a friend assist you in making this comparison. Select the figure type that best fits you, and then turn to the page on which your figure type is featured.

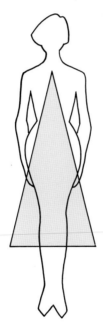 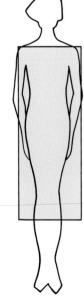 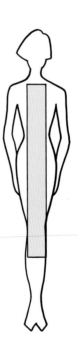 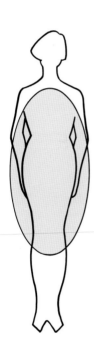 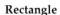

Triangle
Shoulders narrower than the hips or thighs. She should avoid jackets which stop at the fullest part of the hips, and bulky skirts. Her accessories should be up high to draw the eye upward.

Rectangle
Balanced shoulders and hips but few curves or no definition to the waistline. She should avoid boxy, short, or fitted jackets. Her most flattering styles are those that are graceful and flowing.

Thin
Narrow in the shoulders, waist, and hips, with no obvious curves. She has a very slim and straight look, and needs to create the illusion of more fullness and curves. She should wear oval or S-shaped patterns and lines, as well as slightly textured fabrics, and designs with a more full appearance.

Oval
Full in the bust, waist, and hips, with a prominent tummy area. She is usually short-waisted, and has a rounded look. She should try to create a longer, slimmer line by de-emphasizing the middle or her torso. Her best style lines draw attention to her face and shoulders, such as long and flowing styles.

WEDGE

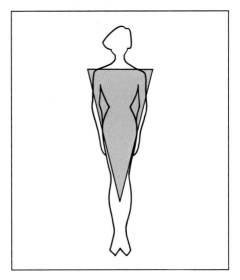

Body Shape:
- Wide in the shoulders
- Can be full-busted
- More narrow in the waist and hips
- Broad back
- Slender legs

Objective:
- Minimize the bust and midriff area, and widen the hips

Do's:
- Raglan sleeve, which draws the eye downward
- Skirts that are full at the bottom, have wide pleats, or have a border
- Blouses of a simple design
- Dresses in drop-waisted, straight line or shirtwaist style

Don'ts:
- Avoid shoulder details such as epaulets, wide lapels
- Stay away from tops with horizontal lines, patch pockets, ruffles, or oversized sleeves
- Avoid short jackets and short vests
- Don't use bulky fabrics or heavy layering on top

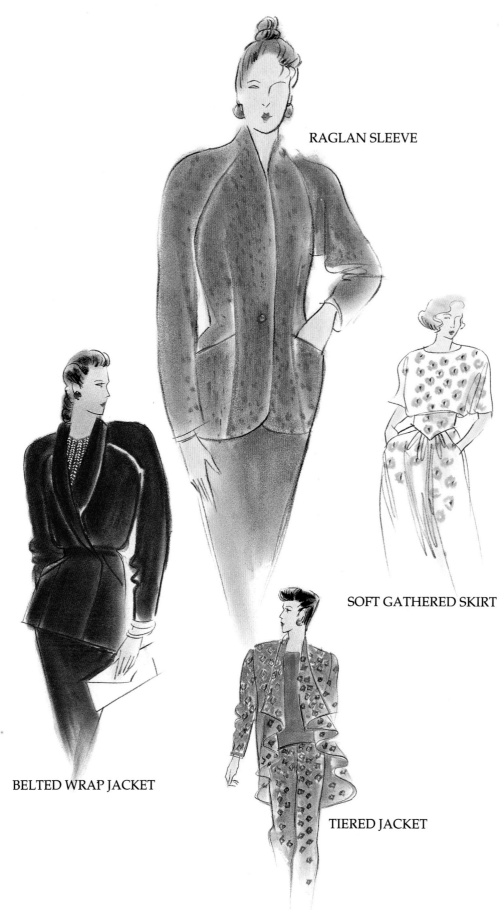

RAGLAN SLEEVE

SOFT GATHERED SKIRT

BELTED WRAP JACKET

TIERED JACKET

HOURGLASS

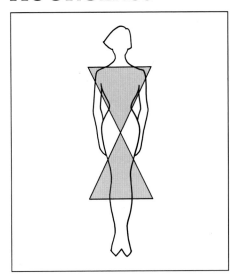

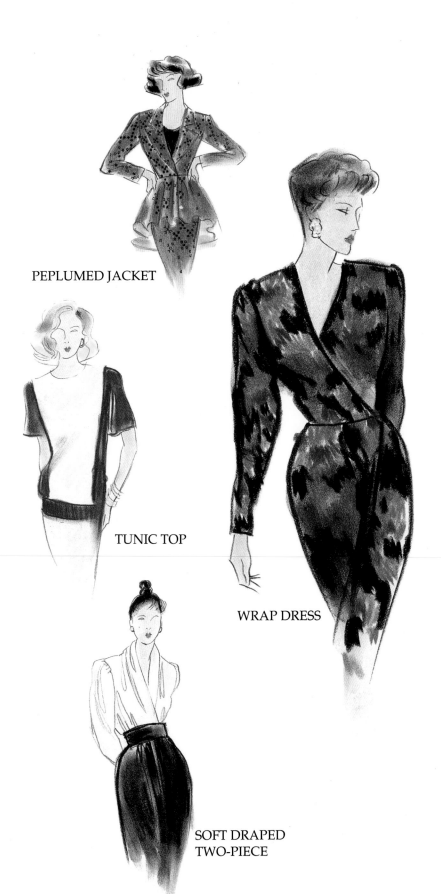

PEPLUMED JACKET

TUNIC TOP

WRAP DRESS

SOFT DRAPED
TWO-PIECE

Body Shape:
- Full upper body
- Small waist
- Wide hipline
- Broad back
- Full thighs

Objective:
- Minimize curves and elongate the figure

Do's:
- Shirtdresses with a full skirt, possibly with gathers, wrap dresses, peplumed dresses
- Skirts with a soft fullness or a flared hemline
- Tapered or straight pant legs, soft pleats, or gathers
- Outfits using soft fabrics that drape over the hips

Don'ts:
- Avoid boxy jackets and bulky sweaters
- Don't wear tight clothes, or anything that emphasizes the bust
- Stay away from empire waistlines, and blouses that tie at the bustline
- Avoid patch pockets, horizontal lines, and patterns at the bustline or hips

TRIANGLE

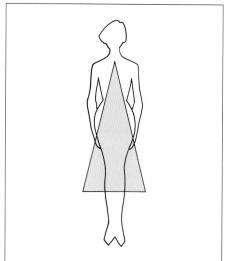

Body Shape:
- Smaller in bust area than hips
- Wider or heavier below the waist
- Narrower in the shoulders than in the hips or thighs

Objective:
- Create fullness and width above the waistline while minimizing the hips and thighs

Do's:
- Styles with upper body decorations such as gathers, epaulets, pleats, and patch pockets
- Wide or scoop necklines
- Straight line jackets with shoulder pads, length should be above or below the widest part of the hips
- Blousoned tops, drop-waisted tops, two-piece dressing

Don'ts:
- Stay away from halter tops, tank tops, raglan sleeves, and other design lines that draw the eye downward
- Don't wear outfits with horizontal seams, gathers, pleats, or patterns at the hipline
- Avoid fitted jackets that stop at the fullest part of the hips
- Don't wear dark-colored tops with lighter-colored bottoms

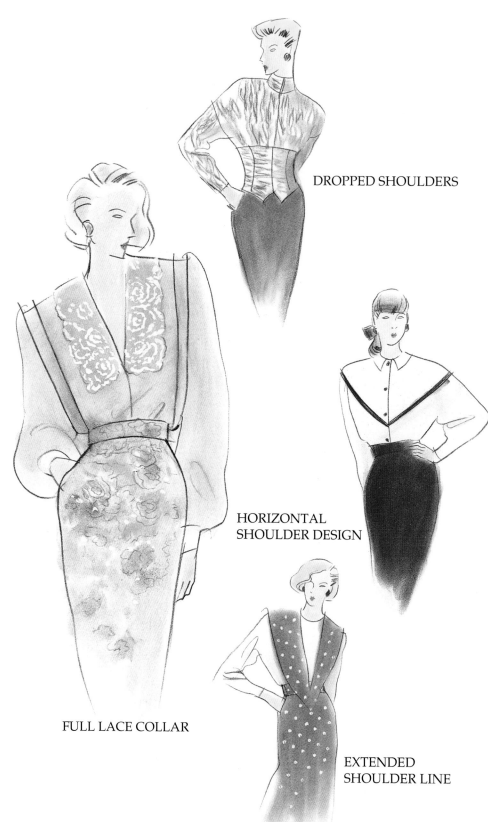

DROPPED SHOULDERS

HORIZONTAL
SHOULDER DESIGN

FULL LACE COLLAR

EXTENDED
SHOULDER LINE

RECTANGLE

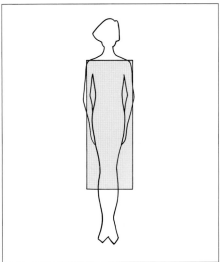

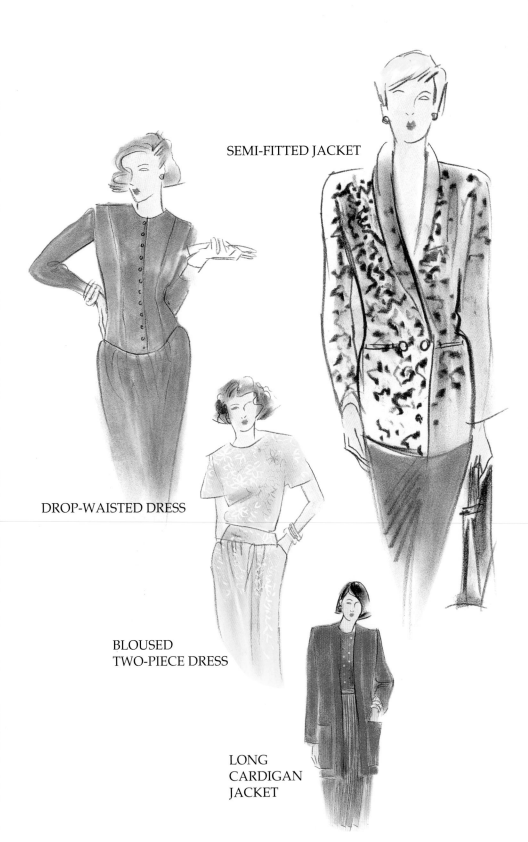

SEMI-FITTED JACKET

DROP-WAISTED DRESS

BLOUSED
TWO-PIECE DRESS

LONG
CARDIGAN
JACKET

Body Shape:
- Angular with few curves
- No defined waistline
- Silhouette is almost straight up and down
- Little difference between waist and hip sizes

Objective:
- Minimize the upper body and create a more slender shape

Do's:
- Sculptured, shaped jackets
- Flared skirts cut on a bias, skirts with pleats
- High or drop-waisted skirts or pants

Don'ts:
- Don't wear belts that are wide or contrasting in color
- Avoid horizontal lines and horizontal patterns
- Stay away from large patch pockets at the hips
- Avoid boxy, wide, or square jackets

THIN

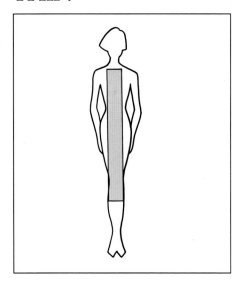

Body Shape:
- Narrow shoulders, waist and hips
- Silhouette is thin and straight, without curves

Objective:
- Create a look with more fullness and shape

Do's:
- Styles with fullness in the tops, sleeves, pants, and skirts
- Lines that add fullness, such as gathers, pleats, ruffles, and patch pockets
- Textured fabrics such as tweed, woolens, velvet, mohair and knits
- Oval and S-shaped patterns in prints

Don'ts:
- Don't wear extremely bulky materials or oversized patterns
- Avoid wearing clinging or tight clothing, and pegged skirts or pants
- Stay away from vertical stripes and vertical designs
- Don't wear sheer fabrics, strapless dresses, or dresses with wide necklines

GATHERED PRINT DRESS

BIAS CUT BLOUSE

TEXTURED SWEATER, PLAID SKIRT

PATTERNED SWEATER, PLEATED SKIRT

OVAL

STRAIGHT CARDIGAN

VERTICALLY
STRIPED COATDRESS

BLOUSED TOP

DROP-WAISTED DRESS

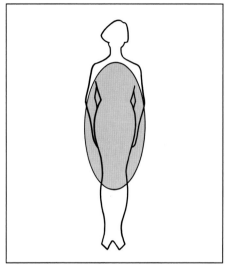

Body Shape:
- Full upper body
- Full at the waist
- Wide hipline
- Prominent tummy

Objective:
- Elongate and slim down the body

Do's:
- Relaxed jackets in hip length or longer
- Waistless styles such as tunics and chemises
- Tops belted out or slightly bloused
- High or drop-waisted skirts or pants

Don'ts:
- Avoid bulky or heavy textured outfits
- Stay away from thick or conspicuous belts
- Avoid tight clothing, or any style that draws attention to the midriff or hip area
- Avoid horizontal lines and horizontal patterns

Figure Solutions

At one time or another, we all have dreamt of having the ideal figure. Through a combination of nutrition, exercise, and body work, we are indeed capable of making dramatic changes and improvements. Unfortunately, we cannot do anything to change the basic structure

LONG NECK	DO'S	DON'TS	HEAVY ARMS	DO'S	DON'TS
	High necklines	Wide necklines		Long sleeves	Tight sleeves

SHORT NECK	DO'S	DON'TS	THIN ARMS	DO'S	DON'TS
	Wide necklines	High necklines		Long sleeves	Sleeveless

NARROW SHOULDERS	DO'S	DON'TS	SMALL BUST	DO'S	DON'TS
	Padded shoulders	Downward lines		Ornate tops	Low or tight tops

BROAD SHOULDERS	DO'S	DON'TS	FULL BUST	DO'S	DON'TS
	Raglan sleeves	Horizontal lines		Simple loose tops	Ornate tops

of our bodies. However, by following some common-sense guidelines, we can dramatically change how our figures appear, without physically changing our bodies. Examine the following figure solutions to see which ones might pertain to you. Using these figure solutions will enable you to maximize your figure assets, and at the same time, minimize any unwanted figure traits.

THICK WAISTED	DO'S	DON'TS
	Loose waist	Wide belts

LONG WAISTED	DO'S	DON'TS
	Wide belts	Drop-waisted style

SHORT WAISTED	DO'S	DON'TS
	Drop-waisted style	Wide belts

PROMINENT TUMMY	DO'S	DON'TS
	Soft draped skirts	Clinging waistlines

PROMINENT BUTTOCKS	DO'S	DON'TS
	Long jackets	Clinging hiplines

WIDE HIPS	DO'S	DON'TS
	Soft draped skirts	Horizontal lines

THIN LEGS	DO'S	DON'TS
	Mid hemlines	Full hemlines

THICK LEGS	DO'S	DON'TS
	Longer hemlines	Shorter hemlines

Design Line Effects

Every outfit has two types of design lines, outside and inside lines. These lines are significant to the look of an outfit because the eye tends to follow them, creating illusions as to the shape of the outfit. Both outside and inside lines can make you appear taller, shorter, slimmer, or heavier, or draw attention to an area of your body.

Outside Lines

The outside lines follow the edge of your outfit, and form a silhouette of your body.

Inside Lines

The inside lines run down and across the front of the body, and follow decoration lines, seams, trim, buttons, prints, or pleats.

Examples of Outside Lines

A triangle line minimizes the top and enlarges the bottom

An inverted triangle line enlarges the top and minimizes the bottom

A rectangular line creates an angular, straight look

An hourglass line creates curves and puts emphasis on the waistline

Examples of Inside Lines

Vertical lines add height

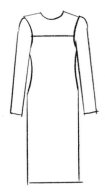

Horizontal lines add width

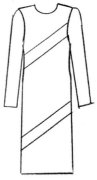

Diagonal lines can shorten or lengthen (depending on placement)

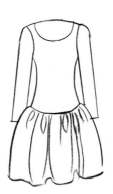

Curved lines add roundness and fullness

Changing Proportions with Design Lines

Dividing your body into unequal proportions, such as one-third to two-thirds, is more pleasing to the eye than dividing it in half. The illusion of proportions can be created by horizontal lines representing designs, hemlines, or differences in color and contrast.

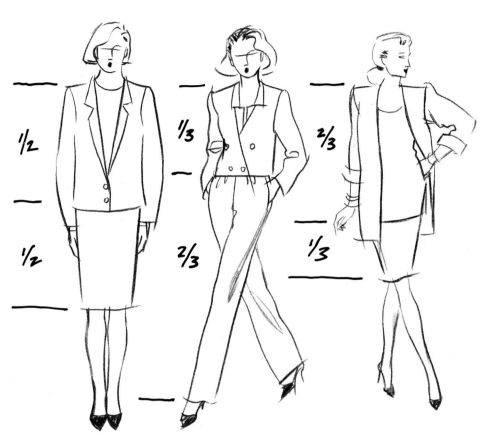

Jacket and skirt of equal proportions cut the body in half

Short jacket and longer pants proportions catch the eye

Longer jacket and shorter skirt proportions create a pleasing look

A drop-waisted style elongates the waist

Empire waist lengthens the waistline

A vertical line lengthens the torso

Short jacket with pants lengthens the legs

CHAPTER 8 YOUR PERSONAL STYLE

Although we all have a personal style with which we feel comfortable, it is not all that easy to identify what that personal style is. Our personal styles are constantly evolving as we go through the different phases of our lives. However, my experience as a wardrobe consultant and personal shopper has taught me that every woman has a dominant style with which she can best identify. This chapter will help you identify your dominant style, and also teach you how to pull your wardrobe together to fit that style. At the same time, you will learn what it takes to enhance and refine your own sense of personal style.

The first step in this process is to identify what your dominant style is.

EXERCISE 4

Which is my dominant style?

My style system identifies six distinct styles: Classic, Dramatic, Romantic, Natural, Artistic, and Feminine. The following questions are designed to help you identify which of these six styles best expresses your own personal style.

1. Which of the following blouses do you prefer?

A.

B.

C.

D.

E.

F.

2. Which description best fits you?

A. Aristocratic and traditional

B. Striking and contemporary

C. Sexy and enchanting

D. Sporty and casual

E. Creative and free-spirited

F. Demure and ladylike

3. Which of the following headwear do you prefer?

A.

B.

C.

D.

E.

F.

4. Which of the following shoes do you prefer?

A.

C.

E.

B.

D.

F.

5. Which of the following descriptions of styles best fits you?

A. Conservative, refined, symmetrical, practical

B. Sophisticated, sleek, minimal lines, angular, exaggerated, high-contrast

C. Body hugging, plunging necklines, ornate, flouncy

D. Casual chic, unconstructed, loosely-tailored, easy, comfortable

E. Daring designs, one-of-a-kind, avante garde, unusual combinations

F. Soft textures, pastels, ruffles, bows, dainty, ladylike

Answers: If most of your answers are A's your dominant style is Classic, if B's – Dramatic, if C's – Romantic, if D's – Natural, if E's – Artistic, if F's – Feminine. Now refer to the page on which your dominant style is featured.

If two or more styles tied with the most answers, your personal style would be a combination of those styles. In this event, refer to the pages on which each of those styles is featured.

CLASSIC

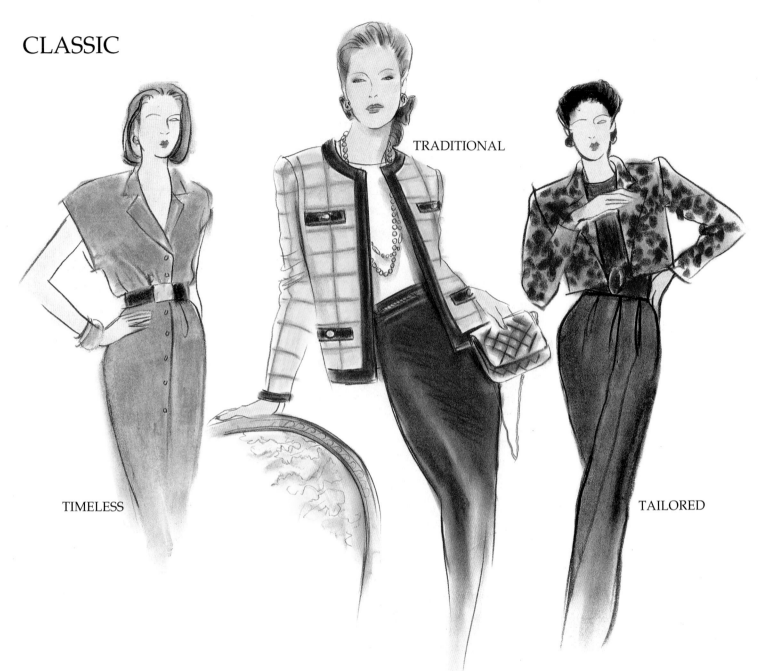

TRADITIONAL

TIMELESS

TAILORED

The Classic Woman's look is traditional, conservative, tailored, and aristocratic. She has an air of elegance and refinement, and always appears poised and organized.

Styles: Softly tailored shirtdresses or sheaths, well-tailored suits, notched lapels, refined detailing, understated quality.

Fabrics: Moderate weight, high quality, linen, gabardine, flannel, cashmere, tweeds, twills, herringbone, camel's hair, refined, natural.

Prints: Traditional and small symmetrical patterns, polka dots, geometrics, tartan, houndstooth, plaid.

Makeup/Hair Style: Soft natural makeup shades, balanced eyes and lips, hair is softly styled and in place.

Accessories: Clean, simple, elegant; pearls, gold chains, tapered pumps, sheer hose, and designer belts, bags, and scarves.

Don'ts: Avoid looking too controlled, serious, or matronly.

Celebrities: Margaret Thatcher, Catherine Deneuve, Princess Grace Kelly.

DRAMATIC

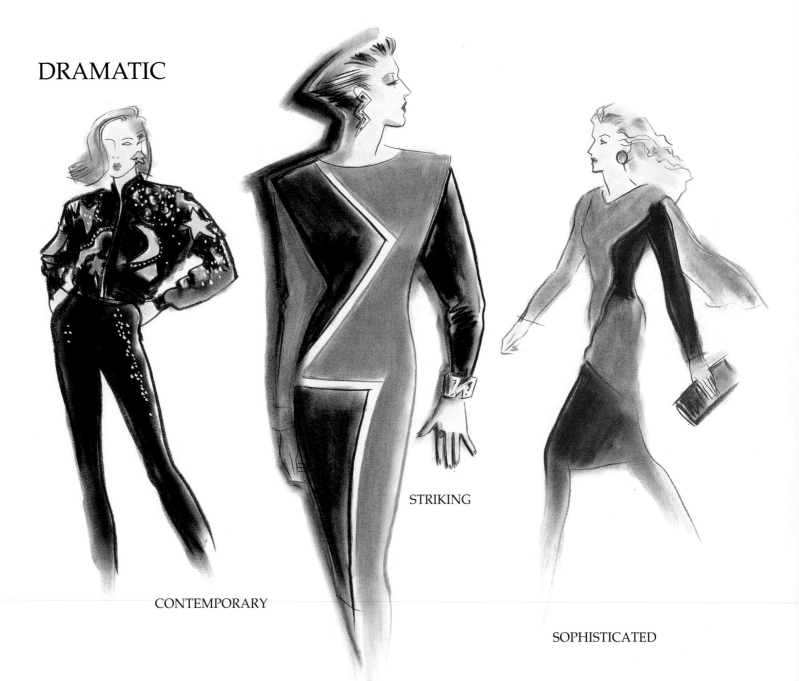

CONTEMPORARY

STRIKING

SOPHISTICATED

The Dramatic Woman is the entrance maker who turns heads wherever she goes. She is sophisticated, chic, assertive, confident, contemporary, striking and intimidating.

Styles: Straight, angular, stark, simple necklines, asymmetric cuts, tailored, sculptured, stylized, large shoulder pads.

Fabrics: Shiny, glittery, tightly woven textures, silk jacquard, raw silk, wool jersey, lame, silk faille, leather, stiff brocades, heavy satins, patterned velveteens, velours, hand-painted.

Prints: Bold, dramatic, strong geometrics, zigzags, irregular shapes, black mixed with metallic.

Makeup/Hair Style: Dramatic makeup that accentuates cheekbones, intense lipstick, sharp eyeliner; hair is sculptured off the face, very controlled.

Accessories: Striking, bold, and unusual pumps, bold metallic jewelry, angular designs, shiny stones and metals, large, hand-painted or dyed scarves.

Don'ts: Avoid looking too hard or intimidating.

Celebrities: Cher, Paloma Picasso, Grace Jones.

ROMANTIC

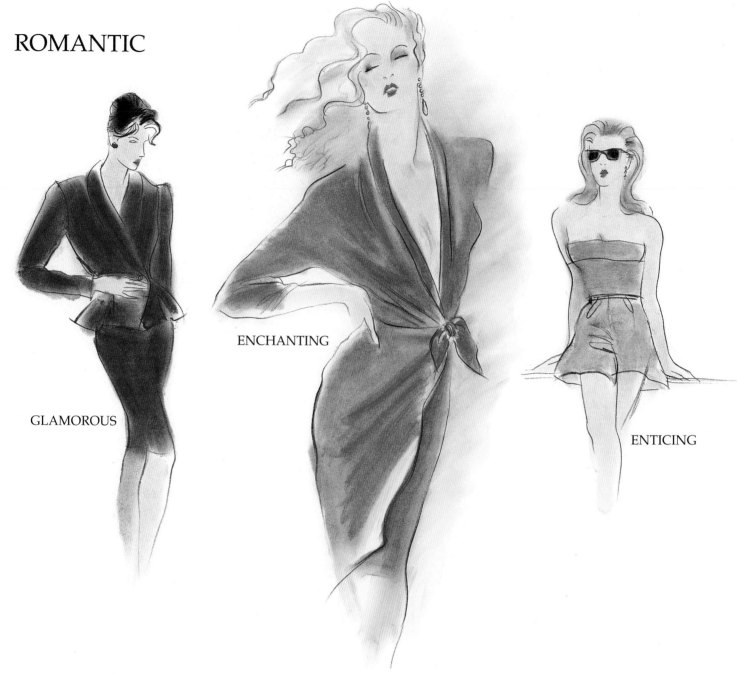

GLAMOROUS

ENCHANTING

ENTICING

The Romantic Woman is enchanting, glamorous, and sexy, and men respond to her instantly. She is proud of her body and wears clothes that reflect that attitude.

Styles: The characteristics of her style are revealing lines, soft drapes, peplum, plunging or sweetheart necklines, rounded shoulders, defined waistline.

Fabrics: Lightweight, fluid and soft, jersey, crepe de chine, velvet, silk, angora, chiffon, clinging knits, soft suedes.

Prints: Swirly, floral.

Makeup/Hair Style: Darker eye makeup and full, shiny lips. Her hair can be full, unrestricted, layered, or tousled. She looks great with her hair up.

Accessories: Open toe or slings with high heels. Jewelry is big and bold, dangling or loop earrings, sparkling stones.

Don'ts: Stay away from stiff or heavy textures, excessive makeup, chunky jewelry, straight, tailored, or structured lines.

Celebrities: Dolly Parton, Elizabeth Taylor, Marilyn Monroe.

NATURAL

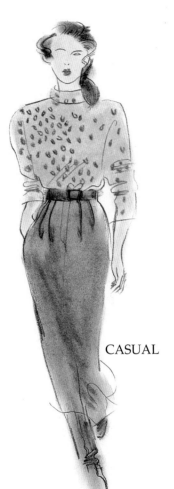

CASUAL

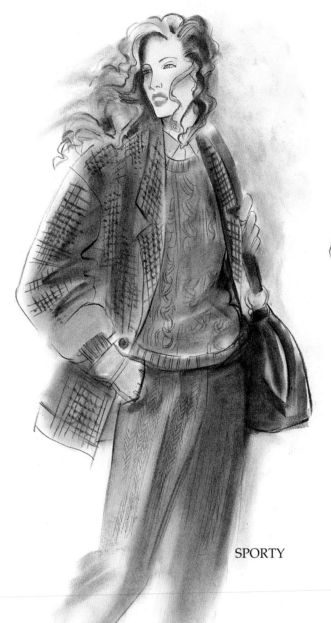

SPORTY

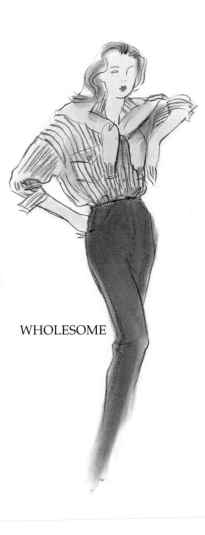

WHOLESOME

The Natural Woman is casual, sporty, informal, and wholesome. She is warm and friendly, energetic and direct.

Styles: Comfortable, dressed down, loosely tailored, T-shirts, long cardigans, safari, unconstructed, minimal padding, simple straight skirts, long dirndls, sweats, jeans, cotton jumpsuits, oxford cloth shirts.

Fabrics: Natural, woven, textured, soft knits, linen, suede, leather, raw silk, cashmere, angora, camel's hair, wool flannel, tweed.

Prints: Animal prints, batiks, paisley and plaids.

Makeup/Hair Style: Minimal, soft eye makeup and lipstick, or no makeup; loose, carefree hair.

Accessories: Small scale jewelry, simple low heels, loafers, argyle socks, leather or fabric sashes, ethnic jewelry, paisley scarves.

Don'ts: Avoid looking unkempt or tomboyish.

Celebrities: Chris Evert, Jane Fonda, Shirley MacLaine.

ARTISTIC

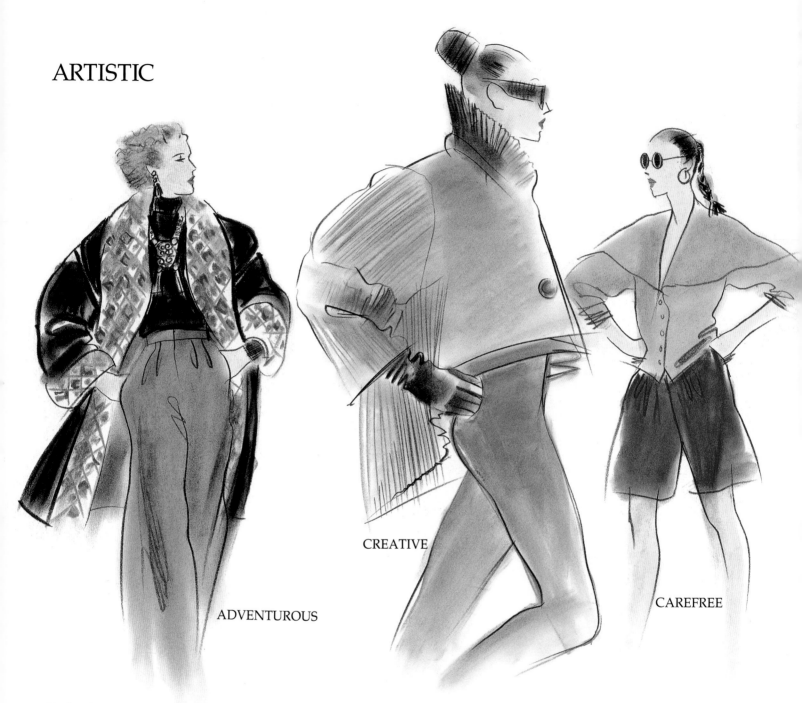

CREATIVE

ADVENTUROUS

CAREFREE

To the Artistic woman, fashion is art. She loves making an artistic statement with innovative, creative, and avant-garde clothes and accessories.

Styles: Free-spirited, unconstructed, oversized, exotic, antique, architectural, asymmetrical, ethnic.

Fabrics: Handwoven, novelty tweeds, natural, tapestry, sculptured velveteens.

Prints: Pattern mixing, Japanese prints, hand-dyed colors, hand-painted designs, exotic patterns, ethnic, abstract, animal skin.

Makeup/Hair Style: Intense eye makeup, deep-color or no lipstick, matte makeup texture. Hair is asymmetric or straight-cut, pulled back or loose.

Accessories: One-of-a-kind, textured or unpolished metals, free-form designs, art-to-wear, sculptured, ethnic jewelry.

Don'ts: An extreme artistic look can out-of-place for business or other traditional settings.

Celebrities: Barbra Streisand, Cyndi Lauper.

FEMININE

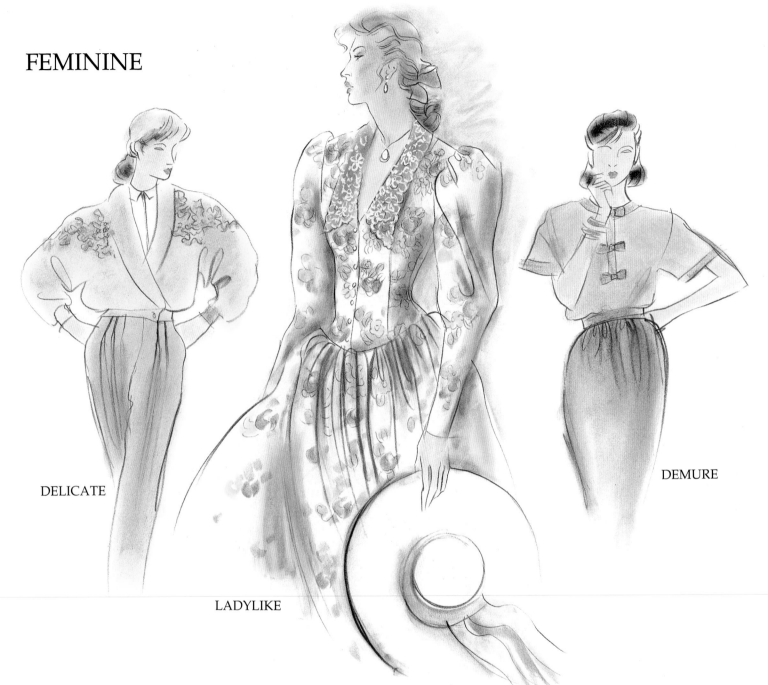

DELICATE

LADYLIKE

DEMURE

The Feminine Woman is soft, dainty, and ladylike. She is the girl-next-door, with a soft and demure look.

Styles: Victorian floral dresses, frilly, lots of detail such as lace, applique, bows, and trim. Soft flowing skirts, tops with high necklines, puff sleeves, softly tailored jackets.

Fabrics: Soft, delicate, lightweight, lace eyelets, velvet, wool crepe, chiffon, soft cotton, chambray, angora, silk, challis.

Prints: Small patterns, floral and garden motifs. Laura Ashley and Liberty of London generally feature prints of this type.

Makeup/Hair Style: Light, sheer, natural-looking makeup. Hair is soft, wavy, long, soft bob, or piled up with light curls on the side.

Accessories: Delicate, intricately designed jewelry such as cameos, teardrop pearl earrings, floral pins, heart-shaped lockets, antique jewelry.

Don'ts: Avoid looking too soft for business, heavy makeup, chunky jewelry, sculptured hair styles.

Celebrities: Mia Farrow, Olivia Newton-John.

CHAPTER 9 MAKEUP STRATEGIES

As amply demonstrated in those startling before and after makeup pictures that we often see, makeup can make a world of difference. Indeed, makeup applicators and brushes in the hands of a skilled makeup artist can truly create magic. This chapter is designed to give you an introduction to makeup color selection and technique. However, I always recommend that my clients have a session with a professional makeup artist, who will be able to provide the personal instruction on all aspects of makeup application that is beyond the scope of any book.

MAKEUP COLOR SELECTION

Once you learn what your wardrobe colors are, you will also automatically know what most of your makeup colors are. Like your wardrobe colors, your makeup colors are either cool or warm. If your skintone is cool, you should use cool makeup colors. If your skintone is warm, you should use warm makeup colors.

Cool makeup colors are red with blue added (red blue, magenta, and pink). Warm makeup colors are red with yellow added (red orange, yellow orange, coral, and peach).

Cool foundations and powders have a pink undertone and range from pale ivory or bisque, to dark olive. Warm foundations and powders have a yellow undertone, and range from light peach to deep brown.

Makeup Color Guide

Makeup color selection, if done correctly, offers us very dramatic and satisfying means of self-expression. We can vary the hue, value, and intensity of our makeup colors to create a desired impact or mood. Each of us has range of flattering makeup colors from which to choose.

We look our best in makeup colors that flatter our natural coloring, just like our wardrobe. A list of makeup color suggestions was included in the discussion of each of the categories. For additional suggestions, refer to the range of reds in your palette.

This chart is limited to my favorite combinations of lipstick and blush for each category. It can be used as a ready reference guide in selecting your basic makeup colors. You can also identify which colors you should avoid, by studying my suggestions for dissimilar groups.

CAUCASIAN

COLOR GROUP							
LC WINTER	**HC WINTER**	**LC SUMMER**	**HC SUMMER**	**LC SPRING**	**HC SPRING**	**LC AUTUMN**	**HC AUTUMN**
LIPSTICK RED ORANGE	BLUE RED	ROSE PINK	DEEP ROSE	CORAL PINK	ORANGE RED	MARIGOLD	RUST
BLUSH LIGHT CORAL	CLEAR PINK	SHEER PINK	GINGER ROSE	WARM PINK	CLEAR PEACH	APRICOT	TAWNY PEACH

ASIAN

COLOR GROUP								
STARLIGHT	**MIDNIGHT**	**MOONLIGHT**	**FROST**	**HORIZON**	**SUNRISE**	**SUNLIGHT**	**SUNSET**	**TWILIGHT**
LIPSTICK MAGENTA	RED VELVET	RED ROSE	AZALEA PINK	MELON PINK	ORANGINA	POPPY RED	PUMPKIN RED	TERRA-COTTA
BLUSH PINK	SILK ROSE	TEA ROSE	SNOW PINK	SOFT MELON	SOFT PEACH	PEACH PINK	NECTAR	SOFT SALMON

BLACK

COLOR GROUP			
MAHOGANY	**EBONY**	**GOLDEN**	**COPPER**
LIPSTICK COCOA ROSE	WILD BERRY	BRICK RED	FLAME RED
BLUSH MAGENTA ROSE	PLUM	AMBER	MANGO

HISPANIC

COLOR GROUP			
ROSE	**ONYX**	**BRONZE**	**TOPAZ**
LIPSTICK MAGENTA RED	RUBY RED	SPICE RED	CINNAMON
BLUSH FUCHSIA PINK	ROSE RED	RIPE APRICOT	GOLDEN PEACH

WARM
Yellow, peach, brown, green

WARM
Rust, olive, yellow

WARM
Pink, turquoise, copper

COOL AND WARM
Purple, turquoise, gold

Color Your Eyes

Eye shadows can enhance and brighten up your eyes. In order to give you ideas for the selection and placement of highlighter, contour, and fashion eye shadow colors, featured on this page are ten eye shadow placement suggestions. Use these suggestions to help you find your own favorite color combinations. Generally, cool combinations are for cool skintones, warm combinations are for warm skintones, and cool and warm combinations can be used for both.

WARM
Black, brown, gold

COOL
Pink, lavender

COOL AND WARM
Yellow gold, rose, charcoal

COOL
Eggplant, plum, rose, gold

COOL
Purple, pink, yellow

COOL
Purple, emerald green

127

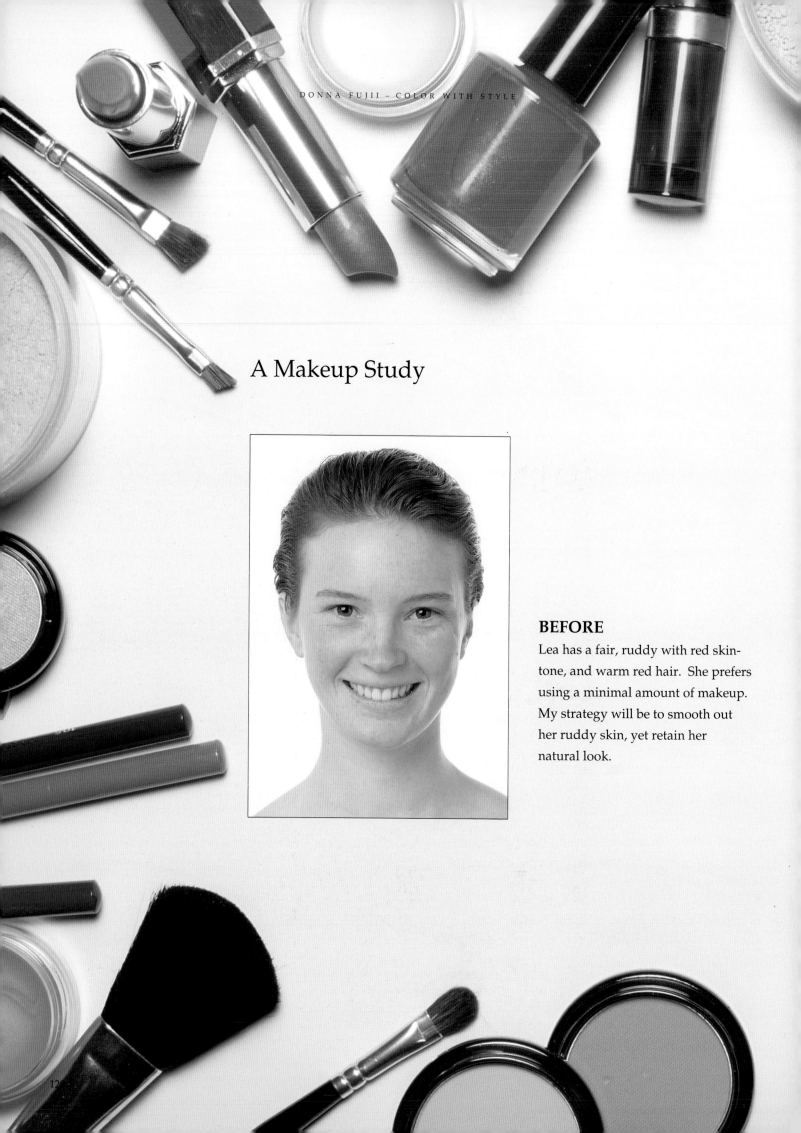

A Makeup Study

BEFORE

Lea has a fair, ruddy with red skin-tone, and warm red hair. She prefers using a minimal amount of makeup. My strategy will be to smooth out her ruddy skin, yet retain her natural look.

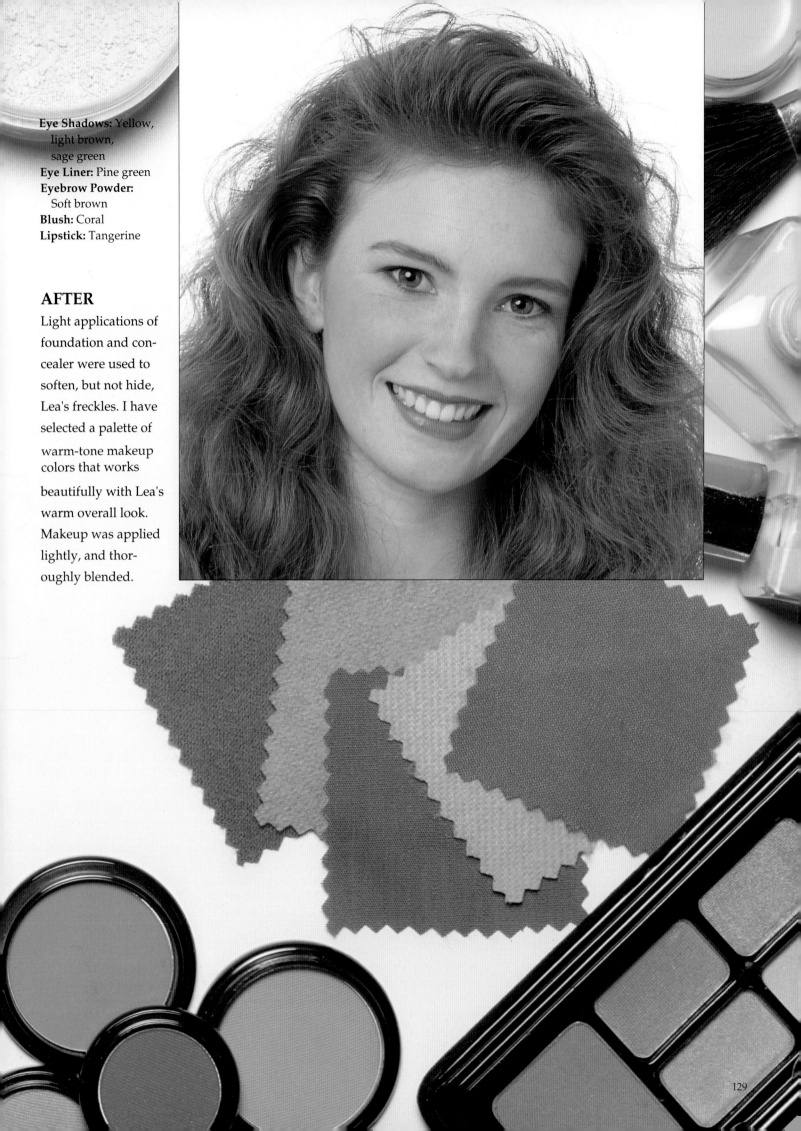

Eye Shadows: Yellow, light brown, sage green
Eye Liner: Pine green
Eyebrow Powder: Soft brown
Blush: Coral
Lipstick: Tangerine

AFTER

Light applications of foundation and concealer were used to soften, but not hide, Lea's freckles. I have selected a palette of warm-tone makeup colors that works beautifully with Lea's warm overall look. Makeup was applied lightly, and thoroughly blended.

129

CHAPTER 10
THE FINISHING TOUCHES

Now that you are able to create a great look for any occasion, you are ready to put on the finishing touches. These are the subtle, yet highly important things that superb dressers do to create a sense of personal flair or style. Make sure that your total look not only is flawless, but also has that special quality that separates you from the other good dressers. You can accomplish this by pulling together all of the elements that have been discussed in this book, in a complete, stylish, and balanced way. This will give you the confidence of knowing that you are looking truly sensational every single day!

Also covered in this wrap-up chapter are useful techniques for enhancing your face shape, and valuable tips on accessorizing, and changing your hair color.

THE "TOTAL LOOK" FORMULA

When a woman achieves the total look, this does not happen by accident, but by careful planning, attention to every visible item of clothing, and conscientious grooming. Only then can a person be sure that her total look, from head to toe, is well-balanced and in harmony. Like a flower arrangement, every visible detail must contribute to the whole, otherwise, the desired effect is lost. There are eight different ingredients to the total look formula, all of which must be present. Review this formula from time to time so that you will be sure that, in putting your look all together, you have left nothing to chance.

1. COLOR
After reading this book, you should have a good background in color theory, selection, and coordination. However, wearing the right colors is only the beginning.

2. STYLE
This is a reference to overall style, not just the style of your clothes. Cultivate your own personal style and let your wardrobe reflect it in a way that makes you feel comfortable.

3. SILHOUETTE
Your silhouette is the outline created by your clothes, and will determine how your figure is perceived. Make sure that you select the fashions that will best enhance your silhouette and your figure.

4. FABRIC/TEXTURE
Fabric can make a garment look cheap or luxurious. When combining separates with different fabrics, make sure that the fabrics complement each other. The texture of your hair, your complexion, and your facial bone structure, will affect how much texture is best for you.

5. PRINTS AND PATTERNS
Keep the size of prints or patterns in proportion with your figure. The dominant colors in any print or pattern should be in your palette.

6. ACCESSORIES
Accessories can add the finishing touch to your outfit, or spoil it altogether. Make sure that the colors and shapes of your accessories fit in with your outfit, and the look you are trying to achieve. It pays to invest in quality accessories.

7. THEME
Try to achieve a unified theme in which the style line, mood, and season of each piece of apparel, fit and work together. For example, cuffed wool trousers do not work with open-toe, slingback high heels.

8. HAIR AND MAKEUP
Your hair style should support or be consistent with the theme of your outfit. For example, a Margaret Thatcher hairdo will support a classic outfit, but not a free-form Issey Miyake outfit. Also, select makeup colors that not only enhance your own natural coloring, but also support the theme of your outfit.

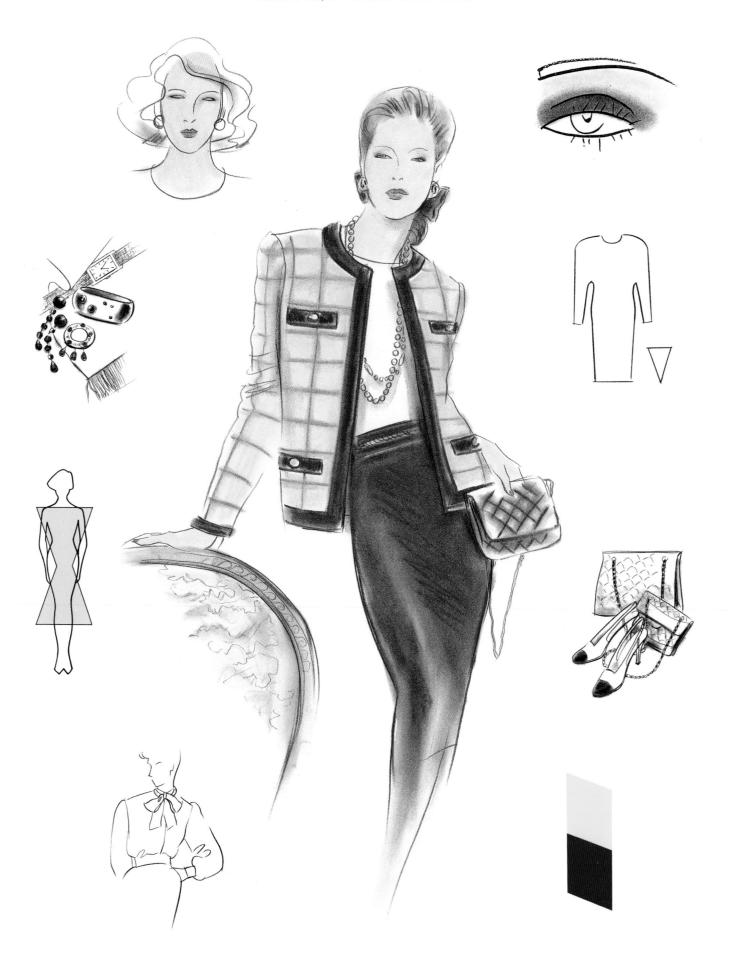

Finishing The Total Look

Curves, Angles, and Textures

Instinctively, our eyes are attracted to the repetition of curves, angles, and textures. This repetition is evident in paintings, sculpture, flower arrangements, and other works of art. This is because we seek to visually experience the balance and harmony which comes from this repetition. By the same token, our eyes are not drawn toward visual experiences lacking balance and harmony. You should be aware of the need for consistency in using curves, angles, and textures, so that you can achieve a look that is both pleasing to the eye, and fashionable at the same time.

Textures

Smooth-textured fabrics blend nicely with straight hair and a clear complexion.

Heavy-textured fabrics work well with tightly-curled, or frizzy hair, and a ruddy complexion.

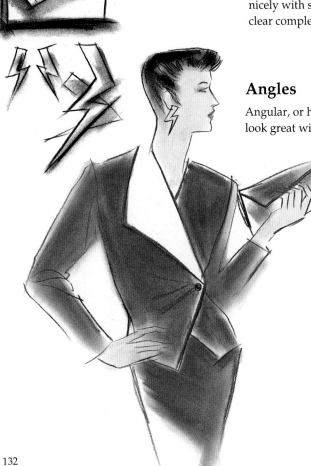

Angles

Angular, or hard-edged accessories look great with angular style lines.

Curves

Round, or soft-edged accessories go best with rounded style lines.

Color Your Hair?

I have placed a question mark after the above heading, because your first consideration should be whether you really want to change your hair color at all. After all, the hair color that nature has given you will almost always nicely complement your skintone. If you dye your hair a color that does not go with your natural coloring, the fact that it was colored will be obvious. If you are considering a hair color change, and you want it to appear natural, read the following guidelines, and then follow the applicable suggestions on the adjoining Hair Coloring Chart.

- Your hair color should be in harmony with your skintone. If your skintone is warm, you can add warm golden highlights or red tones. If your skintone is cool, you can add cool ash brown, dark brown, or black shades.
- If your eyebrows are dark, they will tip off the fact that your natural hair color is dark. For this reason, avoid going more than a few shades lighter than your eyebrows.
- In order to make sure that your new hair color will complement your skintone, first consult with your hair stylist.

HAIR COLORING CHART

SKINTONE	BLONDE	LIGHT TO MEDIUM BROWN	DARK BROWN TO BLACK	RED/AUBURN
COOL-LIGHT	HIGHLIGHT 1 TO 3 SHADES LIGHTER	HIGHLIGHT 1 OR 2 SHADES LIGHTER OR DARKER IN ASH TONES	HIGHLIGHT 1 SHADE LIGHTER, OR GO 1 OR 2 SHADES DARKER IN ASH TONES	BRIGHTEN BY GOING MORE RED OR AUBURN
COOL-DARK	WEAVE IN HIGHLIGHTS 1 TO 3 SHADES LIGHTER FOR A NATURAL LOOK	WEAVE IN HIGHLIGHTS 1 SHADE LIGHTER, OR GO 1 OR 2 SHADES DARKER	GO 1 OR 2 SHADES DARKER, ACCENT WITH BURGUNDY HIGHLIGHTS	MIX IN SOME DEEP, RICH, RED BROWN TONES
WARM-LIGHT	HIGHLIGHT 1 TO 3 SHADES LIGHTER WITH GOLDEN TONES	HIGHLIGHT 1 OR 2 SHADES LIGHTER WITH GOLDEN TONES, OR GO 1 OR 2 SHADES DARKER	WEAVE IN RED HIGHLIGHTS, OR GO 1 SHADE DARKER	HIGHLIGHT IN GOLDEN OR RED TONES, OR GO 1 SHADE DARKER
WARM-DARK	HIGHLIGHT CLOSE TO YOUR NATURAL COLOR	WEAVE IN GOLD OR RED TONE HIGHLIGHTS	GO 1 OR 2 SHADES DARKER OR ACCENT WITH BURGUNDY HIGHLIGHTS	GO WITH A DEEPER RED OR AUBURN WITH SPICE TONES

- If you have very fair, translucent skin, with no apparent pink or yellow undertone, you will have more flexibility selecting a new hair color. For example, fair-skinned actress Meryl Streep can look natural as a blonde, redhead, or brunette.

133

Faces With Style

Your face is by far your most important feature because it is truly distinctive and unique. Others will notice your face before anything else, and also remember you by it. Regardless of the shape of your face, your face is perfect for you. By selecting the best hairstyle, the proper makeup placement and the appropriate accessory shapes, you can achieve the face style that will help you to achieve the balance and grace that comes with true beauty.

First, determine your face shape by pulling your hair back, looking in a mirror and comparing your face shape with those illustrated on these pages. If you are not sure of your face shape, ask a friend to help.

ROUND

Description: Cheekbones are wider than the browbone and jawline. Outline is curved in a circular shape.
Objective: Elongate the face.
Best Lines: Curves.
Hairstyles: Build hair up on top of the head, any length will work. Avoid very short styles, or a center part.
Earrings: Curved lines that are longer than they are wide, shapes which will give a lift to the face.

TRIANGLE

Descripton: Jawline significantly wider than the browbone and cheekbones.
Objective: Minimize jawline. Balance the face by adding width to brow and cheek area.
Best Lines: Vertical angles.
Hairstyles: Keep hairline away from jawline. Short or neck length is fine. Fullness is important.
Earrings: Earring length should not hit the jawline. Choose angular shapes that sweep upward.

OBLONG

Description: Browbone, cheekbones, and jawline are almost the same width. The length of the face is noticeably longer than the width.
Objective: Soften and shorten the face.
Best Lines: Wide elongated curves.
Hairstyles: Bangs and mid-length work well with some fullness at the sides. Avoid long, straight hair, height on top, exposed hairline, or hair pulled back.
Earrings: Wide, curved shapes will create width through the middle of your face.

DIAMOND

Description: Cheekbones wider than the browbone and jawline. The jawline is angular and pointed.

Objective: Balance the difference between the width and length of the face.

Best Lines: Elongated oval curved lines.

Hairstyle: Add fullness at the top of the head and below the ear, to balance the cheekbones. Bangs will add fullness to the forehead. Avoid exposing the hairline and ears.

Earrings: Oval or curved triangle shapes worn close to the face.

OVAL

Description: Considered the ideal face shape. The face length is noticeably longer than the width. It is not too wide or too long.

Objective: Repeat the natural balance of the face.

Best Lines: Curved or angles, as long as the scale of the shape is in proportion with you.

Hairstyle: Can wear most hairstyles. Symmetrical lines work well with your balanced features.

Earrings: Most shapes will work well. Avoid extremely long shapes that can elongate your face.

HEART

Description: The forehead and cheekbones are wider than the jawline, creating a prominent V-shaped chin.

Objective: Balance the lower portion of the face to the upper portion.

Best Lines: Curves and swirly lines.

Hairstyle: Bangs to camouflage a wide forehead. Avoid a top-heavy look and extremely short hair styles. Chin to shoulder length.

Earrings: Dangling oval shapes that are more broad at the bottom, to add width near the chin line.

Description: The browbone, cheekbone, and jawline are approximately the same width. The length of the face is short in proportion to the width.

Objective: Lengthen the face.

Best Lines: Angular lines that are not too long, asymmetric lines.

Hairstyle: Add height to the crown, use layered or asymmetrical cuts. Swirly and light waves at the temples and jawline will soften bone structure.

Earrings: Medium size, angular with soft corners, no squares.

SQUARE

Accessory Strategies

Accessories are my favorite wardrobe components, because they allow me to add my personal touch to any outfit, and enable me to achieve many different looks with the same outfit. Learning how to use accessories effectively will give you wardrobe options you never thought possible!

- Once you know your best colors, you can enhance your appearance and complete your look with accessories.
- Jewelry can be the focus of an outfit, or a distraction. If you own a significant piece of jewelry, put together an outfit with that piece in mind.
- Scarves are wonderful for expanding your wardrobe, drawing attention away from any figure flaw, and drawing the eye to your best features.
- Shoes, belts, and handbags and can upgrade or downgrade your entire outfit, so invest in quality.
- If you blend your hosiery color with your hemline, this will create a longer and a slimmer line.
- Never wear hosiery darker than your shoes, or black hosiery with a white skirt.

- Make sure that the color of your shoes is coordinated with the color of your outfit at your hemline.
- Your handbag does not have to match your shoes, but should be coordinated with it, in terms of color and value.
- Avoid mixing the themes of your handbag and outfit, such as the extreme example of carrying a sporty canvas shoulder bag, while wearing an elegant silk dress.
- Avoid mixing seasons, such as wearing a summer bright plastic necklace with a winter woolen dress.

To begin
Start with a one-color dress, or a two-piece of simple design. This will allow the flexibility of adding different accessory pieces to create different looks.

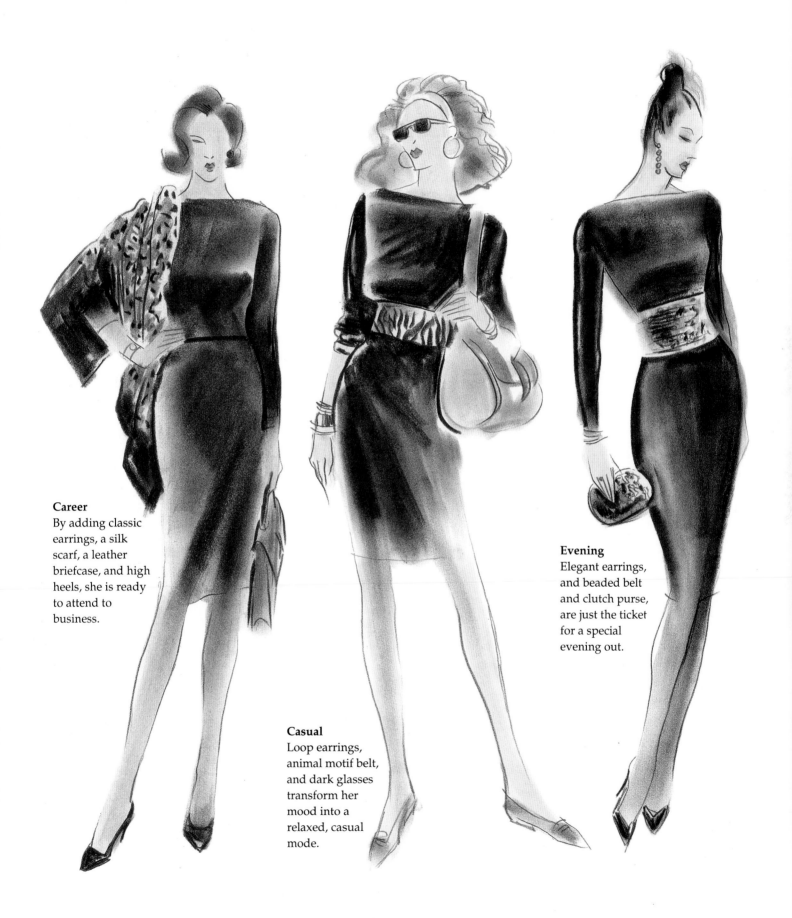

Career
By adding classic earrings, a silk scarf, a leather briefcase, and high heels, she is ready to attend to business.

Casual
Loop earrings, animal motif belt, and dark glasses transform her mood into a relaxed, casual mode.

Evening
Elegant earrings, and beaded belt and clutch purse, are just the ticket for a special evening out.

Accessory Statements

I find it useful to organize my accessories on a chart, so that I can keep track of what I have for career, casual, and evening wear. After studying my chart, make up one for yourself, and see if you can fill each box with your own accessory statements. You can then use your own chart as a shopping guide for future accessory purchases.

	JEWELRY	SCARVES
CAREER	Simple and Bold	Liven Up Neutrals
CASUAL	Fun and Humorous	Highlight Your Face
EVENING	Striking and Glamorous	Elegant

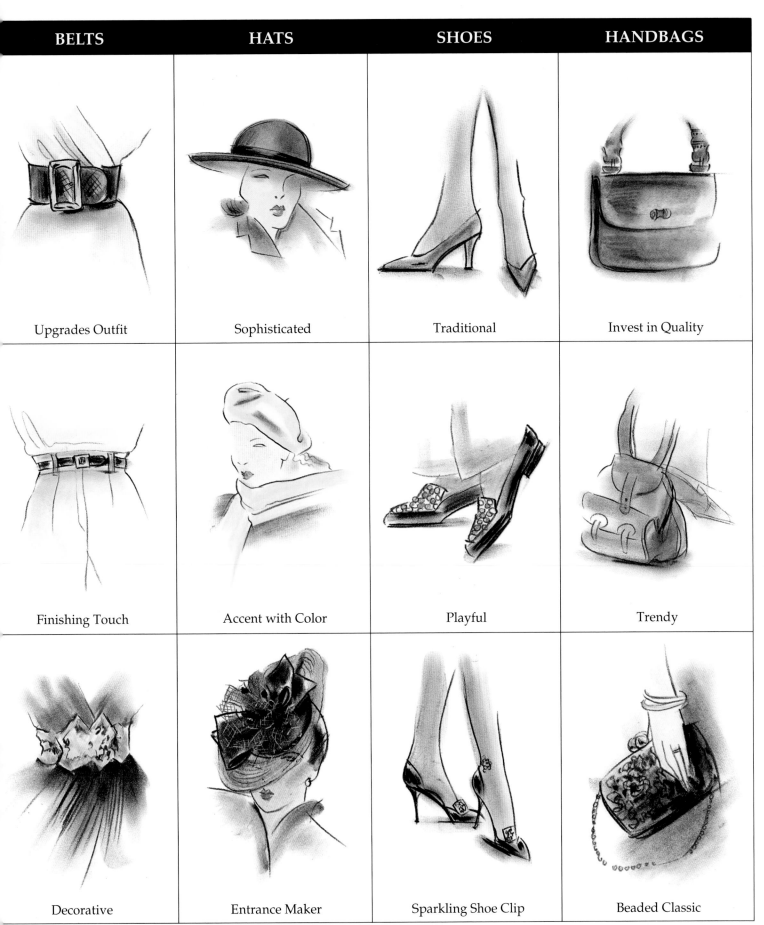

BELTS	HATS	SHOES	HANDBAGS
Upgrades Outfit	Sophisticated	Traditional	Invest in Quality
Finishing Touch	Accent with Color	Playful	Trendy
Decorative	Entrance Maker	Sparkling Shoe Clip	Beaded Classic

Conclusion

After you finish reading this book, my suggestion is that you continue to use it as a reference guide whenever you are about to shop for apparel, or make any decisions affecting your wardrobe. This will allow you to get the most out of the information which I have included in this book. You will then be well on the road toward looking your very best every single day. You can also benefit greatly from the services of a professional Color and Image Consultant, who can verify which colors are best for you, and provide you valuable assistance in all aspects of your wardrobe and shopping needs.

In using your new knowledge of color and style, you have every reason to feel good about yourself for the self-improvement you will be achieving. Allow yourself what you are due, to feel a sense of self-gratification and enjoyment in working toward this noble objective. If you do this, my purpose in writing this book will have been fulfilled. All the best to you and your new image!

Color With Style
Order Form

The following services and products are available through the Donna Fujii Color Institute:

- Personal color fans, which are hand-made of selected fabrics, and color-keyed makeup kits.
- Fashion workshops and shopping tours in San Francisco.
- Individual color analysis and image consultations.
- Professional training to be a Color and Image Consultant, including all color tools and supplies.
- NEWSLETTER, "Color With Style News" containing all the latest on color trends, fashion, beauty, and more.
- Free list of Color and Image Consultants trained by Donna Fujii and practicing in your area.

1. *COLOR FAN* (a) in your category, with free color and shopping guide, plus color-keyed *MAKEUP KIT* (b), with free makeup guide.....................$49.95

2. *COLOR FAN* (a) plus free guide ..$34.95

3. *MAKEUP KIT* (b) plus free guide ...$21.95

4. *COLOR FANS AND DRAPES* (c) for professional consultations Send in order form for further information.

5. *NEWSLETTER* – 2 issues per year (Spring and Fall)......................$8.00 per year

California residents add 7% sales tax. For postage and handling, per order form, add $3 in the United States, and $6 for international orders (Newsletter excepted).

For further information, or to place orders, send the order form to:

DONNA FUJII, INC.
P.O. Box 471175, San Francisco, CA 94123 USA
Telephone, (415) 922-9000, or Fax (415) 474-4999.

O R D E R F O R M

Name _____

Address _____

City _____ State_____ Zip_____ Country_____

Color Category _____

☐ Rush my COLOR FAN, MAKEUP KIT, and free guides. .. $ _____

☐ Rush my COLOR FAN and free guide only. .. $ _____

☐ Rush my MAKEUP KIT and free guide only. .. $ _____

☐ Newsletter subscription for one year $8.00 ☐ Two Years $15.00 $ _____

TOTAL AMOUNT ENCLOSED $ _____

Rush me *FREE* information on: ☐ Tours, workshops, and seminars ☐ Individual consultations

☐ Professional training ☐ Color and Image Consultants in my area

☐ MasterCard® # _____ ☐ VISA® # _____

Expiration Date:_____Signature:_____

Color, Hair Color and Skintone Samples

208 COLOR SAMPLES

ICY YELLOW	SOFT YELLOW	LEMON	YELLOW	CHROME YELLOW	YELLOW GOLD	CHEDDAR YELLOW	MANGO
DAFFODIL	GOLDEN YELLOW	CANTALOUPE	MARMALADE	TANGERINE	ORANGE	PUMPKIN	TERRA-COTTA
STRAW	SAFFRON	PERSIMMON	RUST	PAPRIKA	CINNAMON	COGNAC	GINGER
PEACH	APRICOT	CORAL	POPPY	ORANGE RED	SUNSET	TOMATO RED	SIENNA
PINK PINK	ROSE CORAL	SALMON	CORAL PINK	MELON RED	RED	RED ORANGE	STRAWBERRY
FLAMINGO PINK	GINGER ROSE	LIPSTICK PINK	BLUSHING PINK	ROSE	CHERRY	CARNATION	GARNET
LIGHT PINK	DUSTY ROSE	ROSE PINK	HOT PINK	SHOCKING PINK	RASPBERRY	BLUE RED	RUBY RED
PEPPERMINT	LAVENDER MAUVE	FUCHSIA	MAGENTA	PASSIONATE PLUM	ROSE MAGENTA	BERRY	CRANBERRY
MAUVE PINK	LIGHT HEATHER	HEATHER	THISTLE	AMETHYST	CABERNET	GRAPE	PLUM
ICY LAVENDER	HYDRANGEA	LIGHT AMETHYST	ULTRA VIOLET	VIOLET	PALE LILAC	LILAC	WISTERIA
LAVENDER PINK	LAVENDER	AURORA	ORCHID	PURPLE	PASSIONATE PURPLE	BLUE VIOLET	INDIGO
CHANTILLY	MAUVE	ROSEWOOD	WINE	EGGPLANT	CASSIS	BURGUNDY	MAHOGANY
WARM LIGHT GRAY	WARM GRAY	TAUPE	LIGHT GRAY	MEDIUM GRAY	GUNMETAL GRAY	CHARCOAL	BLACK

HAIR COLOR SAMPLES

BLUE BLACK	BLACK	SOFT BLACK	GRAY	STRAWBERRY RED	HONEY BLONDE	GOLDEN BLONDE	ASH BLONDE

SKINTONE SAMPLES – Cool

PORCELAIN	PINK	LIGHT BEIGE	BEIGE	LIGHT ROSE BEIGE	ROSE BEIGE	OLIVE	ROSE BROWN	LIGHT BROWN	ASH BROWN

The following are color, hair color, and skintone samples for your reference in using this book. There may be some duplications of the names for the colors, hair colors, and skintones. For example, the hair color *red* should not be, and is not the same as, the color *red*.

208 COLOR SAMPLES

PISTACHIO	PEA GREEN	LIMA BEAN	LEAF	KHAKI	LIGHT OLIVE	OLIVE	DARK OLIVE
BAMBOO	CURRY	MUSTARD	MUSTARD GREEN	TOBACCO	MOSS GREEN	TOBACCO BROWN	CHOCOLATE
NEON GREEN	JADE	AVOCADO	LIME	CHARTREUSE	YELLOW GREEN	GREEN	SPRUCE
LIGHT GREEN	APPLE	NEW LEAF	GREEN GRASS	FERN	COOL GREEN	EMERALD GREEN	FOREST GREEN
MINT	SPEARMINT	SHAMROCK	ZUNI TURQUOISE	EMERALD	GREEN BLUE	VERDE	PINE GREEN
MARINE GREEN	OCEAN SPRAY	TROPICANA	LIGHT AQUAMARINE	AQUA	PEACOCK GREEN	BRAZILIAN EMERALD	TEAL GREEN
POWDER BLUE	NAVAJO BLUE	TURQUOISE	HOT TURQUOISE	OCEAN	BLUE BONNET	DEEP OCEAN	ELECTRIC BLUE
Y BLUE GREEN	LIGHT BLUE GREEN	LIGHT TURQUOISE	TURQUOISE GREEN	SEA BLUE	BLUE GREEN	TURQUOISE BLUE	SKY BLUE
BABY BLUE	LIGHT PERIWINKLE	HEAVENLY BLUE	CLEAR BLUE	ASH BLUE	FRENCH BLUE	PERIWINKLE	CORN FLOWER
MYSTIC BLUE	NAVY	OCEAN BLUE	SAPPHIRE	MAJESTIC BLUE	LAPIS	COBALT	INK BLUE
SEA MIST	CELADON	SLATE	SEA FOAM	GRAY BLUE	HEATHER BLUE	SMOKE BLUE	STEEL BLUE
CELERY	GRAY GREEN	DARK GRAY GREEN	SAGE	CHARCOAL GREEN	ADRIATIC BLUE	TEAL BLUE	PEACOCK BLUE
BEIGE	TAN	CAMEL	WARM CAMEL	DARK CAMEL	WARM BROWN	BARK	COOL BROWN

HAIR COLOR SAMPLES

BLACK BROWN	DARK BROWN	BROWN	LIGHT BROWN	DEEP AUBURN	AUBURN	DEEP RED	RED

SKINTONE SAMPLES – Warm

IVORY	PEACH	LIGHT YELLOW BEIGE	YELLOW BEIGE	YELLOW OLIVE	LIGHT PEACH BROWN	PEACH BROWN	LIGHT GOLDEN BRONZE	GOLDEN BRONZE	MEDIUM BROWN